EDWARD HOPPER

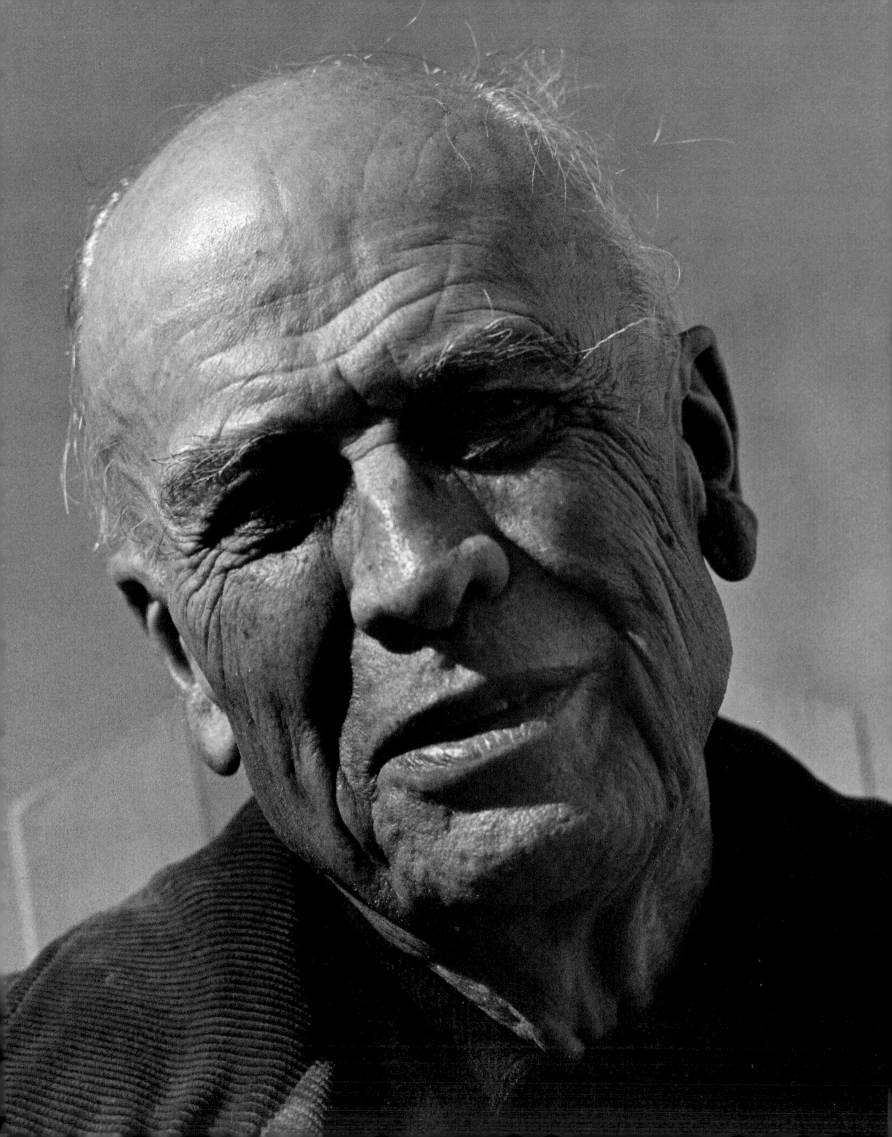

Peter L Folkes
2005

Folkes
61 Ethelburt Avenue
Southampton
SO16 3DF
Tel. 023 8055 6918

Peter L Folkes
2005

Ivo Kranzfelder

EDWARD HOPPER

1882 – 1967

Vision of Reality

MIDPOINT
PRESS

Cover:
New York Office (detail), 1962
Oil on canvas, 101.6 x 139.7 cm
Montgomery (AL), The Montgomery
Museum of Fine Arts, The Blount Collection

Illustration Page 2:
Hans Namuth
Edward Hopper, 1963
Hans Namuth © 1990

This edition published by Midpoint Press
by arrangement with TASCHEN GmbH

© 2004 TASCHEN GmbH
Hohenzollernring 53, D–50672 Köln
www.taschen.com

Original edition: © 1998 Benedikt Taschen Verlag GmbH
© 1994 for the illustrations of Segal: VG Bild-Kunst, Bonn
Cover design: Angelika Taschen, Cologne
English translation: John William Gabriel, Worpswede

Printed in South Korea
ISBN 3–8228–3886–1

Contents

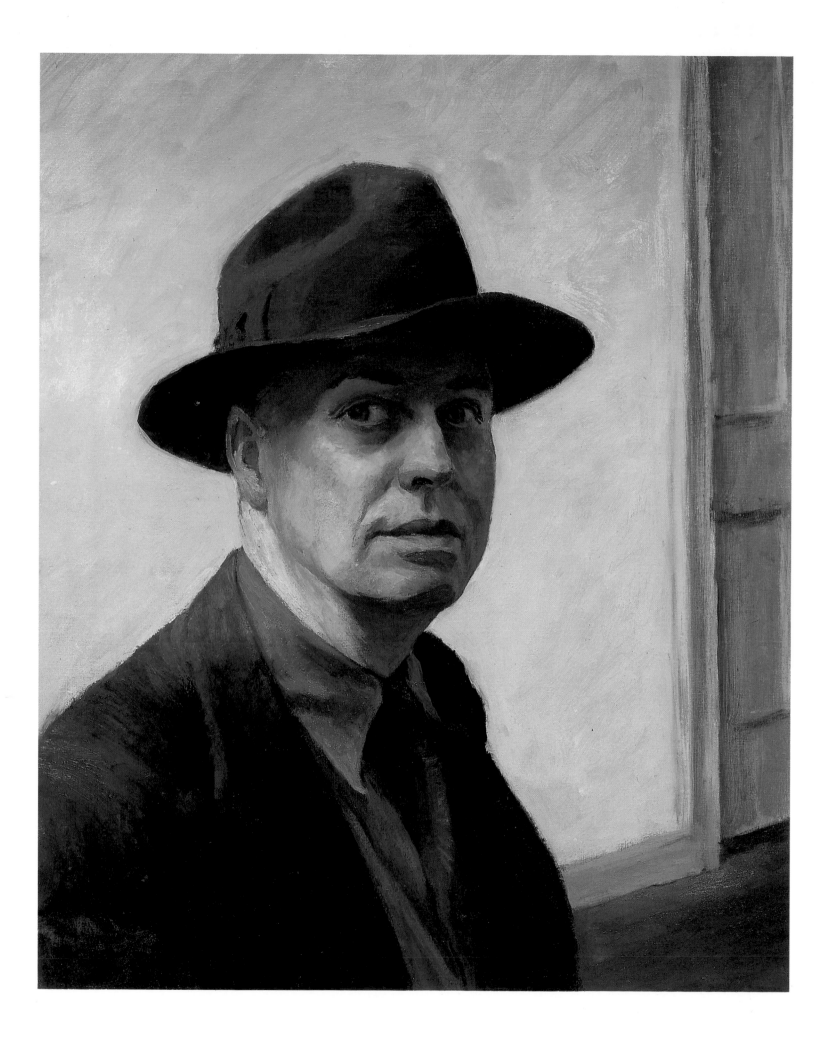

Life, Times, Style

The circumstances of Edward Hopper's life are only sparingly documented.[1] Nor have more than a very few anecdotes that shed light on his personality and character come down to us. To further complicate matters, Hopper himself was not especially forthcoming with information about his life and art, or his opinions about art in general. A great deal is left to speculation. Still, there are a few established facts to report.

Edward Hopper was born on 22 July 1882, in Nyack on the Hudson River, in the State of New York. His family, American for several generations, was of English and Dutch descent on his father's side, and of English and Welsh on his mother's. Edward had a sister, Marian, who was two years his elder. In 1890 their father, Garrett Hopper, acquired a dry goods business on South Broadway in Nyack. The Hoppers were a middle-class family and belonged to the Baptist Church.

By the age of five, like most children, Edward had begun to enjoy drawing, and at ten he started signing his work. He copied illustrations by Phil May and Gustave Doré from books. As regards his environment, commentators emphasize the strong impression made on the boy by Nyack harbor and the ships on the Hudson River.

After attending a local private school and Nyack High School, from which he graduated in 1899, Edward decided to study art. His parents had no objection, although they did advise him that illustration or commercial art would provide more financial security than painting. From adolescence, Hopper's career took a well-ordered course. At seventeen he went to New York City, where he enrolled in the Correspondence School of Illustrating. A year later he transferred to the New York School of Art, better known as the Chase School. After spending the year 1900 studying illustration with Arthur Keller and Frank Vincent DuMond, Hopper switched to the painting class.

His teachers there were William Merritt Chase, Kenneth Hayes Miller, and Robert Henri. Several of his fellow students, who included George Bellows and Rockwell Kent, were to make a name for themselves much more rapidly than Hopper. In 1904 a drawing of his was reproduced in an

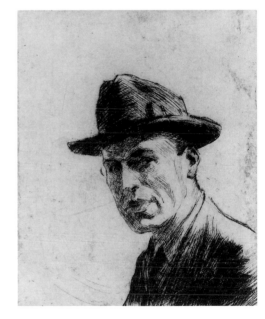

Self-Portrait with Hat, c. 1918
Etching, 12.4 x 10.2 cm
New York (NY), Collection of Whitney Museum of American Art. Josephine N. Hopper Bequest

Self-Portrait, 1925–30
Oil on canvas, 63.8 x 51.4 cm
New York (NY), Collection of Whitney Museum of American Art. Josephine N. Hopper Bequest
70.1165

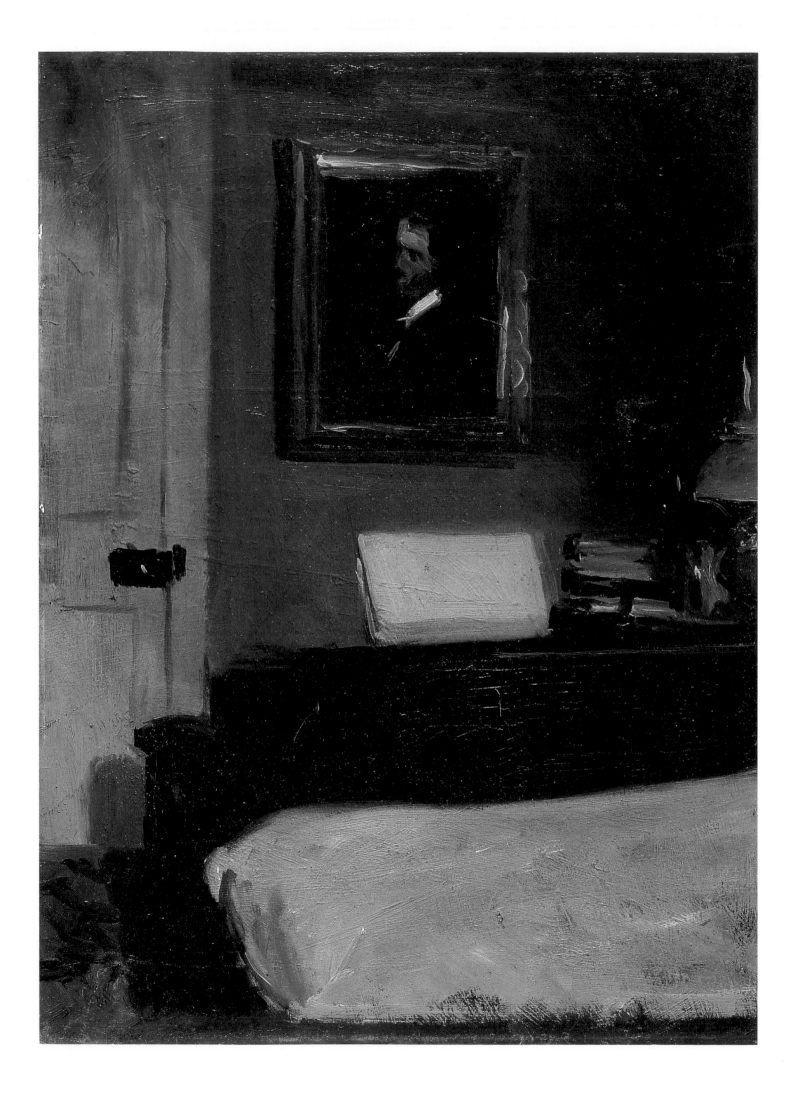

Self-Portrait, c. 1903–06
Oil on canvas, 66 x 55.9 cm
New York (NY), Collection of Whitney Museum
of American Art. Josephine N. Hopper Bequest
70.1253

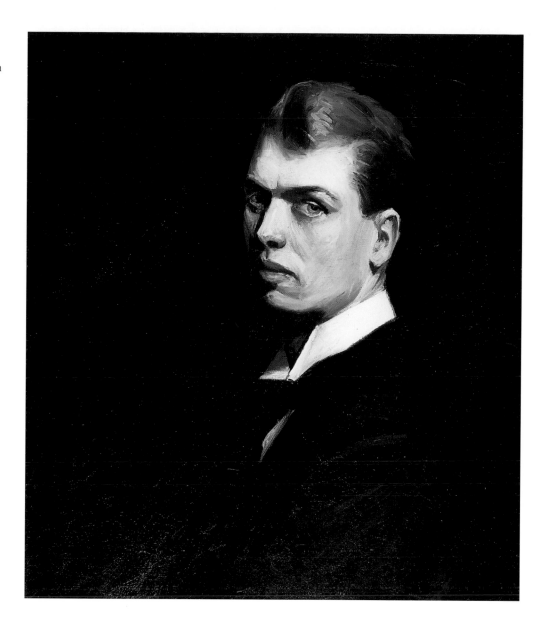

Artist's Bedroom, Nyack, c. 1905–06
Oil on cardboard, 38.3 x 28.1 cm
New York (NY), Collection of Whitney Museum
of American Art. Josephine N. Hopper Bequest
70.1412

article on student work at the New York School of Art, published in the magazine *The Sketch Book*.

In 1906, after finishing his training, Hopper went to Paris for nearly a year. But instead of attending an art school or academy, he visited exhibitions and painted out of doors. Writing to his mother, Hopper described the annual Salon d'Automne show as largely very bad, but still much more liberal in its aims than exhibitions at home. The salon he saw included retrospectives of Paul Cézanne and Paul Gauguin, and paintings by two Americans almost the same age as Hopper, Henry Bruce and Max Weber.

The year 1906 saw several key events in the Paris art world: Picasso painted his portrait of Gertrude Stein, Juan Gris and Gino Severini arrived in town, and Henri Matisse had a one-man show at Galerie Druet. Bruce, a fellow-student in Robert Henri's class in New York, drew Hopper's attention to the Impressionists. But the avant-garde then gathering its forces in Paris evidently made little impression on him. Asked whom he met there, Hopper replied, "Nobody. I'd heard of Gertrude Stein but I don't remember having heard of Picasso at all."[2]

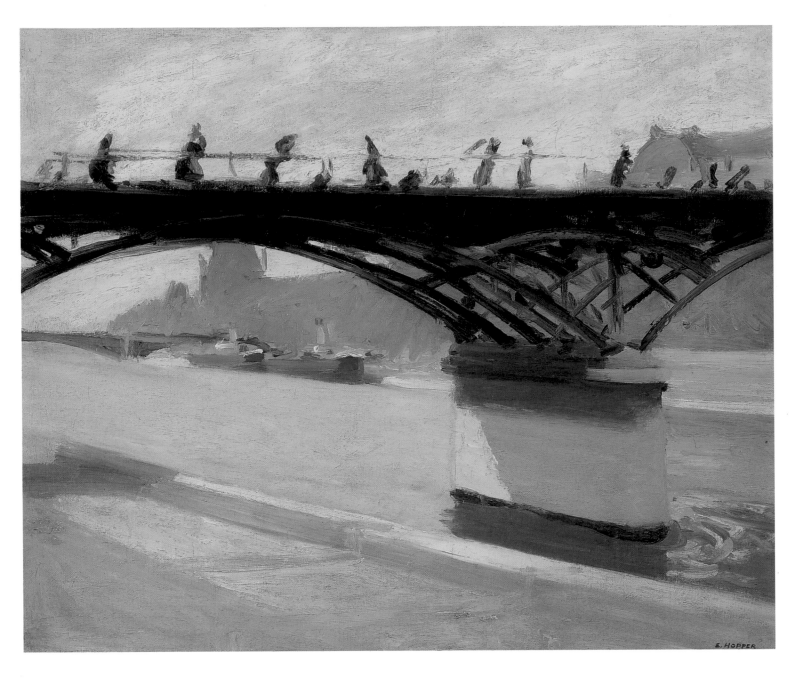

Le Pont des Arts, 1907
Oil on canvas, 58.6 x 71.3 cm
New York (NY), Collection of Whitney Museum
of American Art. Josephine N. Hopper Bequest
70.1181

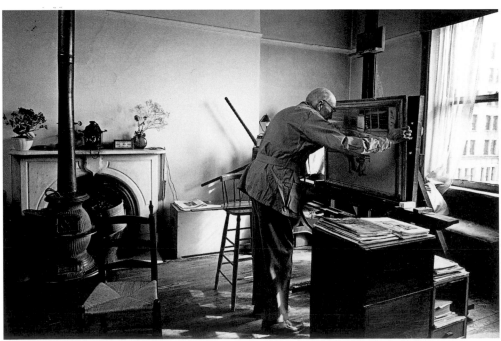

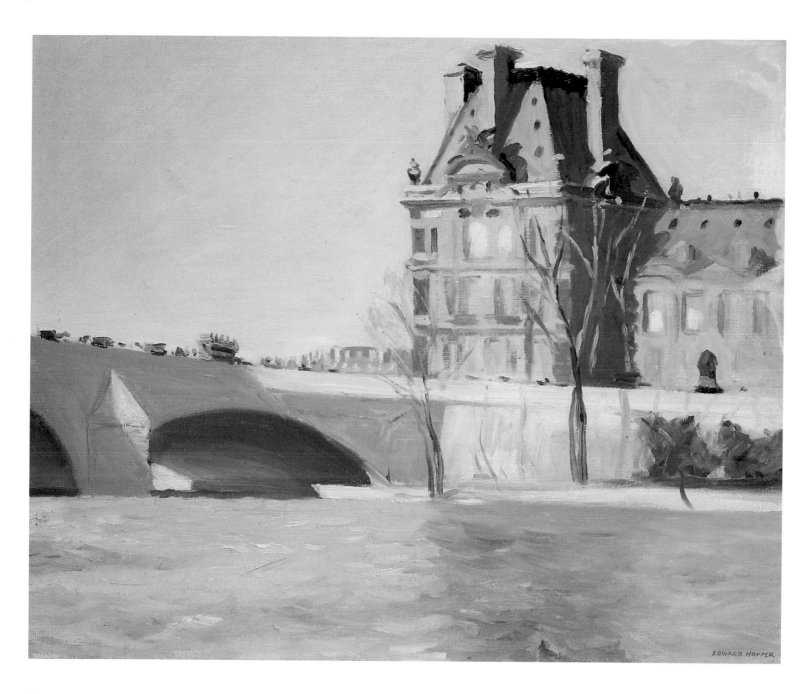

Le Pont Royal, 1909
Oil on canvas, 59.7 x 72.4 cm
New York (NY), Collection of Whitney Museum
of American Art, Josephine N. Hopper Bequest
70.1175

Smash the Hun
Poster, 1919

Hopper won a war poster competition with this design, gaining first recognition in the field of commercial art, of which he was only a reluctant practitioner.

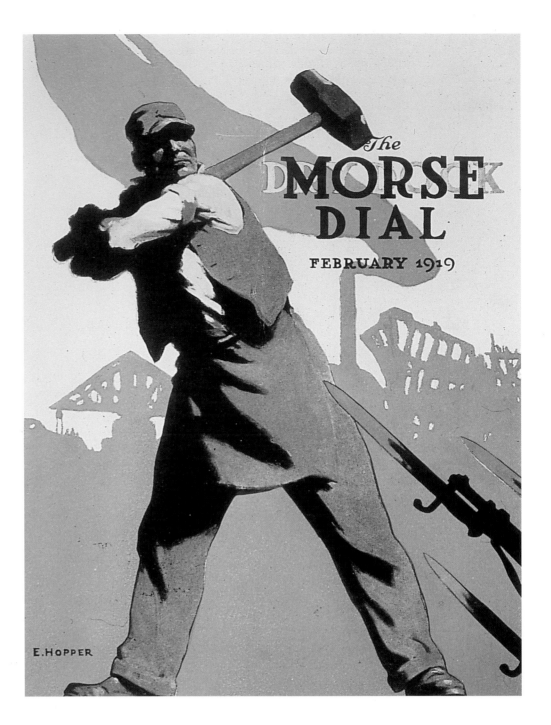

On 27 June 1907 Hopper travelled to London, where his itinerary included the National Gallery. His knowledge of Turner's work likely dates from this time. From London he went on to Amsterdam. There, Hopper later reported, he was specially impressed by Rembrandt's famous *Night Watch* in the Rijksmuseum. While in Haarlem he saw paintings by Frans Hals. After short stopovers in Berlin and Brussels, and another three weeks' stay in Berlin, Hopper returned to New York. Taking a job as illustrator with the Sherman & Bryan advertising agency, he painted in his spare time. The first public airing of his work came in 1908, in a group exhibition of former Henri students. Hopper contributed three oils and one drawing, all with French motifs.

Hopper's second Paris sojourn, in 1909, was brief, being terminated after only two months due to bad weather. His third and last trip to Europe was undertaken in 1910. From May to 1 July, Hopper interrupted

his weeks in Paris to travel to Spain, where his main destinations were Madrid and Toledo. The latter he described as a wonderful old town, but made no mention of Toledo's greatest artist, El Greco. Nor did Spanish art as a whole apparently make much of an impression on him. This was Hopper's final journey to Europe; from then on he was never to cross the Atlantic again.

Subsequently Hopper was represented in several open, non-jury group shows, initiated by Robert Henri, at the MacDowell Club. In 1913 he also submitted work to the groundbreaking International Exhibition of Modern Art, better known as the Armory Show. Inspired by the example of the Cologne *Sonderbund* exhibition of 1912, this mammoth presentation comprised 1600 works, two-thirds by American and one-third by European artists. Hopper was represented by a single canvas, *Sailing* of 1911 (p. 107), which was sold for $250. He was thirty-one at the time; this was his first sale, and it was to remain the last for another ten years. Although he continued to exhibit in various group shows, Hopper's oils went largely unremarked. In 1915 he took up the technique of etching, which brought initial successes in 1922 and 1924, when the first essays devoted to Hopper's art were published. However, he ceased printmaking in 1923, and was to return to it only rarely in subsequent years.

In 1918, Hopper had won first prize in a war poster competition. It is indicative that this design gained him more attention than his work in painting, and that his first public recognition came as an illustrator, a profession of which Hopper was not enamored. Also, his etchings and graphic works had begun to sell quite well at the time. The same year, 1918, marked the establishment in New York of the Whitney Studio Club, where independent artists were given an opportunity to exhibit. Hopper was among the founding members of the club, which was later to become the Whitney Museum of American Art. The first one-man show of the oils Hopper had done in Paris took place in the Whitney Studio in 1920, followed in 1922 by an exhibition of French caricatures (*A Zouave*, c. 1907, p. 13; *Parisian Woman Walking*, c. 1907, p. 13).

In the meantime, however, Hopper had long returned to American themes. He spent the summers in Maine, either in Ogunquit or Monhegan Island, whose landscapes fascinated him. But his interest went beyond picturesque features like the rugged, rocky coastline. Already, subjects were beginning to crystallize out which were to play an outstanding role in Hopper's later imagery. An example is *Road in Maine* (p. 14), with its sharp contrast between the natural topography and the road and telegraph masts, results of human activity and signs of civilization. This is a theme to which the artist would frequently return throughout his career.

In 1923, Hopper began working in watercolor again, a technique he had neglected since his stays in Paris. That year his girlfriend, artist Josephine Nivison, was invited by the Brooklyn Museum in New York to contribute watercolors to an exhibition. She drew the curators' attention to Hopper's work, which was accepted and ultimately drew very positive reviews, while her own was largely ignored. This did not affect the couple's private relationship, however, for they were married on 9 July 1924.

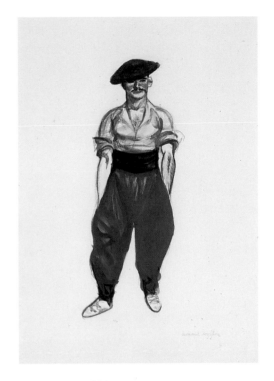

A Zouave, c. 1907
Watercolor and pencil on cardboard, 38.4 x 27.1 cm
New York (NY), Collection of Whitney Museum of American Art. Josephine N. Hopper Bequest 70.1333

Parisian Woman Walking, c. 1907
Watercolor on cardboard, 30 x 23.5 cm
New York (NY), Collection of Whitney Museum of American Art. Josephine N. Hopper Bequest 70.1323

Hopper's French caricatures were reproduced in the February 1916 issue of *Arts and Decoration*.

That fall, the Frank K. Rehn Gallery mounted Hopper's first one-man show in a commercial gallery. It comprised eleven watercolors, all of which were sold – and five further works as well. This financial success at last permitted Hopper to give up his work as an illustrator.

In 1913 Hopper had rented an apartment at 3 Washington Square North in New York, where he and his wife were to live until the artist's death. In 1934 they built a studio house in South Truro, Massachusetts, and began to spend the summer months of practically every year there. From the mid-1920s onwards, few significant changes were to occur in Hopper's life and art.

By this point in time – he was forty-two years old – Hopper had developed a genuinely personal style that would remain essentially unchanged over the following forty-three years of his career. Let us now review this development, with an eye to the artist's subsequent œuvre. For the moment I shall focus on the individual features of his style, postponing observations on its place within the art of the period, and American

Road in Maine, 1914
Oil on canvas, 61 x 73.7 cm
New York (NY), Collection of Whitney Museum of American Art. Josephine N. Hopper Bequest 70.1201

Despite its heavy impasto, this painting already anticipates the character of Hopper's later work in terms of theme and cropping. The only traces of human occupation are the telegraph masts.

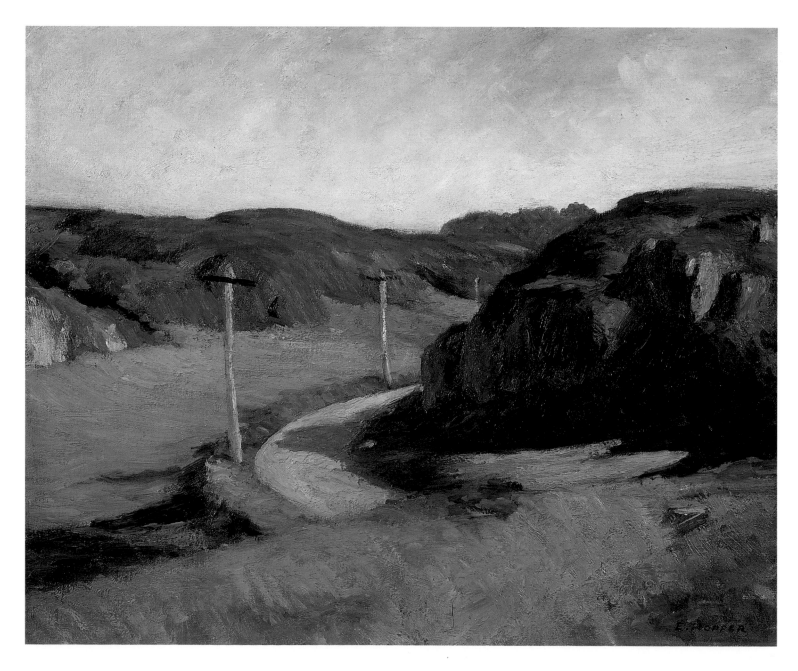

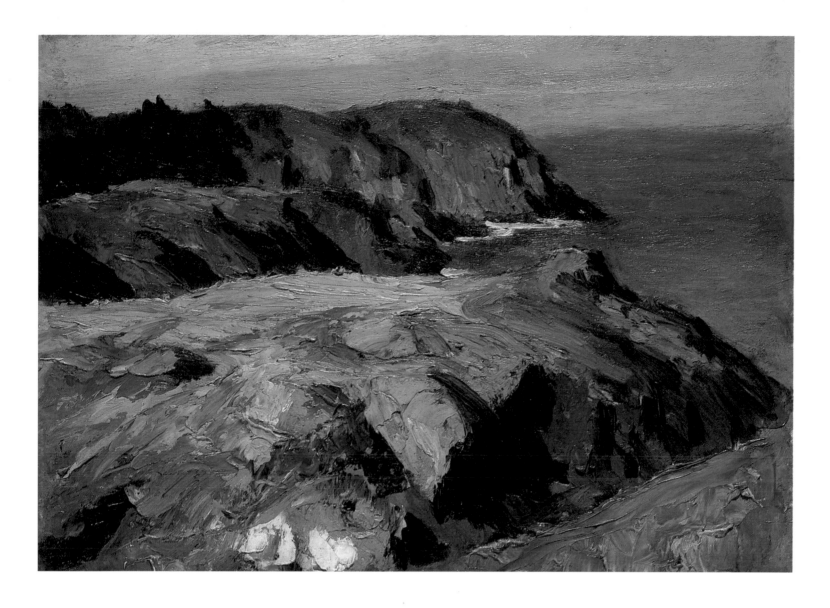

art in general. When I use the term style, I refer not only to form, color and texture in paintings but to their content and themes as well. A good introduction to Hopper's style, thus defined, is given by a few examples of his commercial art.

Early in his career Hopper regularly provided illustrations to magazines like *Farmer's Wife* and *Country Gentleman*, and covers for *Wells Fargo Messenger* and *The Dry Dock Dial*, the house organ of a shipping company. Drawings of his also appeared in the *Sunday Magazine*, *The Magazine of Business*, and *Scribner's Magazine*. This last periodical, by the way, distinguished itself by its rejection, indeed revilement of the modern European art that had arrived in America under the aegis of Alfred Stieglitz and in the wake of the Armory Show. "In *Scribner's* opinion," wrote Franz Roh, "Rodin was the chief of a gang of bogeymen, Cézanne lacked all training, and Matisse was absolutely untalented. All of the new art, as usual, was considered 'dissolute' or 'a symptom of decadence'."[3]

Hopper tended to speak disparagingly of his activity as an illustrator. He said he never devoted more than three days a week to it, in order to have time for his own, his real work. Illustration was a depressing affair, and not very well paid either, especially, Hopper admitted, because often

Blackhead, Monhegan, 1916–19
Oil on wood, 24.1 x 33 cm
New York (NY), Collection of Whitney Museum of American Art. Josephine N. Hopper Bequest 70.1317

Jo in Wyoming, 1946
Watercolor on paper, 35.4 x 50.8 cm
New York (NY), Collection of Whitney Museum
of American Art. Josephine N. Hopper Bequest
70.1159

The Hoppers bought a car in 1927. Working
from the car played an important role in shaping
Hopper's pictures, which frequently have the
character of film stills.

Louise Dahl-Wolfe
Edward and Jo Hopper, 1933
Tucson (AZ), Collection of the Center for
Creative Photography, University of Arizona.
© 1989 Center for Creative Photography,
Arizona Board of Regents

he did not supply what was expected of him. Of course Hopper was not
the only American painter who made his living as an illustrator or com-
mercial artist – Arthur G. Dove, Walt Kuhn, and Mark Tobey did so, not
to forget the later, famous example of Andy Warhol. Most of the members
of The Eight group, derisively known as the Ash Can School, were also
originally newspaper artists, as is evident from the style and approach of
their work in oils.

Hopper's illustrations presaged certain themes that would preoccupy
him throughout his career. In *Boy and Moon* (undated; p. 18) elements of
the later, famous etching *Evening Wind* already appear (1921; p. 41). *On
Deck* (undated) shows an affinity to a canvas done fifty years later,
People in the Sun (1960; pp. 164–165).

A quite different character, on the other hand, is evinced by a number
of crayon drawings, such as *In a Restaurant* (1916–25; p. 22) or the depic-
tion of two sisters sitting on a bed and talking, captioned *"I'm afraid, she
said, looking at me straightly now, that Shady's cough is more than just a
cough"* (1924; p. 23). The title itself indicates the difference: there is truly
communication taking place between these people, something Hopper
would tend to avoid in the works he classed as fine art. In addition, the
love of detail so evident in these illustrations, which emphasizes the real-
ism, or better, the naturalism of the scenes, was strongly reduced in his

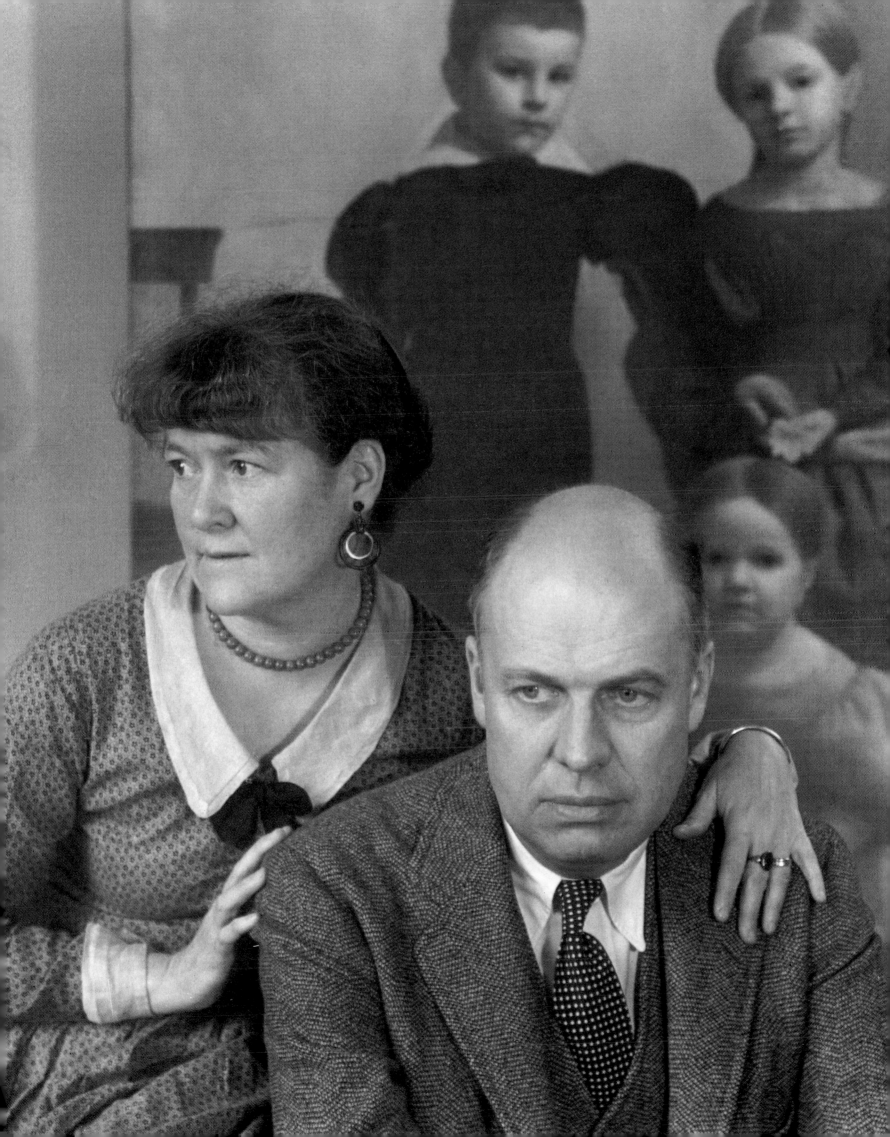

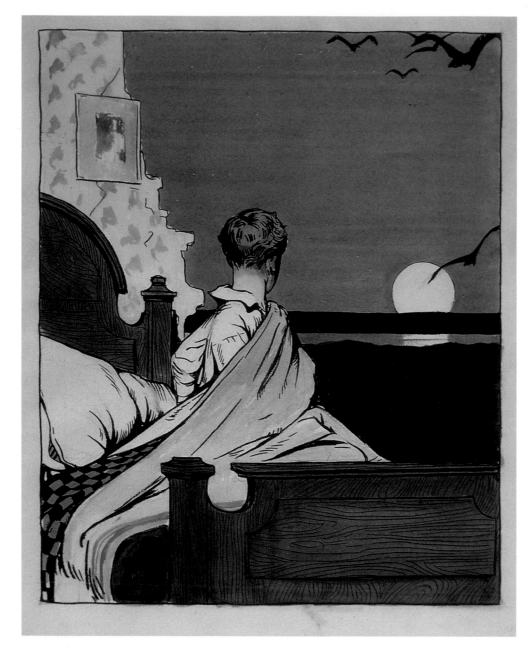

Boy and Moon, undated
Watercolor and India ink on paper, 55.6 x 37 cm
New York (NY), Collection of Whitney Museum
of American Art. Josephine N. Hopper Bequest
70.1349

The commercial illustrations Hopper did for
various magazines often exhibit the same basic
methods as his painting, and employ similar
motifs. Here it is an abrupt transition from inte-
rior to exterior space.

paintings. The restaurant scene also contains a great deal of movement,
such as the gesture of the man on the left, or the glass raised halfway to
the mouth of the other man.

Both drawings include a curtain blowing into the room, an element
that would again become a leading motif in Hopper's work.

The figure at the far left, cut off by the edge of the drawing, shows a
device derived from Edgar Degas which would become a frequent feature
of Hopper's compositions. Another characteristic feature occurs in *Boy
and Moon*: a merger of interior and exterior spaces, brought about by con-
tinuing the hilly landscape right to the head of the boy's bed, a device also
used to similar effect in *Rooms by the Sea* (1951; p. 176).

Figures cut off by the edge of the canvas and unusual perspectives,
again, were devices inspired by Degas. Hopper's œuvre contains many
compositions in which the scene is viewed diagonally from above, a van-
tage point that serves to interrupt the planes parallel to the picture surface
by introducing diagonals. What his commercial work permitted him to ex-

periment with only tentatively, appears full blown in an etching of 1921: *Night Shadows* (p. 19). Here, recurring to Degas, the artist employs a vantage point that would later be described, by László Moholy-Nagy, as an example of a "view from above." In his 1927 book *Malerei, Fotografie, Film (Painting, Photography, Film)*, Moholy-Nagy wrote that the interest of such bird's-eye views lay not in the subject itself but in the high vantage point and the balanced visual relationships this produced.[4] The eccentric vantage point and resulting shadow configurations would subsequently have a great influence on photographers such as Alexander Rodchenko and the Bauhaus student Otto Umbehr, alias Umbo.

Hopper, too, loved to experiment in his illustrations, constantly searching for pictorial solutions which, once found, were put through variation after variation in all the media he employed. During his student years he had used a dark palette, based either on a cool greyish-blue or a warm brown. Then, in Paris, under the influence of Impressionism and Pointil-

Night Shadows, 1921
Etching, 17.5 x 21 cm
Sheet 33.8 x 36.2 cm
New York (NY), Collection of Whitney Museum of American Art. Josephine N. Hopper Bequest 70.1047

The bird's-eye view would be employed a few years later by avant-garde photographers such as Alexander Rodchenko and Otto Umbehr.

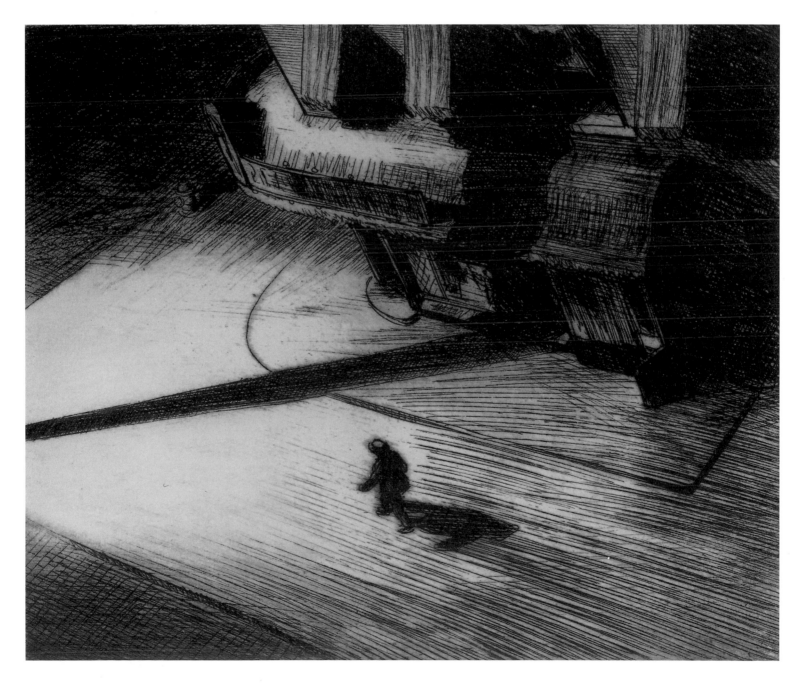

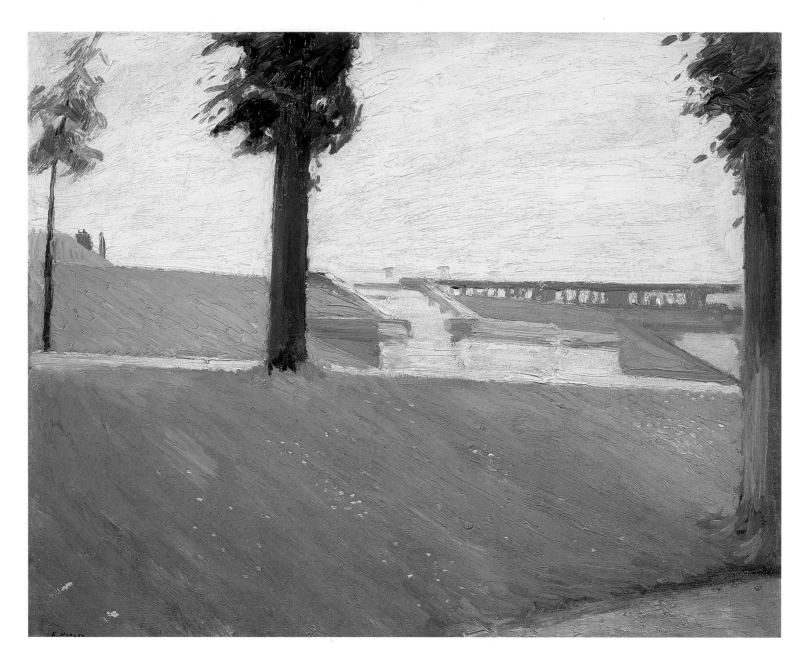

Le Parc de Saint-Cloud, 1907
Oil on canvas, 59.7 x 72.4 cm
New York (NY), Collection of Whitney Museum
of American Art. Josephine N. Hopper Bequest
70.1180

This canvas anticipates the carefully arranged
and selected elements and non-narrative char-
acter of the artist's later œuvre. It also shows
Hopper's penchant for geometrically oriented
compositions accented by gentle diagonals.

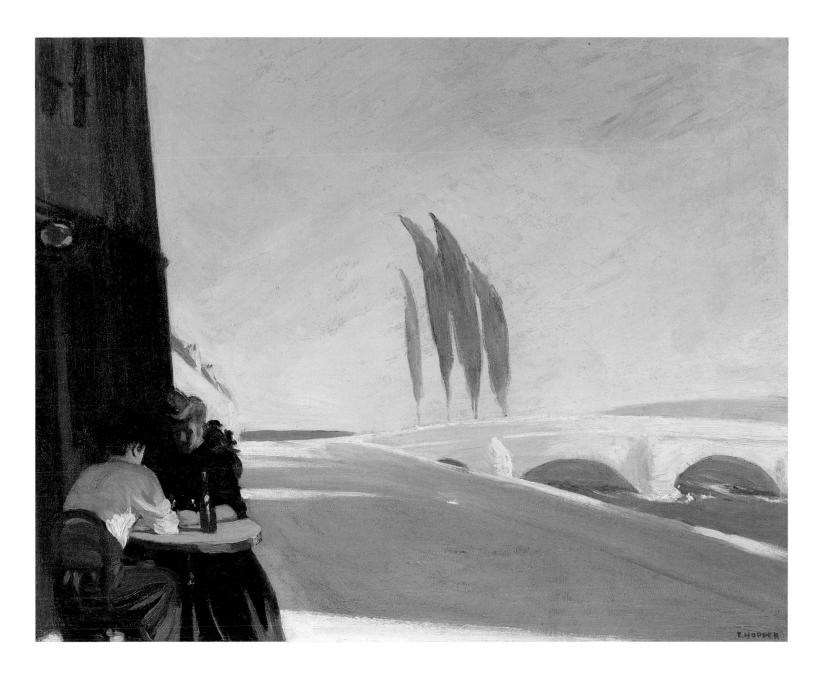

Le Bistro or **The Wine Shop**, 1909
Oil on canvas, 59.4 x 72.4 cm
New York (NY), Collection of Whitney Museum
of American Art. Josephine N. Hopper Bequest
70.1187

This is one of the very few Hopper pictures to
contain reminiscences of French or Belgian
Symbolism. It combines a genre scene, at left,
with a spacious, dreamlike landscape.

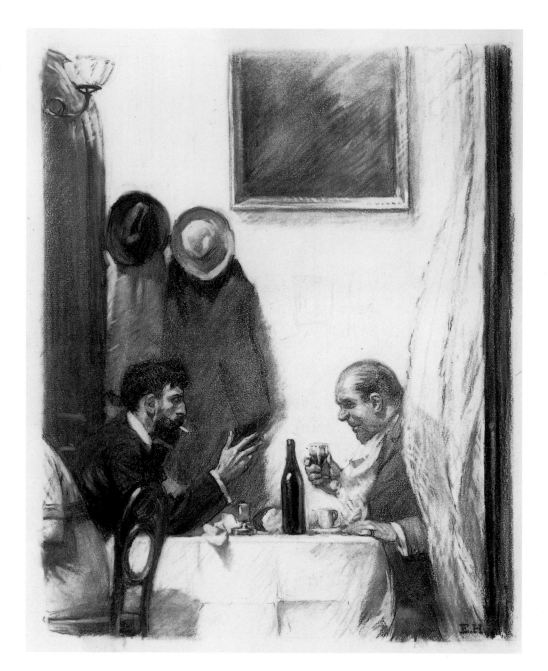

In a Restaurant, 1916–25
Conté crayon on cardboard, 67.6 x 55.1 cm
New York (NY), Collection of Whitney Museum
of American Art. Josephine N. Hopper Bequest
70.1449

lism, Hopper's colors grew lighter, more blond. "I went to Paris," he re-
called, "when the pointillist period was just dying out. I was somewhat
influenced by it. Perhaps I thought it was the thing I should do. So the
things I did in Paris – the first things – had decidedly a rather pointillist
[i.e. Impressionist] method. But later I got over that and the later things
done in Paris were more the kind of thing I do now."[5]

Hopper once said it took him ten years to get over Europe – and by the
blanket term Europe he really meant France. The best example of this is
the canvas *Soir Bleu* (pp. 24–25), done in 1914. It holds a quite singular
position in Hopper's œuvre, simply because here, human figures predomi-
nate. The space they occupy is only suggested, but it apparently repre-
sents the terrace of a café, bounded by a balustrade. The background is in-
determinate, being articulated solely by an undulating line dividing the
upper, light blue surface from the lower, dark blue one. A second division
of the picture space, into far and near, outside and in, is given by the
stone balustrade. Vertically, the left third of the composition is separated

from the remainder by a band of color, probably representing the support of an imaginary roof from which the lanterns are suspended. The figures are arranged to correspond to this compositional scheme.

Seated at a separate table at the left is a man who, in the preparatory study (*Un Maquereau* [Study for *Soir Bleu*], 1914, p. 26), is identified as a pimp. At the next table we see a bearded man in profile, his eyes obscured by a large beret, a cigarette in the corner of his mouth, and a heavy shadow under his cheekbone. The cigarette links him to the figure seated in a prominent position in the middle of the right-hand section of the picture, a clown in greasepaint and costume, staring abstractedly in front of himself. Seated between these two is a soldier, probably an officer in dress uniform, with his back to us. Judging by the poise of his head, he is looking at the heavily made-up woman standing very upright

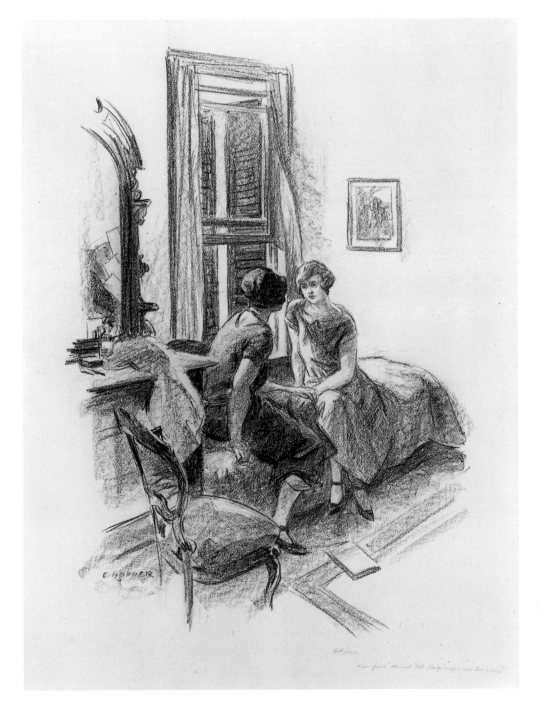

"I'm afraid, she said, looking at me straightly now, that Shady's cough is more than just a cough", Scribner's Magazine, 1924
Conté crayon heightened with white on cardboard, 76.1 x 55.2 cm
New York (NY), Collection of Whitney Museum of American Art. Josephine N. Hopper Bequest 70.1455

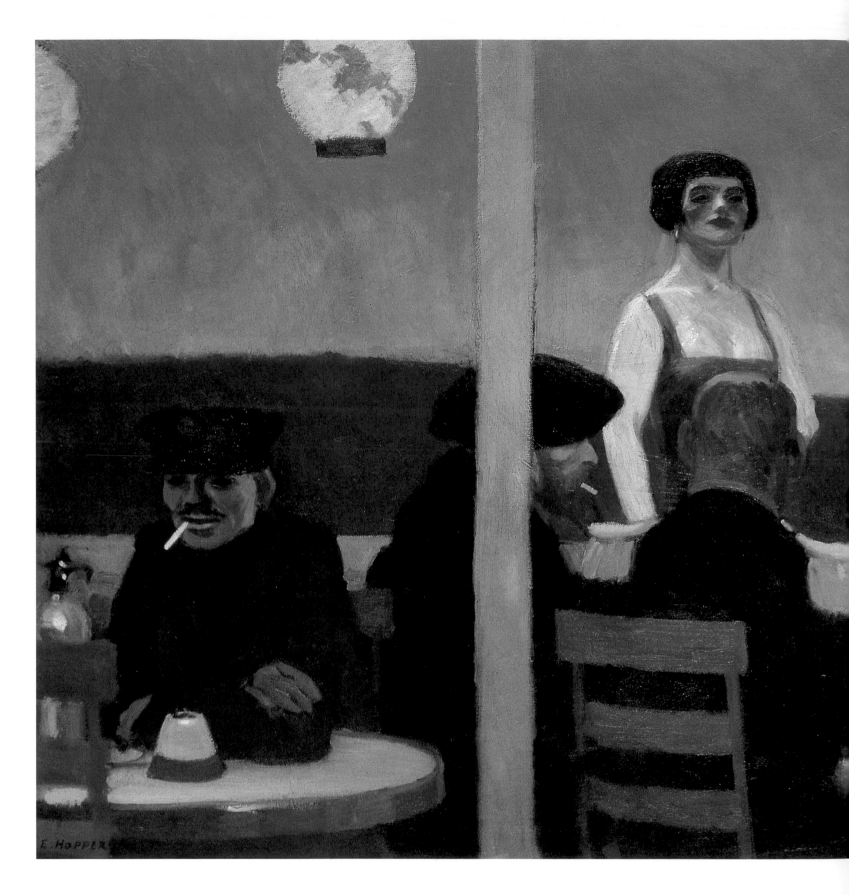

Soir Bleu, 1914
Oil on canvas, 91.4 x 182.9 cm
New York (NY), Collection of Whitney Museum
of American Art. Josephine N. Hopper Bequest
70.1208

Here Hopper reflects upon his position as an art-
ist at a period in which he was still without suc-
cess. The identification of artist with clown has
a long tradition in art. The painting was one of
his last to reveal a direct French influence.

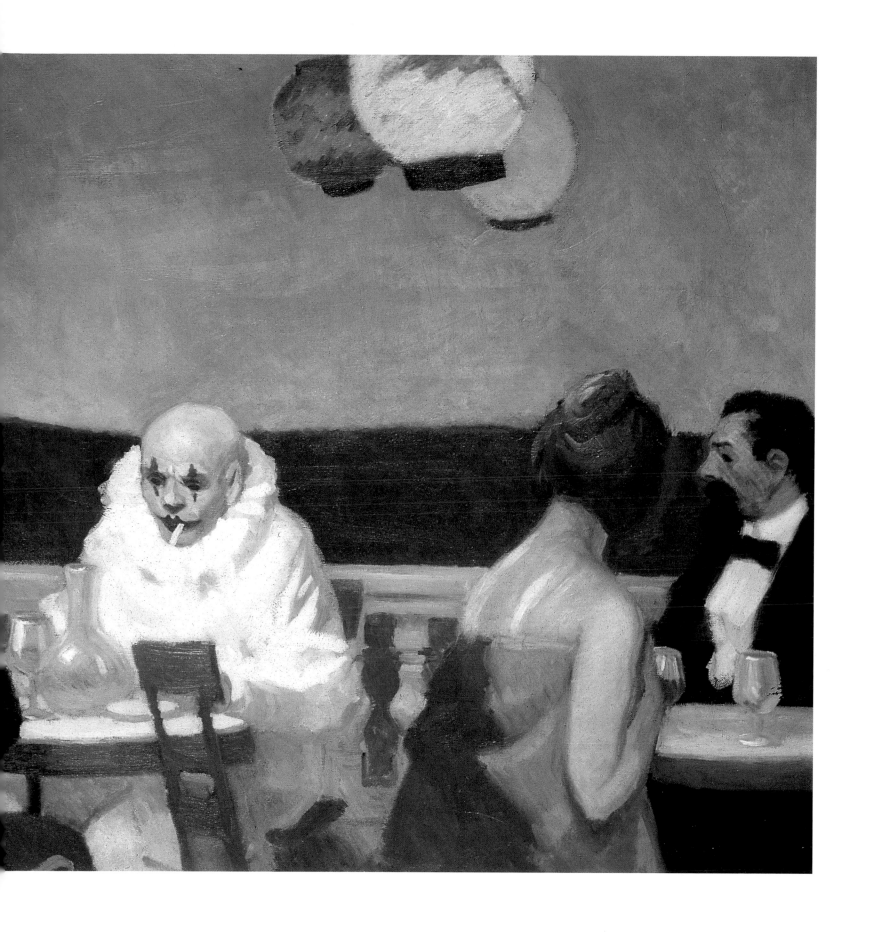

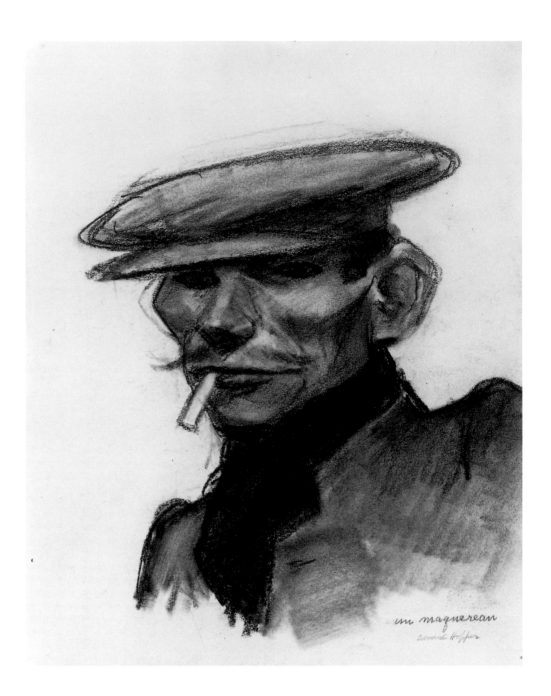

behind the balustrade – evidently a prostitute. Finally, at the table to the far right, a well-groomed, apparently upper-middle-class married couple observes the scene. While most of the other figures overlap, the couple remains definitely separate from the rest.

The figures – not so much individuals as archetypes of the pimp, the bearded Frenchman in a beret, the clown – are involved in certain interrelationships. They have cigarettes in their mouths, or let them dangle from their lips, but strangely, no smoke is to be seen. The cigarette serves here as an attribute, a sign of membership in a certain social stratum, that Bohemian, typically Parisian *demi-monde* in which art and underworld mingled. Yet according to Goodrich, Hopper avoided such society while in Paris.

At any rate, the cafés of the day also attracted people from a higher milieu. The bourgeoisie, represented by the three other figures in the composition, frequented Bohemian haunts without fearing to compromise themselves. Edouard Manet belonged to both groups. As Robert L. Herbert

has remarked, Manet was a member of high society who moved with equal aplomb in cultivated, well-to-do circles and on the margins of urban society where he found his models.[6] The figure in the beret, seated as it were half in the pimp's domain, might be interpreted in this sense. An obvious relationship, in terms of their make-up alone, is established between the clown and the prostitute, who stands self-confidently apart from and above all the other figures. It is difficult to say exactly where she is looking, though her gaze is probably directed towards the military man, a potential customer.

Soir Bleu is surely also concerned with an issue rarely found in Hopper's work, the position of the artist in society, and, we may assume, his own specific position. Hopper's last work, *Two Comedians* (1965; pp. 174–175), is a variation on the same theme. There can be no doubt that Hopper identified the figure of the clown with the artist. The motif of comparing artists with court fools, jesters, and even magicians has a long tradition in artists' biographies. There is a revealing anecdote about Hop-

Notre Dame de Paris, 1907
Oil on canvas, 59.7 x 72.4 cm
New York (NY), Collection of Whitney Museum of American Art. Josephine N. Hopper Bequest 70.1179

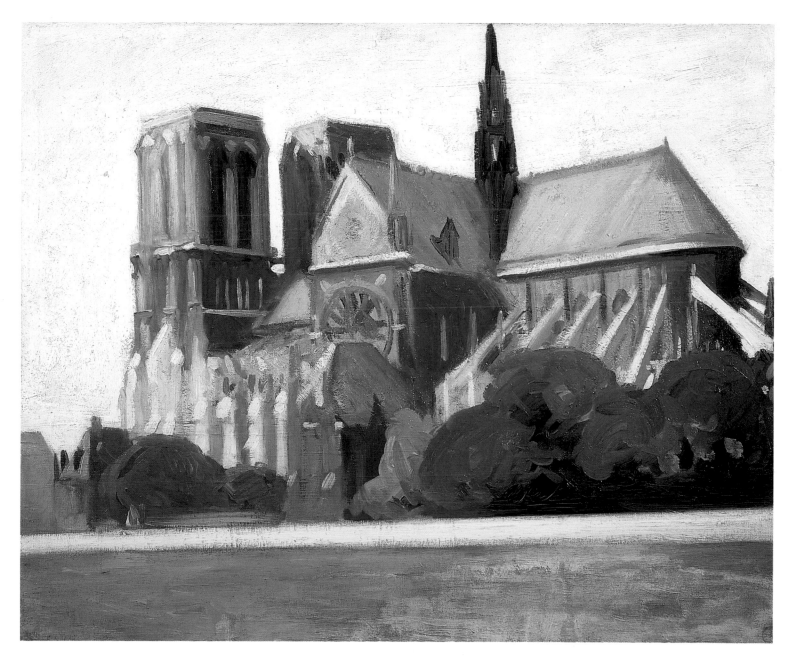

per, related by Gail Levin, concerning painted bedbugs he is said to have placed on the pillow of fellow-student Walter Tittle. The *trompe-l'œil* trickster motif is a perennial one. In classical antiquity it occurs in Pliny's story about Zeuxis' painted grapes that fooled sparrows into picking at them, and it reappears in the Renaissance in Vasari's tale of the master who tried to scratch off an insect a student added to his painting. The motif can be traced all the way down to the twentieth century.

In addition to the traditional trickster or clown motif, Hopper also integrated a number of personal references in *Soir Bleu*. The theme of prostitution, for instance, might be related to his activity as a commercial artist. And the defiant pose of the female figure may possibly underscore, by contrast, the artist's own lack of success at the time, for when *Soir Bleu* was painted, Hopper had sold only a single canvas, at the Armory Show. This lack of recognition might also be reflected in the disgruntled appearance of the man at the far right, who observes the others with a not particularly friendly mien.

Hopper exhibited *Soir Bleu* in 1915, at a group show in the MacDowell Club. It was the first picture of his to be discussed in a review. The critic was not enthusiastic, calling the painting an ambitious product of the imagination, with no intensity of expression. It was described as a portrait of a group of inveterate Parisian absinthe drinkers, and a not par-

November, Washington Square, 1932–59
Oil on canvas, 86.7 x 127.6 cm
Santa Barbara (CA), Santa Barbara Museum of Art, Gift of Mrs. Sterling Morton for the Preston Morton Collection

Hopper rented a studio on Washington Square in New York in 1913. He was to live there for the rest of his life.

Hills, South Truro, 1930
Oil on canvas, 69.5 x 109.5 cm
Cleveland (OH), The Cleveland Museum of Art,
Hinman B. Hurlbut Collection, 2647.31

ticularly successful one at that. The other painting Hopper had in the exhibition, however, drew critical praise: *New York Corner (Corner Saloon)* (1913; p. 117).

After this first attempt, Hopper never exhibited *Soir Bleu* again. The title, Gail Levin writes, was influenced by a line from a poem by Arthur Rimbaud, the French symbolist, which runs: "Par les soirs bleus d'été..." (Through the blue evenings of summer...). Naturally the correspondence of the words "soir bleu" does not necessarily indicate a direct connection. But the literary reference does bring up an important point: Hopper's reading, and the authors he valued. According to Levin he was highly intellectual, and he read French and Russian classics in translation – including Molière, Victor Hugo, Marcel Proust, Rimbaud, Paul Verlaine, and Charles Baudelaire. A frequently cited anecdote tells of Hopper's admiration for Goethe's poem, *Wanderers Nachtlied* ("Über allen Gipfeln ist Ruh..."), which he was able to recite in the original German. He valued the poem for the extraordinary visual image it contained. Hopper also knew and appreciated modern American realist literature, such as the novels of Theodore Dreiser and the plays of Eugene O'Neill, Maxwell Anderson, Elmer Rice, and Thornton Wilder (who belonged to Hopper's generation), as well as, later, the work of Tennessee Williams.

The Hoppers not only frequented the theater but enjoyed going to the movies as well. Although we have no detailed information about his preferences, we do know that the artist looked forward to seeing Jean-Luc

Blackwell's Island, 1911
Oil on canvas, 61 x 73.7 cm
New York (NY), Collection of Whitney Museum
of American Art. Josephine N. Hopper Bequest
70.1188

Blackwell's, now Roosevelt Island, was an ex-
tremely popular motif. Hopper's teacher, Robert
Henri, painted a view of it in 1900, and his fel-
low-students Julius Golz and George Bellows
later followed suit. Such expansive panoramas
are found only in Hopper's early work.

Yonkers, 1916
Oil on canvas, 61 x 73.7 cm
New York (NY), Collection of Whitney Museum
of American Art. Josephine N. Hopper Bequest
70.1215

Depictions of small towns with this number of
figures and atmosphere of vitality are rare with
Hopper. The motif and its handling go back to
French Impressionism.

Godard's film, *A bout de souffle (Breathless),* and once expressed his admiration for French directors in a television interview. His pictures, moreover, contain obvious parallels to the Hollywood *film noir* mode, as well as to Hitchcock. The influences may well have been reciprocal.

As regards the approaches to art that possibly contributed to Hopper's style, mention could be made of Caspar David Friedrich, J.M.W. Turner, and the Impressionists. Hopper's own preferences reveal an idiosyncratic taste. For instance, he valued Thomas Eakins, the nineteenth-century American realist, higher than Manet. Cézanne's work, he said, had a "papery quality," in contrast to the substance and weight of Gustave Courbet or Winslow Homer. Yet it is difficult to detect any direct influence of other artists on Hopper's work. While Degas may have been seminal in terms of vantage point and cropping, his technique seems to have held little attraction for Hopper. Major artist that he was, Hopper developed his own, original style, which made his paintings formally and substantially unique. His approach to the subject of a small-town street (*Yonkers*, 1916; p.31) certainly invites comparison with the cityscapes of the Impressionists. Yet the differences are obvious: Hopper's light is much brighter, the shadows more harshly contoured, and the vantage point is characteristically extremely low, serving to enlarge, indeed to sublimate the objects depicted. In contrast, the Impressionist vantage point, such as that of Pierre-Auguste Renoir, frequently invites the viewer to enter the picture at eye level, involving him in the scene. This is something Hopper seldom does.

Yonkers contains an unusual number of figures by Hopper's standards, though they are seen from a great distance. The bustling crowd and the

Rocks and Houses, Ogunquit, 1914
Oil on canvas, 60.3 x 73 cm
New York (NY), Collection of Whitney Museum
of American Art. Josephine N. Hopper Bequest
70.1202

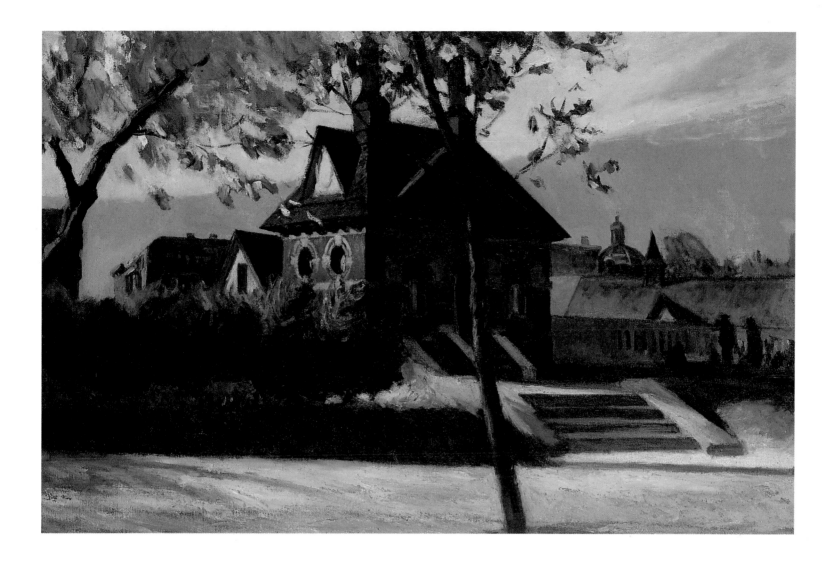

strectcar convey an impression of movement, which is amplified by the impasto, wet-in-wet technique employed. Later pictures would no longer have this dynamic quality, and the paint application would grow thinner. By the early 1920s Hopper had already found the style he was to employ with little alteration until the 1960s. Naturally there were nuances of change, but only nuances. The scenes became increasingly spacious and vacant, and when figures were included, they formed loosely-knit groupings. Larger gatherings or crowds no longer appeared in Hopper's compositions at all.

Small Town Station can be said to mark the point of departure for Hopper's œuvre to come (1918–20; p. 33). After this canvas he began to depict the theme of the small, provincial town in variation after variation. A key role in this imagery would be played by the railroad, that nineteenth-century means of transport and symbol of progress which seemed to shrink distances and shorten days. In the painting as in reality, the railroad parallels the street, artery of commerce before rails were invented, and soon to be revolutionized with the invention of the automobile.

Small Town Station, 1918–20
Oil on canvas, 66 x 96.5 cm
New York (NY), Collection of Whitney Museum
of American Art. Josephine N. Hopper Bequest
70.1209

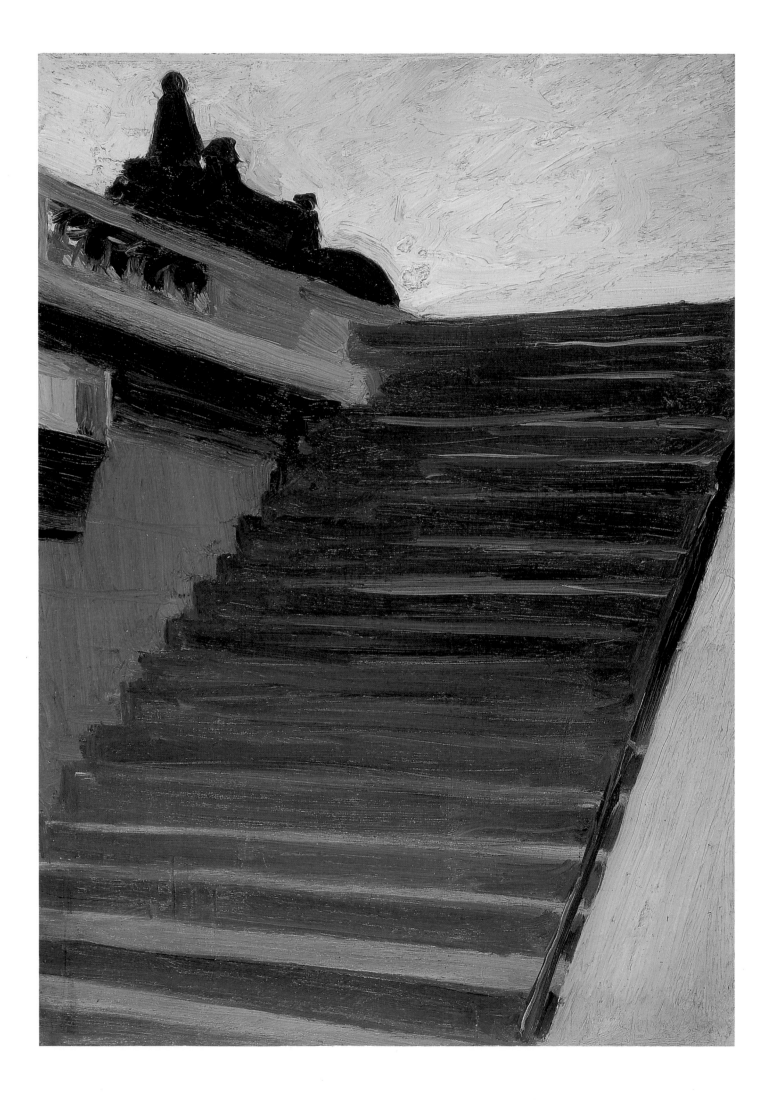

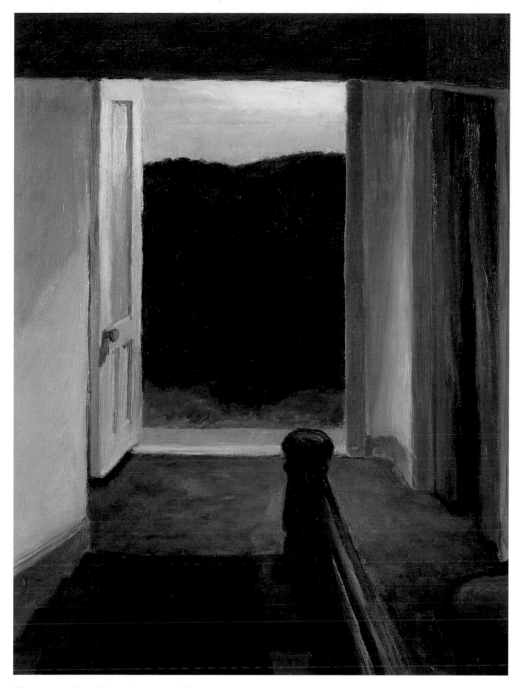

Stairway, c. 1919
Oil on wood, 40.6 x 30.2 cm
New York (NY), Collection of Whitney Museum
of American Art. Josephine N. Hopper Bequest
70.1265

Stairway at 48 rue de Lille, Paris, 1906
Oil on wood, 33 x 23.5 cm
New York (NY), Collection of Whitney Museum
of American Art. Josephine N. Hopper Bequest
70.1295

Hopper employed the stairway motif to suggest a transition from one state to another – from inside to outside, from above to below, from civilization to nature, or from the real world into a transcendental one.

Steps in Paris, 1906
Oil on wood, 33 x 23.5 cm
New York (NY), Collection of Whitney Museum
of American Art. Josephine N. Hopper Bequest
70.1297

The Secularization of Experience

Hopper's paintings do not lend themselves readily to analysis. The traditional instruments of art history prove inadequate when applied to his work. As modern art grows increasingly subjective, the traditions and conventions which formerly permitted of generally valid, relatively objective judgement become blurred. Also, we know very little about Hopper's own intentions, for he tended to sidestep every attempt to interpret his imagery. Werner Hofmann once remarked that there was hardly an artist nowadays who let the opportunity for self-commentary pass. Hopper was one of the few. At most he would describe, apparently naively, what he envisaged when doing a painting, using phrases of a rather homely, self-evident kind. In one case he added, "I am hoping that ideas less easy to define have, perhaps, crept in also."[1] Hopper's silence, and the elusive quality of suspense found in his paintings, have surely contributed much to his popularity. The imagery seems open to practically any interpretation, and it is no coincidence that commentaries abound with such terms as "feeling", "psychology", and "introspectiveness".

As a criterion, "feeling" is certainly not much of a help in reading Hopper's imagery. He took the traditional means of painting to a new threshold, employed conventional motifs and techniques to overcome the traditional canon. Precisely because his paintings apparently depict reality, they remain literally open, multifarious, multifacetted. They cannot be considered without considering the viewer, whose interpretation supplements the message to be interpreted. In veritably all of his paintings, Hopper made the viewer's gaze part of the subject of the work. But apart from a few self-portraits, the figures in the pictures never return this gaze.

Personal interactions take place within the scene depicted, leaving the viewer to stand outside, compelled to assume the role of onlooker, involuntary witness, even voyeur. Yet the protagonists, as is already strikingly evident in *Soir Bleu*, may have a strangely vacant, lost look in their eyes. Hopper coaxes the viewers of his pictures into certain roles or attitudes that actually have very little to do with feeling. In order to shed light on this mechanism, let us turn to a motif that occurs in many, and ambiguous, variations in Hopper's œuvre.

Standing Nude, c. 1920
Conté crayon on paper, 27 x 41.9 cm
New York (NY), Collection of Whitney Museum of American Art. Josephine N. Hopper Bequest 70.414

Nude Crawling into Bed, c. 1903–05
Oil on cardboard, 31.1 x 23.2 cm
New York (NY), Collection of Whitney Museum of American Art. Josephine N. Hopper Bequest 70.1294

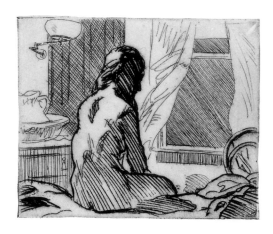

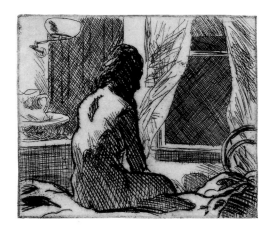

Hopper frequently depicted female figures, nude or clothed, in interiors. The women are generally seen in intimate situations, or at any rate, in situations that are unsensational, unspectacular – in fact commonplace. An early example is *Nude Crawling into Bed*, done during Hopper's student days (c. 1903–05; p. 36). The artist has chosen a moment in which the model is simply clambering into bed, without a thought for the grace or provocativeness of her movements. He has no point to make or story to tell. In such early paintings, movement, even when it appears frozen, still plays an effective role. Later the interior scenes would become entirely static, in a few cases with a dynamic element introduced from outside. If there was any sense of drama, it would be produced by lighting at most.

By comparison to the dark hues of the earlier canvas, *Summer Interior* evinces the blond palette Hopper adopted during his sojourns in Paris (1909; p. 39). A girl is seated on the floor, on the corner of a sheet pulled down from the bed. Her knees bent, she leans back against the edge of the bed, supporting herself on her angled right arm. Her left arm is extended downwards, the hand between the thighs, leaving the pubic area visible. She gazes towards the floor, and her hairdo almost entirely obscures her features. The position of the figure recalls Degas, although it conveys a greater sense of repose. The bed extends into the picture, and the scene is framed on the left by what appears to be a curtain – a formal element to be sure, but also a device seemingly aimed at placing the viewer in the role of outside observer or voyeur.

The sun is shining through a window behind us, outside the picture,

The Open Window (three states*)*, 1915–18
Etching, 10.2 x 12.7 cm
Private collection

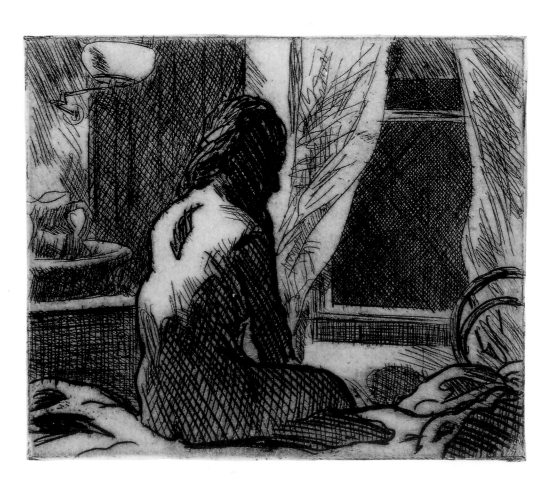

and casts a sharply contoured, nearly white patch on the floor. The fact that the girl's hand is between her legs need not imply a sexual innuendo on Hopper's part. By comparison to similar motifs in the work of Balthus, for instance – almost thirty years Hopper's junior – the gesture is quite innocent. Hopper observes the scene with detachment, taking himself out of the picture and declining to give it a personal touch, an individual signature. *Summer Interior* dates from an early, experimental phase of the artist's development. Let us now take a brief look at the way in which he subsequently ramified the motif of the nude, lending it increased substantiality and focus.

One step on the path may be seen in *The Open Window*, an etching Hopper took through three states (1915–18; p. 38). It shows a nude woman seated on a bed with her back turned. A breeze blows through the open window, slightly billowing the curtains. Visible at the right is the back of a chair, and at the left, a washstand with pitcher and basin in front

Summer Interior, 1909
Oil on canvas, 61 x 73.7 cm
New York (NY), Collection of Whitney Museum of American Art. Josephine N. Hopper Bequest 70.1197

Study for *Evening Wind*, 1921
Chalk and charcoal on paper, 25.4 x 35.4 cm
New York (NY), Collection of Whitney Museum
of American Art. Josephine N. Hopper Bequest
70.343

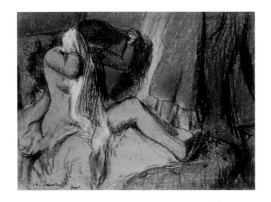

Edgar Degas
After the Bath, c. 1888–92
Après le bain
Pastel on paper, 48 x 63 cm
Munich, Neue Pinakothek

Hopper often combines the viewpoint of
Degas with influences from Romantic art. The
result is a fascinating blend of movement and
contemplativeness.

of a mirror, with a lamp above them. As regards technique, an interesting feature is the varying density of hatching Hopper employs. While the shadows on the figure are rendered in broad, deeply etched crosshatched lines, a finer needle has been used for the wall on the left, and an even finer and denser pattern in the window opening, to evoke the darkness outside.

There are many features of *The Open Window* that anticipate the way in which Hopper would handle the motif in future. Four elements play a key role here: female figure, window, curtain, and the lighting or illumination. A certain relationship is established between viewer and image, by means of the relationship among the elements of woman, window, and outside space. A link between these two relationships is given by the direction of the woman's gaze, through the window, into the outside world – the realm of the viewer.

This might explain what Hopper meant when he talked about painting outside and inside at the same time, and how difficult it was. What we are dealing with here could be described as a model of reflection. An object, in this case a painting and its motifs, must first be perceived and mentally grasped in order to be able to return to the point of departure, the focus of viewer's and subject's gaze, with an expanded consciousness of their interrelationship. This, basically, represents the Romantic method of perceiving and appreciating art.

It was not by chance that Hopper placed great emphasis on this motif. In the famous etching *Evening Wind* (1921; p. 41), he developed the theme of *The Open Window* a step further. The ambience is similar, if somewhat simplified; and the point of view is slightly altered as well. Again we see a woman just getting into bed, as a gust of wind from outside catches the curtains. Surprised, she pauses in her movement and turns her head to look. The visual repertoire here consists of a nude female figure in the act of going to bed, seen from the front, the pubic region visible next to the outstretched arm, and an interior with fluttering curtain. As in the earlier etching, the woman is anonymous, her face concealed by long hair. But the view through the window – contradicting the title, which leads us to expect darkness – reveals a bright, indeterminate space, while the room is filled with shadows.

But this time Hopper has depicted the figure frontally instead of from the back, thus subtly altering the Romantic motif of a woman looking through a window into the outside world. The fluttering curtain, already prominent in *The Open Window*, has now been dramatized by making it a center of interest. The key event, a gust of wind, is rendered visible and tangible by its effect on the curtain. And Hopper has further emphasized its importance by eliminating the view of a building originally planned in the window opening, as seen in the preliminary study (*Evening Wind*, 1921; p. 40). This engenders a contrast similar to the one later employed in *Rooms by the Sea* (1951; p. 176). By leaving the distant building out of the final etching, Hopper created an indeterminate exterior space, a void that has something mysterious, enigmatic about it. Its unexpected brightness only serves to heighten this effect.

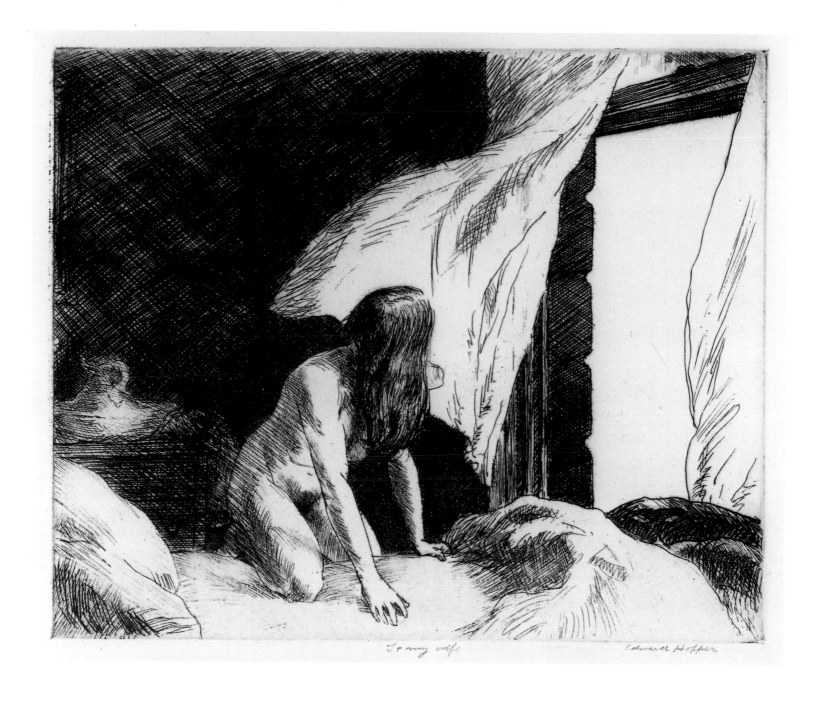

Two key influences on Hopper's etchings might be named. The first, again, is Degas, and his penchant for the momentary, the sense of suspended animation, and for the intimate, carefully composed slice of life. It is enough to compare *Evening Wind* with Degas's pastel *After the Bath* (c. 1888–92; p. 40). In both cases, a woman is depicted in a private moment, in an activity not normally witnessed by an outside observer. And because she is completely concentrated on herself, we as viewers feel almost like voyeurs. Such situations of self-absorption occur frequently in Hopper's art, another early example being *Interior* (1925; p. 43). In the etching, a similar, intimate scene is expanded by something coming from outside – in this case the wind, while in other images it would be impinging light.

This brings us to a second point of comparison, with Adolph Menzel's *The Balcony Room* (1845; p. 42). Menzel was concerned with the effects of color, light, and atmosphere, phenomena then new to painting and thus

Evening Wind, 1921
Etching, 17.5 x 21 cm
New York (NY), Collection of Whitney Museum of American Art. Josephine N. Hopper Bequest 70.1022

Again Hopper creates a link between inside and outside, this time using the wind as an intermediary. Despite the late hour suggested in the title the exterior space is brightly illuminated and undefined. This is a dramatic version of the Romantic motif of a woman gazing out of a window.

East Side Interior, 1922
Etching, 20 x 25.4 cm
Sheet 24.8 x 31.4 cm
New York (NY), Collection of Whitney Museum
of American Art. Josephine N. Hopper Bequest
70.1018

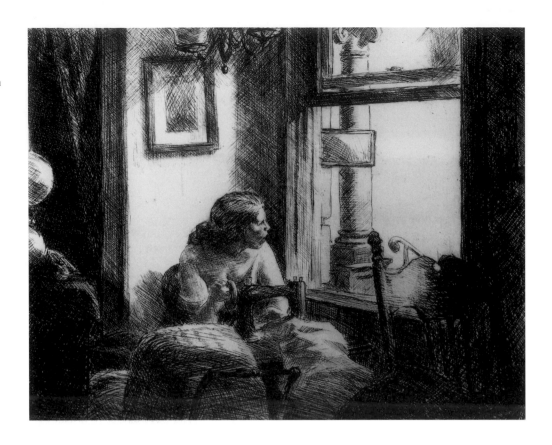

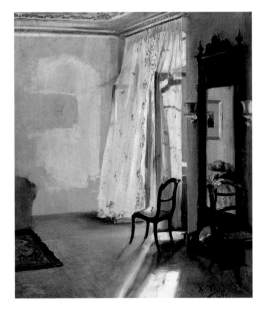

Adolph Menzel
The Balcony Room, 1845
Das Balkonzimmer
Oil on canvas, 58 x 47 cm
Berlin, Staatliche Museen zu Berlin –
Preussischer Kulturbesitz, Nationalgalerie

Like Hopper, Menzel was concerned to com-
bine representations of immaterial phenomena
with a positivistic depiction of reality.

difficult to render, which he addressed in the motif of the fluttering cur-
tain. His aim was evidently to capture such fleeting phenomena and to
make them fast within a concrete, almost positivistic depiction of reality.
In Menzel's painting as in many of Hopper's, only the furniture alludes to
the possible presence of persons in the room.

In Hopper's etching, the salient event is really the gust of air blowing
into the room from an outside space purposely left undefined. This is
underscored by the way the figure turns to the window, and by the pose
of the head. What significance does the wind have here? In order to be
represented at all, it had to be given material form, the form of the billow-
ing curtain. "Pathos formula" was the term applied by art historian Aby
Warburg to similar phenomena. First used in the history of style to clarify
the relationship between Greco-Roman and Renaissance art by reference
to flowing drapery, the term soon expanded in meaning: "The pathos for-
mula embodied in ancient sculpture and revived in the Baroque" wrote
E.H. Gombrich, "is really a deposit of an emotional experience which is
derived from primitive religious attitudes."[2] Could the wind in Hopper's
picture be a tacit symbol of a religious feeling? In the second section of
Alexis de Tocqueville's *De la démocratie en Amérique (Democracy in
America),* published in 1840, we read that Americans find "fixed ideas
about God and human nature are indispensable to men for the conduct of
daily life, and it is daily life that prevents them from acquiring them."[3]

It is a dilemma that Hopper in fact addressed in picture after picture,
and very directly so in *Evening Wind*. Mundane life does divert people
from thinking about the deeper reasons and causes behind their actions.
But in a very private moment, an awareness of them may suddenly arise.
Moonlight Interior (1921–23; not illustrated), done shortly after the etch-

ing, shows Hopper returning to this motif in a further variation. In this case the woman, whose pose is similar to *Nude Climbing into Bed*, is apparently oblivious of the wind coming through the window. This time buildings are visible outside, a reference to an actual context. The whole scene is suffused by an unreal light, a diffuse illumination that produces no harsh shadows as daylight would. The composition relies on gradations of a single hue, of which every object partakes. The unreal light pervading the realistic scene seems to imply that the contradiction between everyday life and the profound mystery underlying it is ever-present, if seldom perceived.

A complementary solution is offered in *East Side Interior* (1922; p. 42). In this etching the exterior space is partially defined, by the column and hand railing visible through the window. A woman sits busy at her sewing machine, but something outside has interrupted her work, and she looks up in surprise. But what has attracted her attention? Just as in other, comparable images, Hopper does not tell us – we are forced to guess. What Hopper wishes to express lies beyond the depiction proper, and yet is conveyed by it nevertheless. This fundamental dichotomy is one of Hopper's key themes. Behind his pure depiction of situations there always lurks the question of what painting is capable of representing at all

Interior (Model reading), 1925
Watercolor over pencil on ivory paper,
35.3 x 50.6 cm
Chicago (IL), The Art Institute of Chicago, Gift of Mr. and Mrs. Lewis L. Coburn in Memory of Oliver Shaler Swan, 1933.487

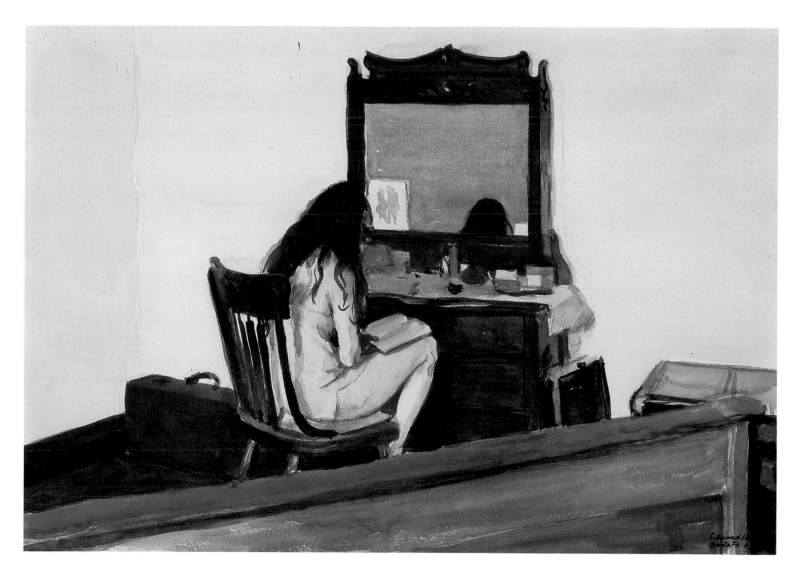

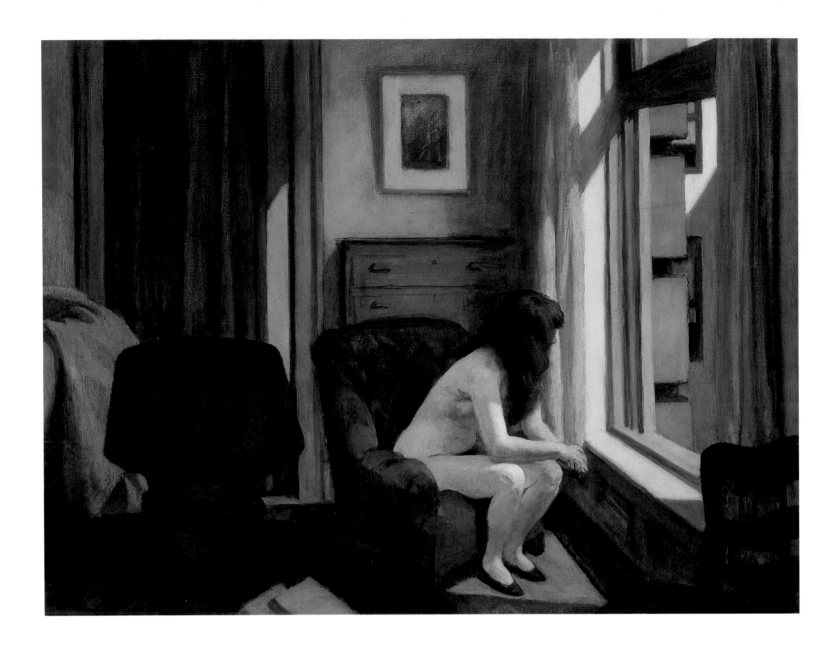

Eleven a.m., 1926
Oil on canvas, 71.3 x 91.6cm
Washington (DC), Hirshhorn Museum and
Sculpture Garden, Smithsonian Institution,
Gift of the Joseph H. Hirshhorn Foundation,
1966

– whether and how it refers to reality. The issue preoccupied Hopper, and he stated it with typical terseness: "I was never able to paint what I set out to paint."[4] Although the idea is certainly not new, the way in which Hopper translated it into visual terms attests to a high level of intellectual reflection, a level not necessarily evident from his oral and written statements but on which his paintings certainly move.

Eleven a.m. (1926; p. 44) shows a woman in a quiet pose much like that of the figure in *The Open Window*, but in an entirely different ambience and, as the title indicates, at a different time of day. Yet as so often, Hopper's suggestion that this is a real, precise situation is not entirely borne out by the visual evidence. Everything seems calm in this late-morning picture, even the curtains. Seated in an armchair, the nude model leans forward, resting her elbows on her knees and looking out the window, apparently enjoying the feeling of the sun on her skin. But again, her face is turned away from us, and the object of her gaze remains hidden. There is something out there that is accessible only to her, but to no one standing outside the picture. The composition possesses a self-contained, autonomous reality. It holds the viewer at a distance, making him or her

an observer who can see only a part of what is happening. If in the previous pictures we could be satisfied to know that it was the wind that attracted the woman's attention, here we are left guessing. Nor does the room itself or its furnishings possess any particular visual appeal or offer a hold for the eye.

Hopper presents us with a transitional situation. He permits us a tiny glimpse of the city outside, and, at the left, he gives a non-committal suggestion of another room behind the slightly open curtain. What in the previous pictures might have been interpreted as an emotional experience deriving from a fundamental religiosity takes on an entirely secular character in *Eleven a.m.*. The sense of mystery, instead of residing in an immaterial phenomenon, is engendered by the simple fact that we cannot see its origin. It is not metaphysical, but merely outside our field of perception.

In an exhibition of 1992, Hopper's works were juxtaposed with pictures by several American photographers. The aim was to let the "obviously related pictorial phenomena in the two media reciprocally elucidate" one another.[5] Joel Meyerowitz (b. 1938), in his *New York City Interior* (1991; p. 45), took up the motif of Hopper's painting, if not its theme. The woman's pose is similar; the bright, impinging light is derived from other Hopper compositions; the ambience is contemporary. The window is closed, and we can see approximately what the woman is seeing. But the complicated interrelationships of Hopper's painting are absent. Meyerowitz refers to the "photographic moment" which he sees at work in Hopper's imagery, that moment of calm with which photography charges mundane time. It is Hopper's special combination of awareness and concentration, his patience and wonder, and ultimately his becoming one with the

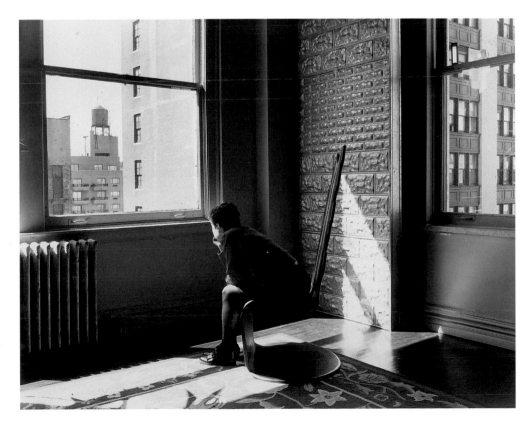

Joel Meyerowitz
New York City Interior, 1991
C-Print
New York (NY), Courtesy James Danziger
Gallery

Hopper's subject-matter and viewpoint have influenced much contemporary photography. Meyerowitz speaks of "stopping and extending a moment in time."

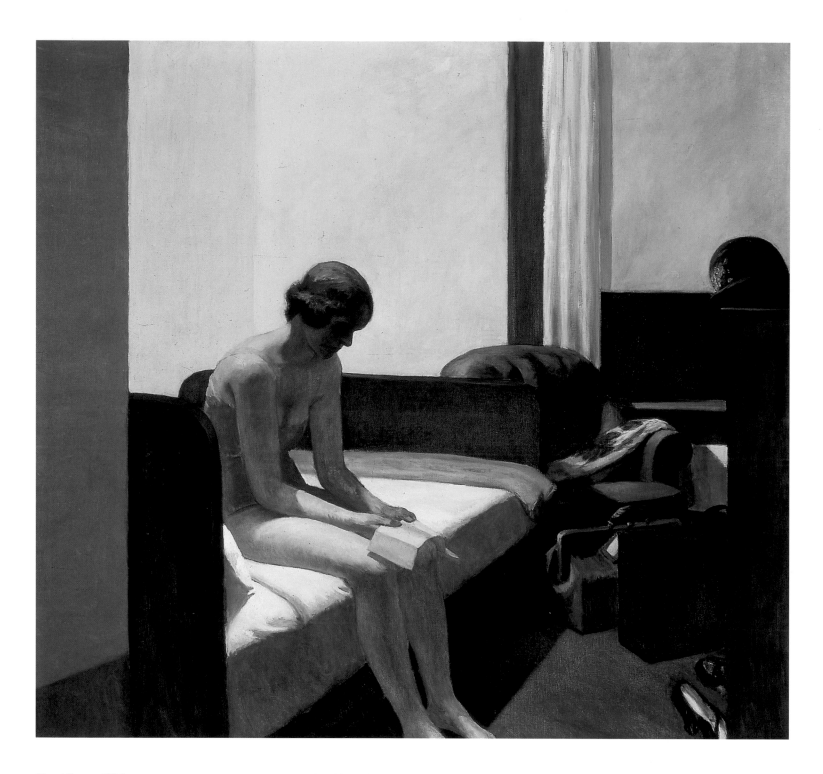

Hotel Room, 1931
Oil on canvas, 152.4 x 165.7 cm
Madrid, Museo Thyssen-Bornemisza

The object of attention of Hopper's female fig-
ures, like the environment, changes from paint-
ing to painting, but all of them depict a moment
of self-absorption in an intimate situation. This
puts the viewer in the role of inadvertent voyeur.

world of appearances, Meyerowitz adds, that suffuse his work with that ineffable quality everyone who deals with it attempts to describe.[6]

In 1981, at a Hopper symposium in the Whitney Museum, Meyerowitz emphasized the fundamental difference between the momentary character of photography and the nature of painting as a process in time. Hopper himself took photographs, many of which he used as aids for illustrations. But when he tried, for instance, to employ photographs of architectural details in his paintings, he was forced to abandon the idea – their perspective, he decided, was too different from that of the eye. This can be understood in two ways: firstly, no camera lens can perfectly simulate the human eye. Secondly, when he talked about the eye, Hopper always tacitly meant his inner vision as well, his subjective perception. Naturally no photograph and no camera can be absolutely objective, but photography, particularly as practiced by Meyerowitz, Robert Frank, or Walker Evans, is considerably more dependent on the givens of the exterior world than painting.

The secularization towards which Hopper's œuvre overtly tended had a tacit aspect as well. This aspect can be explained by reference to the mechanisms of photography. Our visual knowledge of Hopper's work is largely derived from postcards, posters, and illustrated books. All of these, we tend to forget, are produced by photographic means, or, in recent years, digitally. Now, an effect common to all means of reproduction is what Walter Benjamin described as "loss of the aura." Deprived of its aura, a work of art undergoes a change of status as well. The original, instead of being confronted directly in all its immediacy of presence, recedes from sight. The total accessibility of images of all kinds tends to level the differences among them, to negate their uniqueness. "Daily the irresistible urge arises to take possession of the object at close quarters, in the form of its image, or rather, its reproduction. And the reproduction, as provided by illustrated magazines or newsreels, obviously differs from the image. In the latter, uniqueness and permanence are just as closely interlinked as transience and repeatability are in the former."[7]

This insight of Benjamin's, reached in 1936, is still pertinent today. Meyerowitz's statements tend rather to confirm than to deny it. This is why a comparison between the painting and the photograph – or rather, between the available photographic reproductions – is revealing in a substantial as well as a formal sense. Influenced by the laws of the medium and the date of execution, Meyerowitz's photo cannot help but exhibit traits, and produce an effect, completely different from Hopper's painting. Although the photo combines elements familiar from Hopper, these elements, within the medium of photography, have long since become overworked clichés. Thus Meyerowitz's composition tends more to reflect a difference in perceptual processes than a similarity in imagery.

In *Hotel Room* (1931; p. 46) Hopper went a step further. The fundamental situation depicted is familiar by now: a woman seated on a bed, this time in a hotel room. She has begun to undress, but has not yet unpacked her suitcase and bag. Like the previous compositions, this one exhibits the basic elements of bed and armchair, chest of drawers and cur-

Study for **Morning in a City**, 1944
Crayon on paper, 56.2 x 38.1 cm
New York (NY), Collection of Whitney Museum
of American Art, Josephine N. Hopper Bequest
70.294

tain. The curtain indicates the presence of a window, which, however, is
not visible. The object of the model's attention, in contrast, is present in
the picture this time. It is a piece of paper without distinguishing marks –
perhaps a timetable, a travel brochure, or a letter. For the first time in this
series of similar scenes the woman's face, though in deep shadow, is
clearly visible. A similar device was employed in many French Surrealist
paintings.

What the Surrealists depict, however, is the emotional reaction of the
model to an object the meaning of which remains hidden from the viewer.
The face of Hopper's model, in contrast, is quite impassive. And what is
more, the object of her attention has been reduced to a blank sheet of
paper with no recognizable content, as if to say, There is none. As Hopper
once remarked, he attempted to depict his "sensations" in the most appro-
priate and compelling form he could. His use of the term sensations gives
us an important clue. By sensations, Hopper of course did not mean sen-
sational occurrences like disasters or other media-exploited events. He
was referring to the feelings induced by his daily surroundings, and also
to certain, quite specific aspects of his inward life – moments of isola-
tion, loneliness, or a sense of meaninglessness.

Using quite conventional painterly means, Hopper was able to reveal
negative aspects of the modern age which complement the positive ones.
The hotel room, for instance, is generally associated with mobility, travel,
speed, modern transportation – subjects with which Hopper also con-
cerned himself at length. But apart from the great, pervading, technology-
related sensations of the age he drew attention to the everyday, usually un-
noticed sense impressions and emotional reactions of living individuals.
And by so doing Hopper took up a distinctly European heritage, as embo-
died in Impressionism and especially in Degas, and employed this herit-
age to depict his own, American scene.

Hopper's imagery recorded not so much the external changes taking
place in the world, as his own and others' personal reactions to them. For
over fifty years, he explored the nuances of situations in which his own
state of mind was reflected as well. Hopper once explained the subjective
element in his paintings by saying that personal ingredients were neces-
sary to lend a subject beauty. That is why he did not particularly like
flowers, he said, because their beauty was so self-sufficient.

An apparently analogous self-sufficiency is found in his canvas *Room
in Brooklyn* (1932; p.49). By Hopper's standards, the picture is almost a
romantic idyll – but only almost, for the whole scene appears to tilt to the
left. Due to such instabilities, which occur frequently in Hopper's compo-
sitions, they cannot meaningfully be compared with Piet Mondrian's
grids, as Goodrich has done.

Twelve years later Hopper painted another interior with nude figure,
Morning in a City (1944; p.51). In 1944 the artist was sixty-two years
old. It should always be kept in mind that his development was slow, de-
liberate, and correspondingly persistent, and that he hardly concerned
himself with the bustle of daily events. His tenacious search, and the ap-
parent repetition to which it led, compel us to look very closely at each

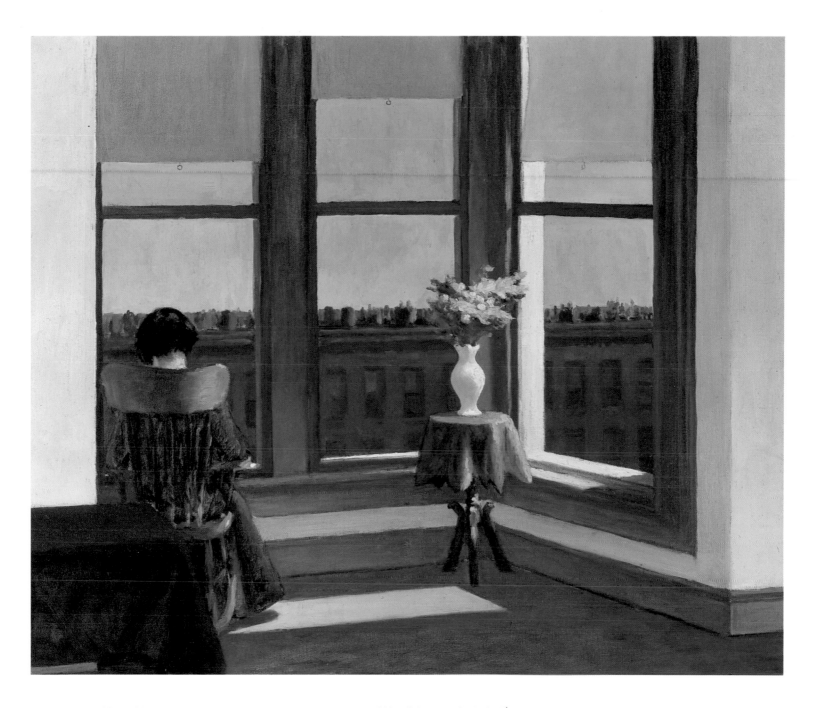

Room in Brooklyn, 1932
Oil on canvas, 73.6 x 86.3 cm
Boston (MA), Courtesy, Museum of Fine
Arts, The Hayden Collection

Hopper once said he did not particularly like
flowers, because they were so self-sufficient
in their beauty. A disturbing aspect is intro-
duced into this apparently idyllic scene by the
slight tilt to the left of the entire composition.
The only elements we see completely are the
bouquet and table, while everything else re-
mains largely hidden.

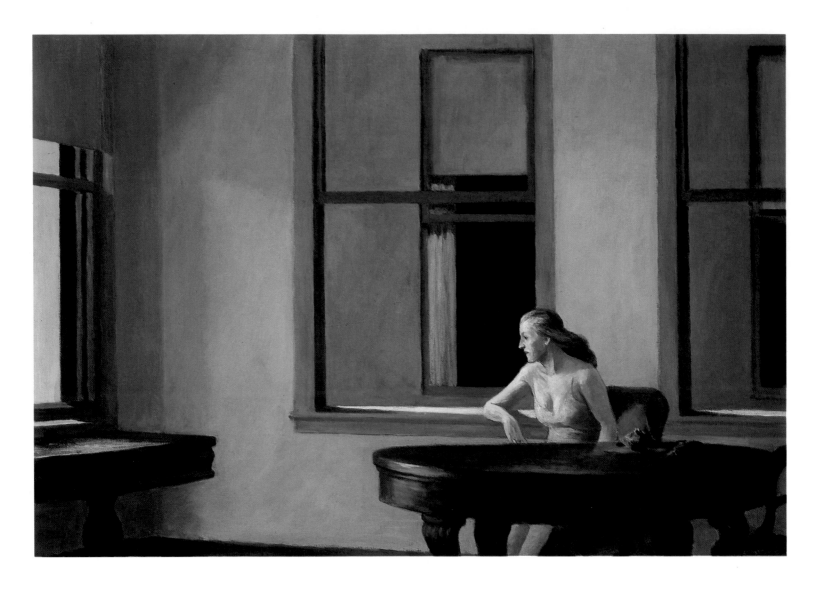

City Sunlight, 1954
Oil on canvas, 71.6 x 101.9 cm
Washington (DC), Hirshhorn Museum and
Sculpture Garden, Smithsonian Institution,
Gift of the Joseph H. Hirshhorn Foundation,
1966

picture, and note its nuances. For as Aby Warburg continually emphasized, God resides in the detail. The salient detail in *Morning in a City* would seem to be the cloth or towel the woman is holding in her hands. The bed she stands in front of has apparently just been vacated, because the sheet is thrown back and the pillow rumpled. To the left of the window there is a desk, and a chair with an article of clothing – probably a coat – draped over its back and a hat on its seat. This little still life recapitulates the recurring theme of Hopper's pictures: the artist conceals more than he reveals. What he reveals are the limits of our perception. Experience alone tells us that a chair must be hidden beneath the coat, because we cannot see it. The same motif is found at the left edge of *Eleven a.m.*. The nakedness of the female figures, who often occupy the visual center of the composition, seldom represents the thematic center as well. Much more important to Hopper were the mental associations engendered by precisely those things he concealed from sight.

By means of the towel, Hopper toys with the opposition between concealing and revealing. The curtain has a similar purpose. Its normal function is to prevent light from coming into the room or to conceal its occupants from inquisitive eyes. But when a curtain is open, or blown by a breeze as in *Evening Wind*, it does just the opposite: it conveys an awareness of the outside world, or the presence of wind. The way in which the

woman in *Morning in a City* holds the towel hides the intimate regions of her body from potential observers outside, whom we, again, cannot see. But much of her nakedness is exposed to us, making us inadvertent voyeurs. Hopper, in other words, is untiringly asking the fundamental question: how does perception work? or even more profoundly, what is reality?

Hopper's consistency and logic made him one of the outstanding figures in twentieth-century art. Another, comparable figure was Marcel Duchamp, who was only five years Hopper's junior. On first glance the two artists could hardly seem more different. One thing they had in common was taciturnity. Duchamp's silence may have been overrated, as Joseph Beuys declared in the 1960s, but it was crucial nonetheless. Duchamp's last great piece, which he worked on in secret from 1946 to 1966, was *Etant donnés: 1° la chute d'eau, 2° le gaz d'éclairage (Given: 1. The Waterfall, 2. The Illuminating Gas)*, which is permanently installed in the Philadelphia Museum of Art. All we initially see is a door made of boards roughly nailed together and fitted into a masonry frame. Then we notice two peepholes that reveal what is behind the door to view. Thus forced into the role of Peeping Tom or voyeur, we see a female nude,

Morning in a City, 1944
Oil on canvas, 112 x 153 cm
Williamstown (MA), Williams College Museum of Art, Bequest of Lawrence H. Bloedel, Class of 1923, 77.9.7

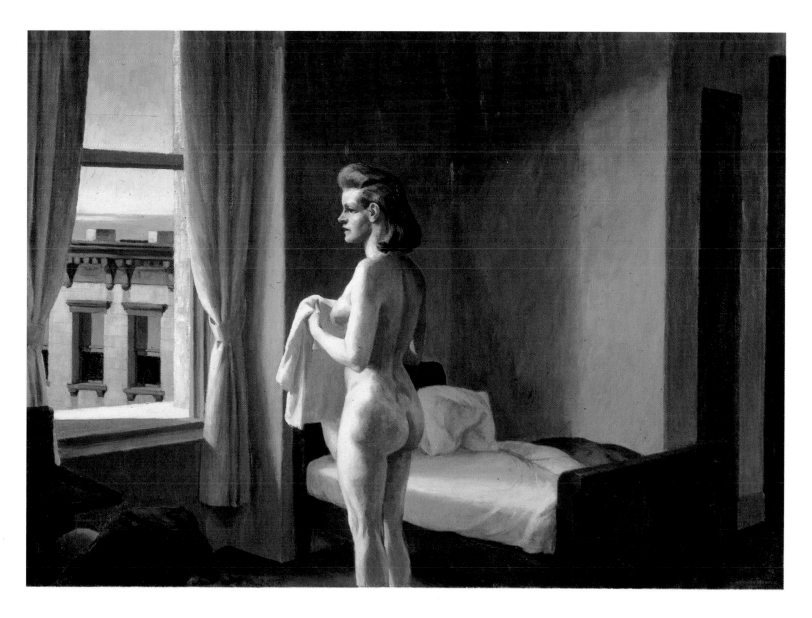

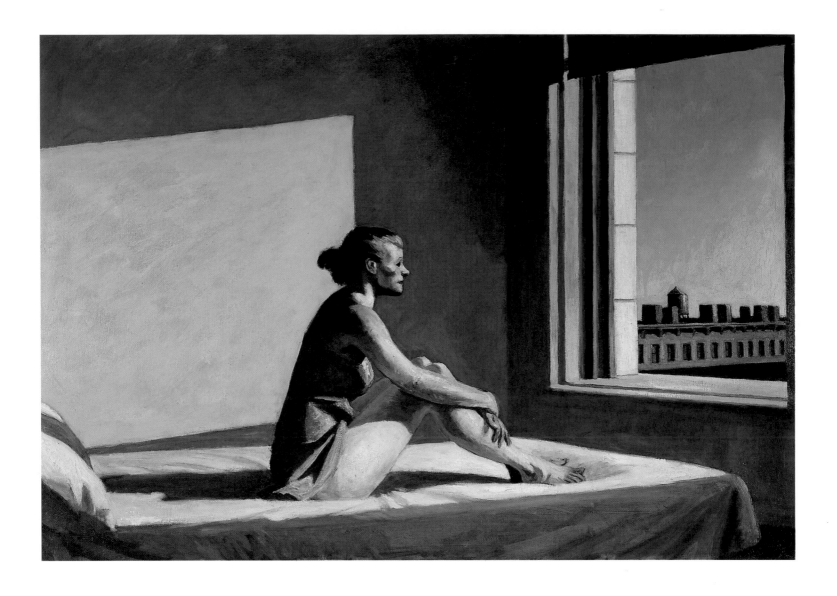

Morning Sun, 1952
Oil on canvas, 71.4 x 101.9 cm
Columbus (OH), Columbus Museum of Art,
Museum Purchase: Howald Fund

sprawling, the genitals prominently visible, but not the head, right arm, or
feet. The nude is embedded in a landscape with a fictitious, *trompe-l'œil*
waterfall, and in her right hand she holds an incandescent gas mantle.
One has to be familiar with the construction to realize what is at the bot-
tom of it, namely that the section visible to the viewer coincides precisely
with his or her field of vision. The scene, in other words, consists of noth-
ing more than what the view through the knothole reveals. The nude in
fact has neither head nor right arm nor feet. What we cannot see does not
exist. Our tendency to mentally supplement the set pieces of perceived re-
ality into a complete image is taken *ad absurdum* by Marcel Duchamp's
piece.

Hopper's concerns were very similar, despite the quite different means
he used to pursue them. As the œuvre developed, the enigmatic, elusive
quality of his imagery would be gradually fleshed out, given material
form, as in the relationship between curtain and towel in *Morning in the
City*. Hopper's imagery continually compells us to oscillate between two
types of reality: that of the painted image and that of the viewer's world.
Nor do the window apertures in his work invariably guarantee an actual
view. In fact they are flat, being in effect pictures within the picture,
sometimes more defined and objective, as in *Morning Sun* (1952; p. 52),

sometimes more abstract, as in *City Sunlight* (1954; p. 50). This device culminates in the works which include a true picture within the picture, in the form of a window that reveals a prospect, such as *Evening Wind* (seen to better effect in the preliminary drawing), *East Side Interior*, *Eleven a.m.*, or the last painting in which Hopper included a nude figure, *A Woman in the Sun* (1961; p. 55).

Here, all the familiar set pieces are once again brought together: a female nude as central motif, a bed with the sheet turned back, a moving curtain and a curtain at rest, and the picture within the picture motif. That Hopper's paintings seem to have a religious aspect has been mentioned. The form it takes, and the way it is introduced into the image, differ from case to case. In *A Woman in the Sun*, light and a breeze, manifested in the moving curtain, come in from outside. But as far as the breeze is concerned, we cannot be certain, for the window opening is hidden, and who is to say whether the curtain belongs to a window at all? The woman's gaze, directed into nothingness, is introspective, as in *Morning Sun* and *City Sunlight*. Her body is depicted with a peculiar torsion, the position of the feet suggesting that she is turning away from us, while her upper body turns in the opposite direction, towards us. The central concern of the painting, as has crystallized out of the previous discussion, is the

Study for *Morning Sun*, 1952
Chalk on paper, 30.5 x 48.1 cm
New York (NY), Collection of Whitney Museum
of American Art. Josephine N. Hopper Bequest
70.291

structuring of a painted image with its own reality and intrinsic laws. Confronted by this reality, we as viewers inadvertantly attempt to virtually extend the real space we occupy into the pictorial space of the image. This draws us into the picture, which at the same time attempts to exclude us. The result is that strange combination of distance and intimacy that is such a fascinating, yet provoking, feature of Hopper's paintings.

The women Hopper depicted in his works grew old with him. This was due largely to the fact that after his marriage in 1924, he used, or was permitted to use, only a single model – his wife. The numerous studies of fe-

George Segal
Woman Standing in Blue Doorway, 1981
Painted plaster and wood,
208.2 x 139.7 x 88.9 cm
New York (NY), Courtesy Sidney Janis
Gallery

Mark Rothko called Segal's environments Hopper paintings you could walk into, which Segal did not appreciate. His plaster figures nonetheless do bear a striking affinity to Hopper's rather wooden-looking figures. Here Segal has rendered the effects of light on the figure's body in a well-nigh Impressionistic manner.

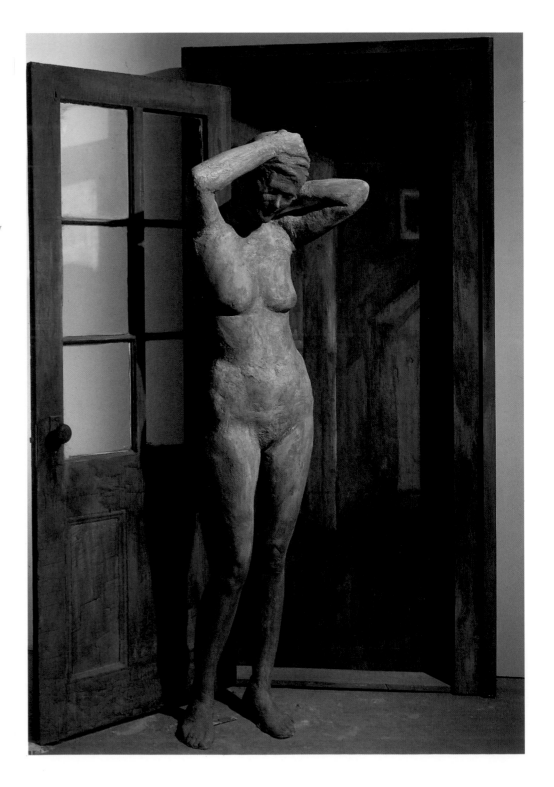

male figures for the paintings all bear her likeness. American society has frequently been described as strongly influenced by women, a case in point being the role played by the First Lady. De Tocqueville remarked the determination of the American wife, saying that "seeing beforehand and clearly the only path that can lead to domestic felicity, from the first step she sets out in that direction and follows it to the end without seeking to turn back. So, in America the wife is still the same person that she was as a girl; her part in life has changed, and her ways are different, but the spirit is the same."[8]

In an attempt to portray America and the Americans, many authors, especially Europeans, revert to terms like "cultural feminism" or "girl cult", at any rate emphasizing a certain female dominance.[9] The extent to which Hopper was typically American, with respect to his origins, his subject matter, and style, will be the topic of our next chapter.

A Woman in the Sun, 1961
Oil on canvas, 101.6 x 152.4 cm
New York (NY), Collection of Whitney Museum
of American Art. 50th Anniversary Gift of
Mr. and Mrs. Albert Hackett in honor of Edith
and Lloyd Goodrich 84.31

Railroad Train, 1908
Oil on canvas, 61 x 73.7 cm
Andover (MA), Addison Gallery of American
Art, Phillips Academy, Gift of Dr. Fred T.
Murphy

Hopper shows the train at the moment it is steaming out of the picture. The continuance of an event beyond the painting's borders, a favorite device of Hopper's, is intended to stimulate the viewer's imagination. The picture is conceived as a window into another reality.

American Art – European America

The emergence of a truly American art was a long and tentative process. Lloyd Goodrich believes that his countrymen were too much involved in building their nation, creating a social structure, and settling the frontier, to concern themselves with art beyond its utilitarian applications.[1] The churches were plain and undecorated, due to the Puritan aversion to imagery that obtained particularly in New England. The first genre to develop was portraiture, which served to demonstrate status and prosperity. The painters were frequently self-taught artisans, and as such they stood in a tradition that would extend down to the twentieth century, and would include Hopper's activity as an illustrator.

American art has always been more folkloristic, more popular, less exclusive than European art. Goodrich offers the example of John Singleton Copley (1738–1815), who was dissatisfied with the provincial atmosphere of New England and went to London. There the original force of his art declined, and, as Goodrich adds, America lost her greatest artist, to add another good painter to the British School. Goodrich sees a basic conflict at work here between the unjaundiced eye of the American painter and a mind thirsting for more knowledge and sophistication, for in the America of Copley's day "the primitive virtues were not valued as we today have learned to value them."[2]

A naturalistic tendency entered American art by way of genre painting, especially that of Winslow Homer (1836–1910) and Thomas Eakins (1844–1916). Eakins worked intensively in photography as well as in painting. He was especially fascinated by the stop-motion photography of Eadweard W. Muybridge of England (1830–1904), and himself undertook similar experiments. Then Eakins turned to the chronophotography developed by a Frenchman, Etienne Jules Marey (1830–1904). But rather than employing photography as an aid to painting, Eakins considered it an independent part of his œuvre. An interesting feature of the motion photography medium was the way in which it mechanically cut up reality and time sequences into small segments, permitting a precise depiction of movements undetectable to the naked eye. Degas, for instance, based certain studies of horses' movements on Muybridge's photographs.

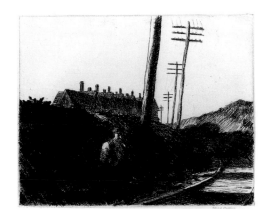

The Railroad, 1922
Etching, 20 x 24.9 cm
Sheet 32.7 x 39.1 cm
New York (NY), Collection of Whitney Museum of American Art. Josephine N. Hopper Bequest 70.1049

Hopper devoted a great number of works to the theme of the railroad. Apart from the human incursion into nature it represented, he was interested in the relationship of motion, speed, and the overcoming of distance to the factors of stasis and limitation.

Night in the El Train, 1918
Etching, 19.1 x 20.3 cm
Sheet 31.1 x 35.6 cm
Philadelphia (PA), Philadelphia Museum of Art,
Purchased: Thomas Skelton Harrison Fund

As in many paintings, Hopper combines a public
space with an intimate situation, in this case
lovers flirting. The darkness outside increases the
impression of privacy.

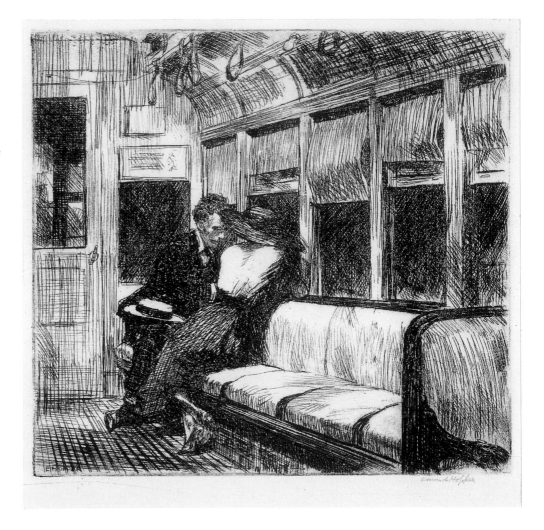

Landscape painting in nineteenth-century America was dominated by
the romantic approach of the Hudson River School. Radical changes, not
to mention artistic revolutions, were not to occur in American art until
after the turn of the century. French Impressionism was considered the
apex of modernity at the time. The generation of artists who followed
Homer and Eakins studied in Paris and, on their return, "they combined
American idealism with Impressionism, Whistlerian refinement and Sargent's brushwork, to produce an academic art which in its way was unmistakably and deplorably 'American'."[3] Its prime purpose was apparently to
glorify American woman in every role and situation, but always decorative, leisured, and virtuous. Despite its preoccupation with the feminine,
noted O'Doherty, this art was in the strict sense sexless.[4] Painting was
restricted to idyllic subjects or to the things that characterized modern
America, such as factories and railroads. Beyond this, Goodrich admits,
American art of the day was entirely humorless.

This changed with the entry upon the scene of a group of artists led by
Robert Henri, Hopper's teacher. The Eight, derogatorily dubbed the Ash
Can School, addressed socially oriented themes in a realistic style that
owed less to Impressionism than to Diego Velázquez and Francisco de
Goya, or to Honoré Daumier. In the wake of The Eight, more and more
American artists began to take their cue from avant-garde movements in
Europe. A trip to Paris remained obligatory, for as Hopper later said, "In

my day you had to go to Paris. Now you can go to Hoboken; it's just as good."[5] In Goodrich's opinion, the Ash Can School represented a far-reaching incursion into the academic tradition of American painting. Barbara Rose places the emphasis differently: "Because the beginnings of American modernism had such popular sources as newspaper illustration and political cartooning, when the time came for a genuine aesthetic revolt, such a revolt was carried out not against any academic notion of style, but against a provincial, illustrational art, which had in turn become officialy entrenched.[6]

Henri's group had its first exhibition in 1908, five years before the Armory Show. The express aim of The Eight was to break with tradition and create a new American art that no longer relied on copying the Europeans. Other members of the group were George Benjamin Luks, William J. Glackens, Everett Shinn, John Sloan, Arthur B. Davies, Ernest Lawson, and Maurice Prendergast.

Back in 1905, photographers Alfred Stieglitz and Edward Steichen had opened a gallery on Fifth Avenue in New York, the Little Gallery of the

House Tops, 1921
Etching, 15.2 x 20.3 cm
Sheet 24.1 x 29.2 cm
Philadelphia (PA), Philadelphia Museum of Art,
Purchased: Thomas Skelton Harrison Fund

Here, in daytime, the public character of the car returns, and the woman gazes out the window at the roofs passing by.

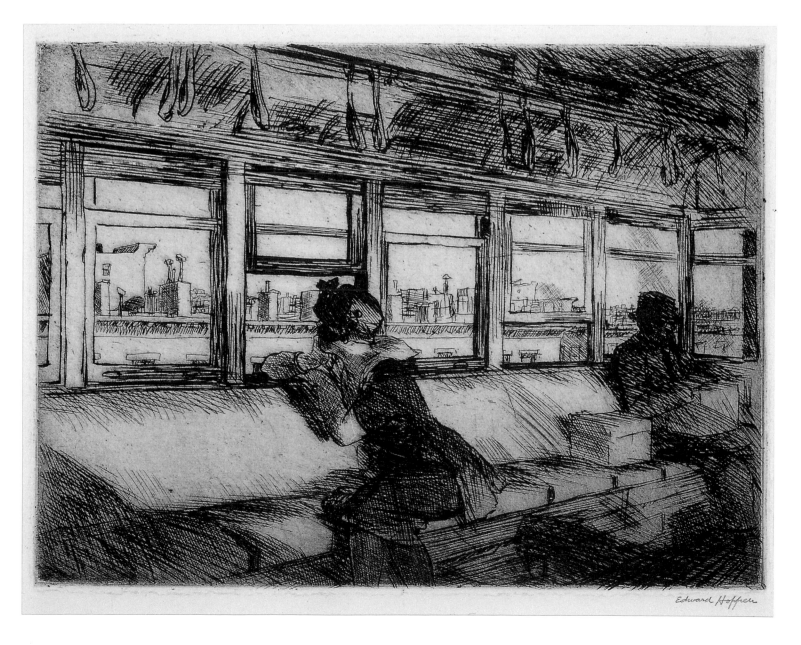

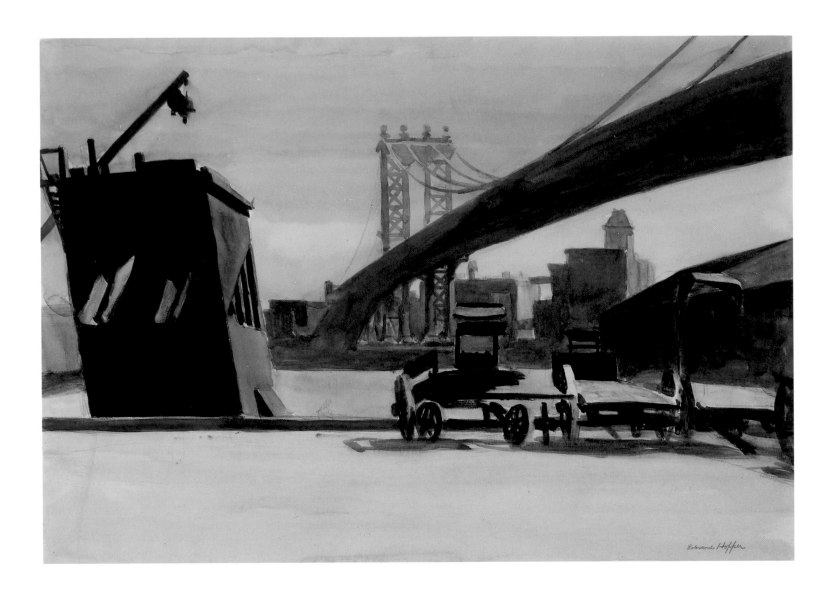

Manhattan Bridge, 1925–26
Watercolor on paper, 35.4 x 50.5 cm
New York (NY), Collection of Whitney Museum
of American Art. Josephine N. Hopper Bequest
70.1098

Photo-Secession, later known by its house number, 291. In 1907 Stieglitz expanded his program to include art as well as photographs, introducing modern European painting to America long before the Armory Show. He began in 1908 with a presentation of Rodin drawings, followed later the same year by a Matisse show. Exhibitions were devoted, in 1909, to Henri de Toulouse-Lautrec, in 1910 to Henri Rousseau, and in April 1911 to drawings and watercolors by Picasso. In 1913 Stieglitz introduced Francis Picabia to American audiences, and in March 1914 he gave Constantin Brancusi his first one-man show.

The relationship between Henri's group and the Stieglitz circle was one of open rivalry. Stieglitz considered The Eight conventional and out-moded; Henri thought the "ultramodernism" represented by Stieglitz over-wrought and undemocratic. The sources of Henri's stance had already been recognized by de Tocqueville: "The social conditions and institutions of democracy also impart certain peculiar tendencies to all the imitative arts, and these are easily pointed out. The soul is often left out of the picture which portrays the body only; movement and sensation take the place of feeling and thought; finally realism takes the place of the ideal."[7]

The year 1913, finally, brought the Armory Show, which confronted a wider American public for the first time with recent European art, not to

mention the latest tendencies in their own country. The work of the Ash Can School was juxtaposed, among other styles, to the Modernism of John Marin and Marsden Hartley, and the Precisionism of Charles Sheeler. Hopper was also represented at the Armory Show, where he sold his first picture. The Americans were faced *en bloc* by a European avant-garde, headed by Picasso and Duchamp, whose *Nude Descending a Staircase* triggered more controversy than any other painting in the show. Special mention should also be made of the circle around Walter Arensberg, the most significant American collector of advanced art at the time. Its members included Duchamp, Picabia, and Man Ray, who were later to introduce the New York variant of Dadaism. This was not really a genuinely American phenomenon, of course, the only American involved being Man Ray, who moreover was soon to move to Paris. There were contacts between the Stieglitz and Arensberg circles, exemplified by Picabia's 1915 cover design for Stieglitz's journal *291*.

Pont du Carrousel in the Fog, 1907
Oil on canvas, 59.1 x 71.8 cm
New York (NY), Collection of Whitney Museum of American Art. Josephine N. Hopper Bequest 70.1245

It should always be kept in mind that these artists belonged to the same generation as Hopper, and that despite their diverse origins, training, and temperament, they all met on the common ground of the Armory Show. The historical constellation alone led to numerous points of contact. Picabia was born in 1879, Duchamp in 1887, and Man Ray in 1890. Considering this ambience it is not surprising that after his *Sailing* (1911; p. 107) was sold at the Armory Show, Hopper went without public recognition for the next ten years. His art was simply out of tune with the period.

Man Ray once described an evening at Arensberg's house, which he said was crammed with modern art. The party included Picabia and Duchamp and numbers of chic women, and George Bellows, wandering around with a disdainful look, obviously feeling very much out of place.[8] Bellows had trained with Henri, like Hopper and Rockwell Kent, and he belonged in the orbit of The Eight. As Goodrich notes, every variety of Modernism – a term then used in America to describe avant-garde tendencies of primarily European origin – was international.

By the mid 1920s, however, a reaction had begun to set in. A wave of nationalist sentiment swept over the country, and American artists began to rediscover their native land, which, according to Goodrich, was still an unknown continent to the majority of them. National awareness even seized Alfred Stieglitz, who in 1925 reopened his 291 Gallery under the

Queensborough Bridge, 1913
Oil on canvas, 64.8 x 95.3 cm
New York (NY), Collection of Whitney Museum of American Art. Josephine N. Hopper Bequest 70.1184

The atmosphere of some of Hopper's paintings of bridges, like this one, shows the influence of Claude Monet. Like railroads, bridges stood for connections between two points, one of which Hopper always placed outside the picture in order to evoke the link between pictorial reality and external reality.

name of Intimate Gallery, and began to show American artists exclusively. In 1930 the Whitney Museum of American Art, successor to the Whitney Studio Club, was established. The signs of the time had changed; the Regionalist style of Grant Wood, John Steuart Curry, and Thomas Hart Benton (Jackson Pollock's teacher) began to gain headway. This movement, known as the American Scene, proved quite favorable to an appreciation of Hopper's art.

Yet he himself was extremely skeptical about the American Scene and its regionalist bent. "The thing that makes me so mad is the 'American Scene' business," Hopper declared. "I never tried to do the American scene as Benton and Curry and the midwestern painters did. I think the American Scene painters caricatured America… The French painters didn't talk about the 'French Scene', or the English painters about the 'English Scene'."[9] Hopper of course did not deny the fact of his American origin. He simply looked at it from a biological standpoint and declared that American traits in a painter were innate rather than acquired. The realism of a Hopper or a Charles Burchfield clearly differed from that of the Regionalists. The former fought for the recognition of American art, which certainly involved nationalist feeling; but their attitude was never outrightly chauvinistic like that of the Regionalists.

Two basic reasons might be named for the upsurge of nationalism at the time. First, there was the veritably allergic reaction to the European avant-garde, which shook American art of the pre-Armory Show period to its foundations. Secondly, a great role was played by the Depression, ushered in by the Wall Street Crash of 1929. In the context of the subsequent reconsolidation scheme, the New Deal, the Federal Arts Project

Macomb's Dam Bridge, 1935
Oil on canvas, 88.9 x 152.8 cm
Brooklyn (NY), The Brooklyn Museum,
Bequest of Miss Mary T. Crockcroft

Claude Monet
Waterloo Bridge, Mist, 1899–1901
Waterloo Bridge, effet de brouillard
Oil on canvas, 65 x 100 cm
St. Petersburg, Hermitage

was founded in 1933 to specially further American art. As Samuel Eliot Morison and Henry Steele Commager noted, the significance of the project went beyond its immediate accomplishments, because for the first time it did justice to the fact that artists could make a contribution to society, and that society in turn had a certain responsibility for art.[10] Naturally such societal obligations are not without their dangers for art. The New Deal programs strove to make art more democratic, to enlist it in national concerns, and to arouse a widespread interest in art among the populace. In brief, the New Deal turned art to political ends, which entailed a denial of its autonomy. Any attempt to democratize art faces basically the same problem as that seen in the case of Socialist Realism: a loss of artistic and aesthetic independence.

A further aspect of the development of art in the United States was, to use Morison and Commager's terms, its transition from transcendentalism to pragmatism. The transition began with Darwin's *Origin of Species*, published in 1859. At that period almost every American believed in the literal truth of the biblical story of Creation, and thought God had created earth's diverse species expressly for man's use and comfort.[11] This belief was undermined by the theory of evolution. It set off a widespread secularization process, a shift in values very much like that we have described in Hopper's art. New philosophies emerged, empiricism and pragmatism, which no longer posited the existence of absolute truths. Truth became a hypothesis subject to laboratory testing; solutions were no longer general but related to the specific case. In fact, critics of pragmatism considered it less a philosophy than a method with the aid of which philosophy could be dispensed with, a quintessentially American development that reflected American conditions and perfectly suited the American temperament.[12]

In 1953 Hopper joined forces with several other objective painters to publish *Reality – A Journal of Artists' Opinion*. The first issue was introduced by a statement of principle signed by forty-six artists. It read in part: "We believe that texture and accident, like color, design and all the other elements of painting are only the means to a larger end which is the depiction of man and his world." The authors then went on to attack museum people, art dealers, critics, and journalists who one-sidedly supported abstract art: "We are asked to believe that only an inner circle is capable of judging contemporary painting, that everybody else must take it on faith."[13] Also published was an open letter to the Museum of Modern Art, regretting the fact that the museum did not show the same interest in objective forms of art that it did in abstraction.

The conflict was a belated recapitulation of the controversy caused by the Armory Show. But it would resolve itself a few years later, when Pop Art irreverently challenged the seriousness of Abstract Expressionism. Pop artist Jim Dine, for instance, considered Hopper much more exciting than Magritte as a Surrealist, even calling Hopper basically a Pop artist. And Robert Rosenblum, apologist of Abstract Expressionism, conceded that "Even Edward Hopper, whose 1964 retrospective occurred at a time of maximum receptivity (in 1955, he might have looked merely provincial), has taken on the stature of a major pictorial ancestor."[14]

El Palacio, 1946
Watercolor on paper, 52.7 x 72.7 cm
New York (NY), Collection of Whitney Museum
of American Art, Exchange. 50.2

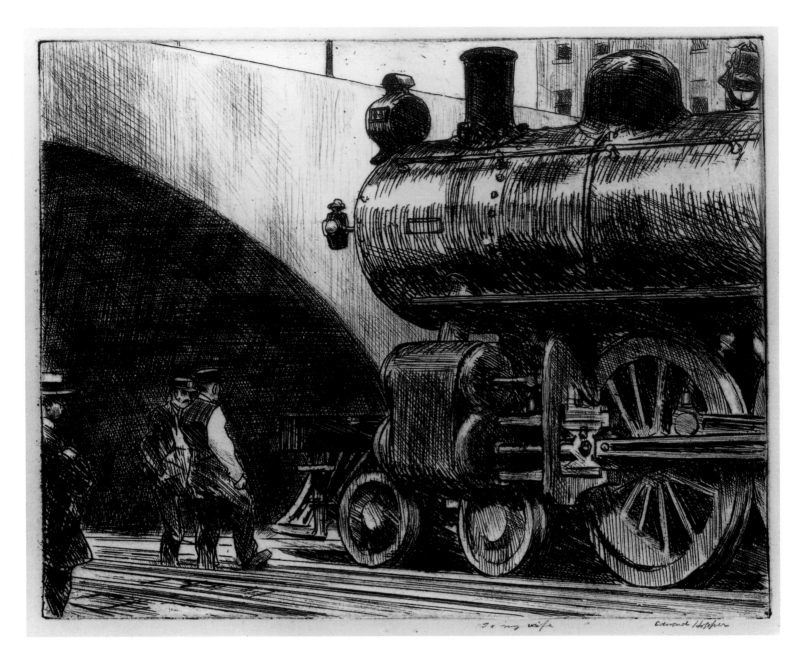

The Locomotive, 1922
Etching, 20 x 25.1 cm
Sheet 34.9 x 44.1 cm
New York (NY), Collection of Whitney Museum
of American Art. Josephine N. Hopper Bequest
70.1039

It was rather untypical for Hopper to depict
mechanical equipment in this much detail. His
main concern apparently lay in suggesting the
imminent passage of the engine into the under-
pass and out of the picture.

Charles Sheeler
Rolling Power, 1939
Oil on canvas, 38.1 x 72.6 cm
Northampton (MA), Smith College Museum
of Art, Purchased: Drayton Hillyer Fund, 1940

Sheeler's extremely precise painting style arose
from a belief in the blessings of technological
progress that seems almost naive. He was fasci-
nated by the aesthetics of machines.

Rosenblum's article was written in 1964, and it would be confirmed three years later when Hopper was spotlighted at the São Paulo Biennale as the American artist *par excellence*, surrounded by protagonists of Pop. The environments of one them, George Segal, were quoted as looking like walk-in Hopper paintings. The quip was made, of all people, by Mark Rothko, a grand master of abstraction. Segal was rather piqued by the statement, especially as it was avidly taken up by the critics, who thought they were doing him a favor. The affinity between Segal and Hopper is in fact striking.

What, then, is so typically American about Hopper's pictures? Is it the subject matter – the railroads, bridges, service stations, rapid transit lines, or the occasional factory? Or is it the manner in which these things are depicted? Actually, both are combined in Hopper's special brand of realism, for it is based on set pieces from his environment, the American scene. One thing it does not contain, however, is overt social criticism. Some writers say Hopper depicted the mood of the Great Depression in America, but if this were so, the same mood continued to appear in his work for over thirty years, from the 1930s to his death in 1967.

The theme of the railroad is frequently treated in a largely symbolic manner in Hopper's work. We see the traces left on the natural environment by this means of transportation, sometimes supplemented, as in the etching *The Railroad* (1922; p. 57), with a reference to another invention that virtually decreased distance, the telegraph. Actual trains, however, seldom enter the picture.

An early exception to the rule is *Railroad Train* of 1908 (p. 56). It anticipates another key device of Hopper's, the suggestion that events in the picture continue beyond its confines. We see the last cars of a moving train, and the smoke plume left behind by an invisible locomotive. Already at this early date, Hopper's imagery has begun to evoke a window into another reality. How much he owed in this respect to the Impressionists may be illustrated by a comparison with Manet's *The Railroad, Gare Saint-Lazare* (1872–73; p. 67). Here, too, no locomotive is visible, only a cloud of steam suggesting its presence. The little girl is separated from the event by a railing, but she looks on through the bars with great interest. The seated woman, unimpressed by what is going on behind her, looks up from her book. Though apparently interrupted in her reading by the observer – painter or viewer – rather than meeting our gaze directly, she seems lost in thought. The general pictorial idea would reappear again in Hopper's *Hotel by the Railroad* of 1952 (p. 169).

In a very few cases Hopper included railroad equipment itself in a composition, though technology was not really his *métier*. Like the *Railroad Train*, *The Locomotive* (1922; p. 66) exhibits a strikingly close-cropped motif. Projecting into the picture from the right is the front of a steam engine. The perspective lines of its boiler converge on the tunnel opening at the left, whose darkness brings the eye up short. Although the mechanical details of the locomotive are painstakingly rendered, these remain subordinate to the basic intention, an evocation of dynamic power. The same theme is treated, to quite different effect, in Charles Sheeler's

Edouard Manet
The Railroad, Gare Saint-Lazare, 1872–73
Le chemin de fer, Gare Saint-Lazare
Oil on canvas, 93.3 x 111.5 cm
Washington (DC), National Gallery of Art, Gift of Horace Havemeyer in memory of his mother, Louisine W. Havemeyer

Manet addressed the theme of the railroad in a more radical way than Hopper. The only remaining sign of the locomotive here is a cloud of smoke, indicating Manet's comparative unconcern with machinery and the technological progress it stood for.

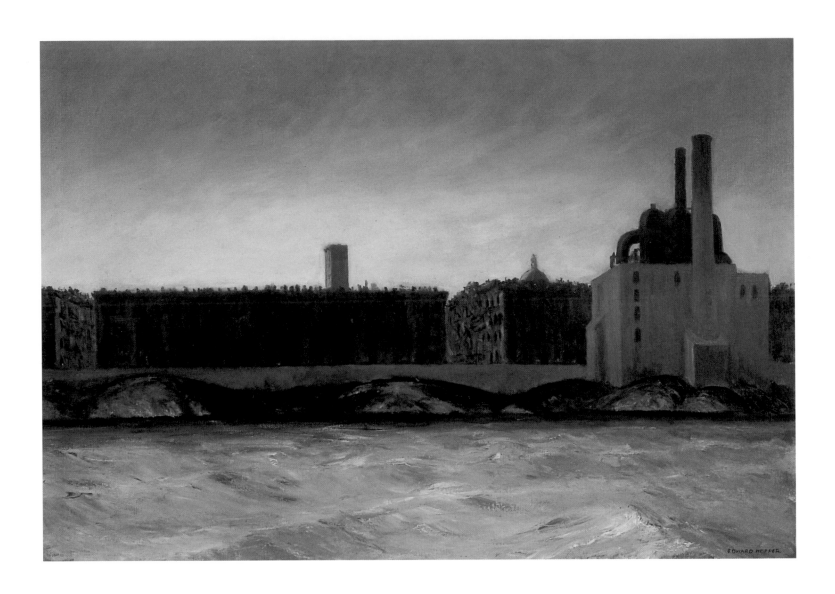

East River, c. 1920–23
Oil on canvas, 81.3 x 106.7 cm
Private collection

This is one of the few pictures in which Hopper
was concerned not so much with the light-
ing of objects, as with light as a phenomenon in
itself. The European Impressionist heritage soon
gave way to depictions of things standing out
sharply in the brilliant American light.

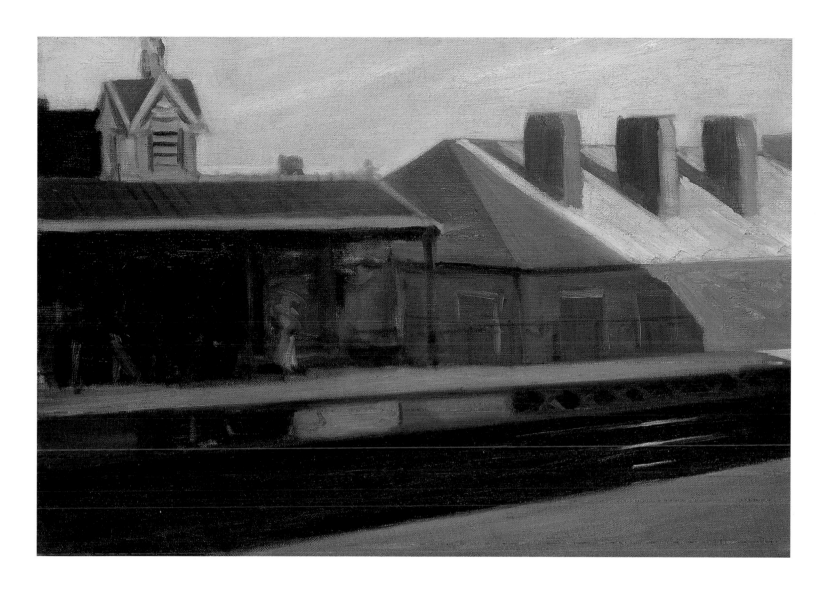

The El Station, 1908
Oil on canvas, 50.8 x 73.7 cm
New York (NY), Collection of Whitney Museum
of American Art. Josephine N. Hopper Bequest
70.1182

Train tracks not only traverse the wide open
spaces in America but divide cities and towns
as well. In his early work Hopper already
began to establish a structural equivalence in
this regard between city and country.

Rolling Power (1939; p. 66). Here the focus is entirely on the mechanisms of the engine, which fill the entire canvas and represent the actual content of the painting, which is strangely static in character.

Such paintings definitely bear comparison with the work of many *Neue Sachlichkeit* (New Objectivity) artists in Germany, such as Carl Grossberg, or with the realistic, technology-oriented styles then current throughout Europe. Yet while these tend to suggest that the old continent has lost its belief in progress, American artists often raised progress almost to the status of a religion. *Rolling Power* was commissioned by *Fortune*, an expensive and beautifully printed business magazine, which presented Sheeler's work in a portfolio of reproductions. "*Fortune's* editors fabricated a toned-up version of the business world's image of itself: a world of power, where the twin gods of science and industry had replaced traditional religion, where, as Henry Adams had noted, the Virgin had been replaced by the dynamo."[15] Picabia treated similar themes, but with European humor and irony. Sheeler's picture is American through and through. It is suffused by a well-nigh religious faith in the blessings of technology, a faith of a kind which, cliché or not, could only flourish in the United States.

Hardly a trace of this attitude is found in Hopper. Once the diffuse religious feeling present in the earlier works had dissipated, nothing new replaced it. Only emptiness, a vacuum, remained. Again, it was not so much Hopper's themes that were typically American, as his pictorial inventory, the actual things he depicted. Besides the railroad, these included train stations and gas stations (*The El Station*, 1908, p. 69; *Gas*, 1940, pp. 72–73). As Pop artists pointed out, Hopper was likely one of the first painters ever to dignify the latter feature of the American landscape by using it as a motif in art.

In 1926 Louis Aragon, a member of the Paris Surrealist group, published a book called *Le Paysan de Paris (Paris Peasant)*. The title itself contains a dichotomy that would form a focus of Surrealist thought – that between culture and nature. One of the wellsprings of the Surrealist movement was nothing less than a desire to create a new mythology, a mytho-

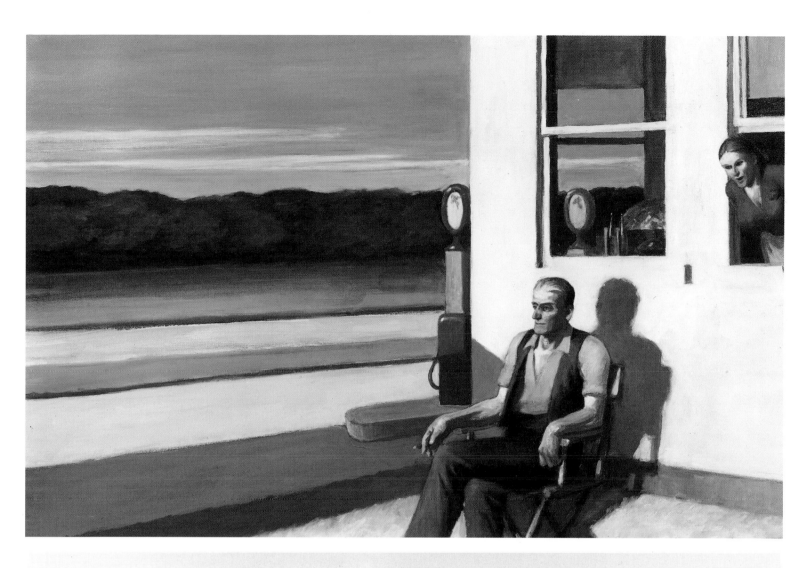

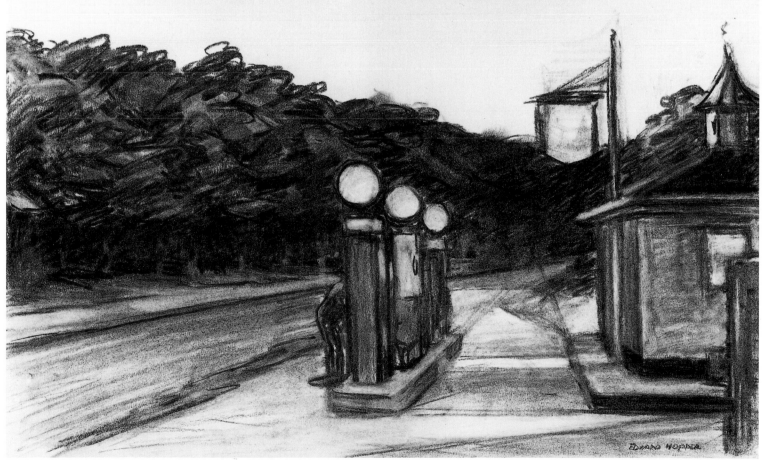

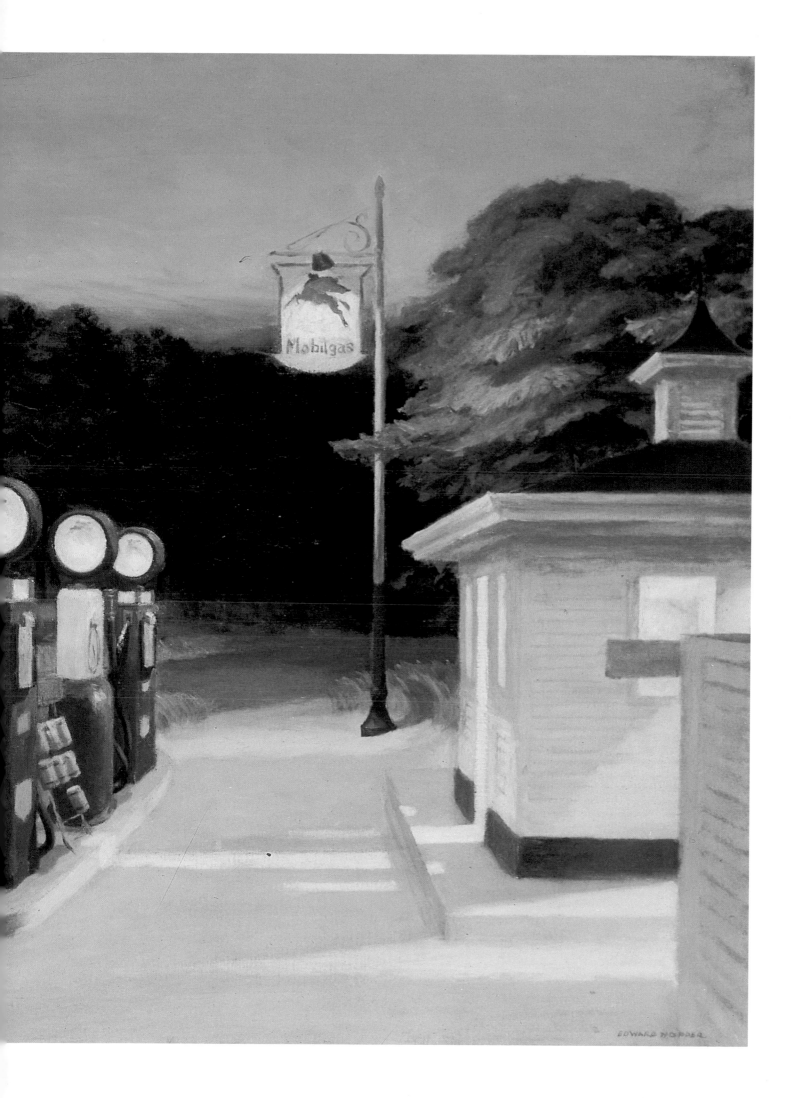

logy of technology and progress. Aragon half seriously and half ironically cast this quasi-religious enthusiasm in literary form, not forgetting a paean to filling stations: "Great red gods, great yellow gods, great green gods have been erected on the margins of the speculative paths followed by the mind in pursuit of perfection, as it progresses from feeling to feeling, from a thought to its consequence. A strange sculpture has presided over the birth of these idols. Hardly ever before have humans found pleasure in such a barbaric aspect of fate and of power. Little did the nameless sculptors who erected these metallic phantoms know that they were bowing to a tradition as vital as that which designed churches in the form of a cross. These idols share a kinship that is threatening. Brightly painted with English words and neologisms, with only a single, long, flexible arm, with their faceless illuminated head, their single foot and belly with rotating dial, the gas pumps sometimes have an air about them of Egyptian deities, or of the gods of cannibals who worship only war. O Texaco Motor Oil, Eco, Shell, grand inscriptions to human potential! Soon we shall make the sign of the cross at your fountains, and the youngest among us will perish, because they have seen their nymphs in naphtha."[16]

In Hopper's *Gas* (pp. 72–73) the attendant's activity – once again, concealed from sight – truly has an almost ritual, priestly character. It is twilight; the pumps and the sign are illuminated, and the lights are on inside the station. Its small spire, and the illumination from within, call up associations with a church. The attendant is clad in white shirt, tie, and vest, not the overalls or at least apron one would expect. The filling station stands symbolically on the border between day and night, between civilization, represented by the road, and nature, represented by the forest in the background, which grows increasingly threatening as night falls.

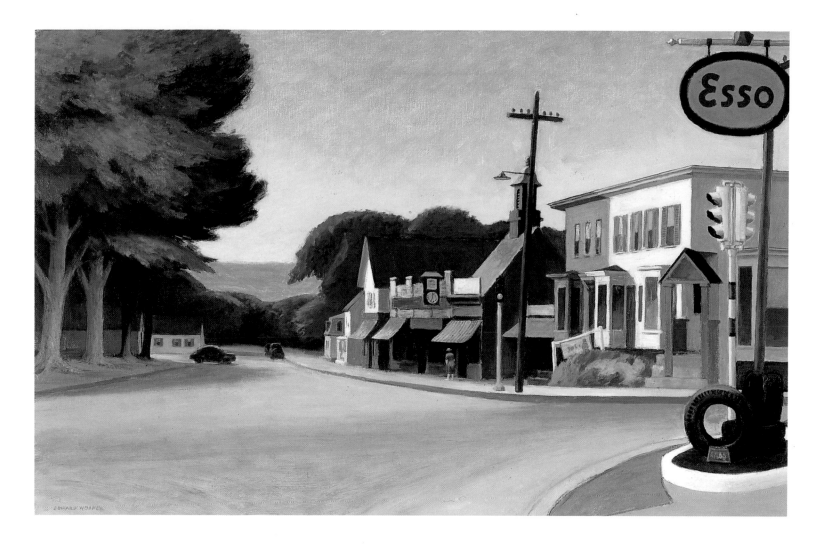

Hopper's pictures truly seem to be located in a twilight zone, an interim condition. They reveal a human world that is no longer in a state of innocence, but has not yet reached the point of self-destruction. His imagery is marked by a tremulous balance that is not yet equilibrium. It evokes no idyllic pre-industrial state, nor does it celebrate mechanization. Hopper shows us a situation that no other American artist captured in quite this way. His work stands intermediate between nineteenth-century Romanticism and the social criticism of the Ash Can School, and also between the conceptually-oriented avant-garde of the early twentieth century and the affirmative approach of Precisionists such as Sheeler. This ambiguity, even indifference, made Hopper a forerunner of American Pop Art. Not so much a reliance on tradition as his conscious use of set pieces from the American environment made him a quintessentially American painter. Nor was it a coincidence that, after his early trips to Paris, Hopper never crossed the Atlantic again, and spent most of the next fifty years in a setting which was as little susceptible to change as he was himself – New England.

Portrait of Orleans, 1950
Oil on canvas, 66 x 101.6 cm
San Francisco (CA), The Fine Arts Museums
of San Francisco, Fractional gift of Jerrold
and June Kingsley, 1991.32

The typically American look of Hopper's paintings arose from his skill in selecting, cropping and framing exemplary slices of the American environment. His viewpoint has influenced many artists, including photographers Robert Frank and Stephen Shore.

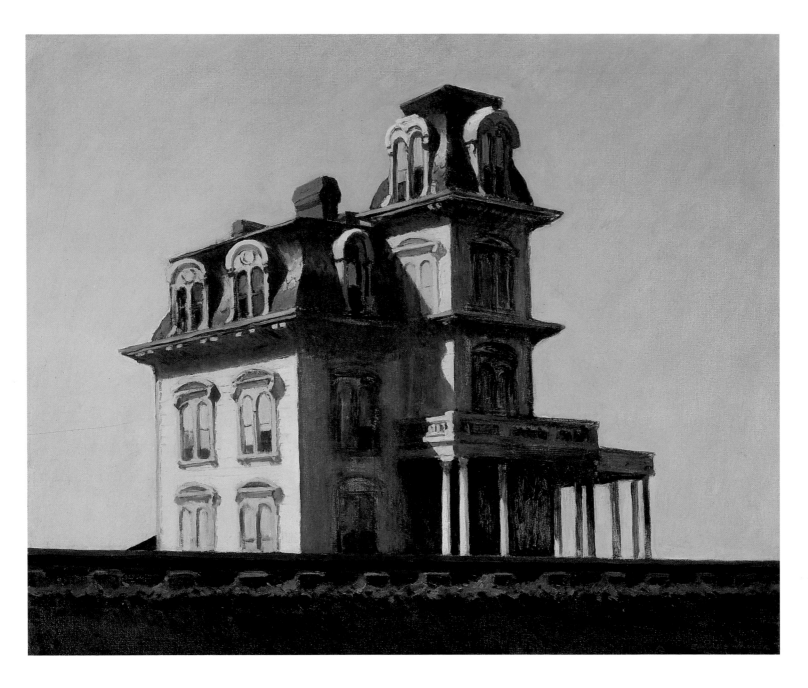

House by the Railroad, 1925
Oil on canvas, 60.7 x 73.7 cm
New York (NY), The Museum of Modern Art.
Given Anonymously

Alfred H. Barr Jr., Director of the Museum of
Modern Art in New York, purchased this picture
in 1930. It has since become one of the incun-
abula of American objective painting. A symbol
of civilization, the house bears certain anthropo-
morphic traits which are contrasted with the
mechanically level railroad tracks, a sort of fore-
ground horizon.

Nature and Civilization

"Nature can be conceived as an 'external world of facts', a realm of things and qualities and the laws governing their changing interrelationships, which are legitimated by their simple existence as what they are. The world full of facts, with their equally factual reasons and explanations, forms a context which, legitimated by its mere being and actual characteristics, is self-sufficient."[1] These words of Arnold Gehlen, German philosopher of culture, might be applied by analogy to modern art. No longer dependent on patronage or commissions, nor forced to serve as a handmaiden to theology or philosophy, modern art has strived to create its own frame of reference and thus to be self-sufficient. But as we know, the autonomy of art is destined to remain a utopian idea, because art will always be dependent on capital, whether it be provided by a patron or sponsor, or derive from market value and opinion. Hopper, too, walked the razor's edge between independence and acclaim, and he did so with great will-power and even obstinacy. In 1932, for instance, he refused a nomination to the National Academy of Design, on the grounds that his early paintings had been refused.

As Immanuel Kant noted, nature, the "exterior world of facts," engenders an aesthetic effect. In this regard, Kant gave clear priority to "natural beauty" over "artificial beauty" – the beauty of human artifice and art. For an aesthetic of modern art, this distinction between natural and artificial beauty might imply that materials of every conceivable type are open to an aesthetic, or specifically, an artistic valuation. Marcel Duchamp demonstrated this in an exemplary way with the urinal he submitted in 1917 to a non-juried exhibition of the Society of Independent Artists in New York. Titled *Fountain* and signed "R. Mutt", the piece caused the board of the Independents to forsake their principles of non-selection and reject it. Duchamp protested the move in *The Blind Man*, a journal of which he was co-editor, writing: "Whether Mr. Mutt with his own hands made the fountain or not has no importance. He CHOSE it."[2] It was absurd to speak of plumbing as immoral, Duchamp added, because the only works of art America had ever produced were her sanitary installations and bridges.

Fireplace at Hopper's New York Apartment, c. 1925–30
India ink on paper, 31 x 17.8 cm.
New York (NY), Collection of Whitney Museum of American Art. Josephine N. Hopper Bequest

Hopper, for his part, painted such things – perhaps not sanitary installations, but bridges, filling stations, and, coming close to Duchamp's gesture, a display window full of laxatives in *Drug Store* (1927; p. 132). De Tocqueville, anticipating Duchamp, had already remarked that "a people who left nothing but a few lead pipes in the ground and some iron rails on top of it might have mastered nature better than the Romans."[3] Plumbing can have an effect on nature, and plumbing can be used in art: in twentieth-century conceptions of reality, nature and art run in close parallel. This is a key precondition of Hopper's approach.

Hopper's paintings should always be understood on two levels, for their form is the shape of their content. The etching *American Landscape* (1920; p. 79) shows three head of cattle, which presumably – since the events in Hopper's imagery take place largely outside it, in the viewer's imagination – stand for an entire herd beginning to cross a railroad embankment. Now, the cattle and railroad are more than simple symbols of the poles of nature and civilization. What on first sight appears almost idyllic and evocative of the pioneer spirit, actually derives from a very specific context.

From the mid-nineteenth century, cattle herds in the Middle West were driven to the nearest railroad and loaded on trains to the slaughterhouses, primarily in Chicago. One such rail connection, chosen by cattleman J.G. McCoy, was the town of Abilene in northern Texas. As Siegfried Giedion records, in 1867 the place "…consisted of twelve shacks; prairie dogs were bred there. Within sixty days McCoy had provided accommodation for over 3000 head of cattle. In autumn of the same year, he shipped 35,000 head. Nearly every train was bound for Chicago. By 1869 the figure had multiplied tenfold, and in 1871, some 700,000 head were consigned to the packinghouses of the Middle West."[4] Hopper was conscious

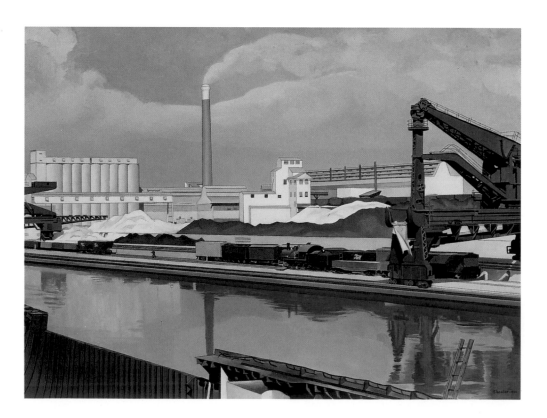

Charles Sheeler
American Landscape, c. 1930
Oil on canvas, 61 x 78.8 cm
New York (NY), The Museum of Modern Art.
Gift of Abby Aldrich Rockefeller

78

American Landscape, 1920
Etching, 18.4 x 31.8 cm
Sheet 33 x 42.5 cm
Philadelphia (PA), Philadelphia Museum of Art,
Purchased: Thomas Skelton Harrison Fund

of this background, though he merely obliquely alludes to it, reducing the elements in the picture to a minimum: a few cattle, a railroad line, a house in an indeterminate landscape. Sheeler, in contrast, in a painting of the same title (*American Landscape*, c. 1930; p. 78), strove for absolute clarity and definition. Hopper's standpoint was not critical, but merely dispassionate. He depicted things as he saw them without making value judgements.

Of course the processes of civilization, mechanization, and technological development did not take place in isolation from "virgin nature." As Gehlen remarks, mankind has been producing tools and goods with the aid of techniques and technologies for half a million years now. Human beings are creatures of nature who entered nature to transform it. They represent *"nature artificielle"*, for "mechanization did not arise out of a free, conscious choice, out of an ethically chaste volition of humanity, but developed inadvertently, even unremarked. Despite its rational and causational structure, it was an involuntary process, an insentient natural occurrence."[5]

Technology, then, is itself part of nature. Similar thoughts are suggested by the perspective and composition of Hopper's image. The scene is viewed, as it were, from the vantage point of the cattle, a point slightly above the path being taken by the herd moving into the picture. The rails demarcate the lower third of the composition from the remainder. The cattle clambering over the embankment pass from an open field into a space occupied by humans and shaped by their hands, as symbolized by the house. By purposely inviting the viewer's participation, Hopper once

again creates a dialectical situation that oscillates between fiction and truth, image and reality, inside and out. From a vantage point in nature, man observes his works, his manipulations of nature, and the effects they have on nature and its denizens. In this sense, the term "mimetic art" is applicable to what Hopper does. Mimetic does not mean merely imitative, though it is frequently used in this false and derogatory sense. Rather, the concept of mimesis denotes a dialectical relationship to reality, in which the image is simultaneously a reflection of reality and an integral part of it. Similarly, humans are both parts of nature and raise themselves above it by transforming it.

Railroad Crossing (c. 1922–23; p. 85) continues the theme of *American Landscape* (p. 79). Here, the network of coordinates is even more strongly emphasized than in the etching of the same title (1923; p. 85). The rails cross the picture just below the center line, with a slight upward incline from right to left. The road enters the picture on an opposite tack, meeting the rails at a point at the right edge of the canvas at which both disappear from view. Composition center is occupied by a house, probably that of the crossing guard. Visible between house and telegraph mast is something rarely found in Hopper's landscapes – a female figure. She appears tiny by comparison to the other pictorial elements, house and mast, signal and crossing sign. The basic hue of the house and its nuances

Cars and Rocks, 1927
Watercolor on paper, 35.2 x 50.8 cm
New York (NY), Collection of Whitney Museum of American Art. Josephine N. Hopper Bequest 70.1104

The perspective emphasizes the similarity in configuration between automobiles and rocks. Hopper shows how man-made machinery can become a part of nature without, however, suggesting a complete reconciliation.

are repeated in the landscape. The blue of the roof corresponds to the blue of the sky; the color of the house relates to that of the field in the foreground and the woods in the background. The works of man, we might conclude, merge with nature (also indicated by the way the foreground tree overlaps the house). But man, symbolized by the figure, seems isolated and insignificant in face both of nature and of his own products, which simultaneously represent an incursion and an expansion.

This brings us to one of Hopper's most famous pictures, *House by the Railroad* (1925; p. 76). Here again the composition is horizontally divided by a railroad line. Behind it rises a bizarre, Victorian house whose foundation is concealed by the embankment. Since our vantage point lies lower than the embankment, we look up at the house from below, but the rendering of the veranda seems to run counter to the logic of perspective. And since the lower part of the house is invisible, we have no point of reference by which to infer its scale. The house seems literally to hover in the air. The tower and veranda appear to tilt forward towards us, while of the tracks, only the foremost rail is visible. Once again, Hopper has played tricks with perspective that put the viewer on shaky ground. "Depicting does not mean reproducing but producing signs for something," as Dagobert Frey, Austrian art historian, has written.[6]

High Road, 1931
Watercolor on paper, 50.8 x 71.1 cm
New York (NY), Collection of Whitney Museum of American Art. Josephine N. Hopper Bequest 70.1163

PAGES 82–83:
Railroad Sunset, 1929
Oil on canvas, 71.8 x 121.3 cm
New York (NY), Collection of Whitney Museum of American Art. Josephine N. Hopper Bequest 70.1170

Hopper combines the Romantic motif of a sunset with an invention of modern technology, the railroad. The largely horizontal emphasis of the composition is interrupted by switch house and telegraph mast, while the rails themselves blend with the surrounding natural environment.

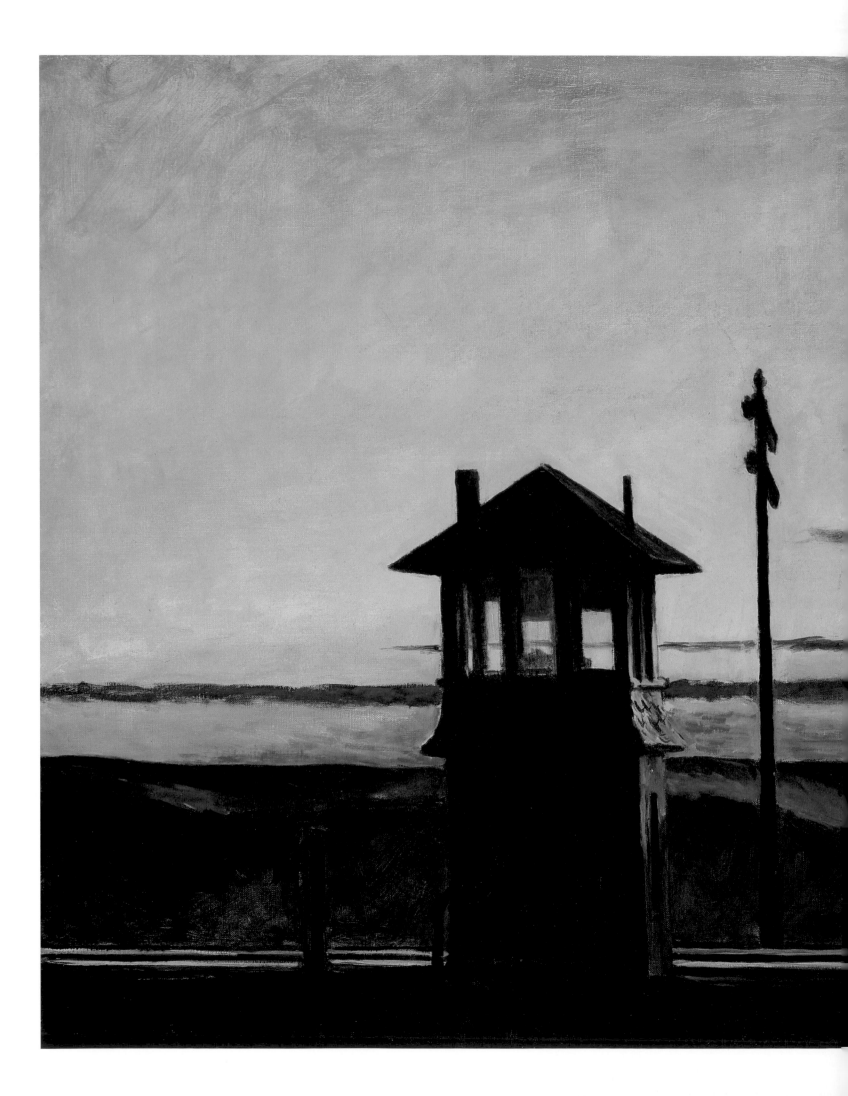

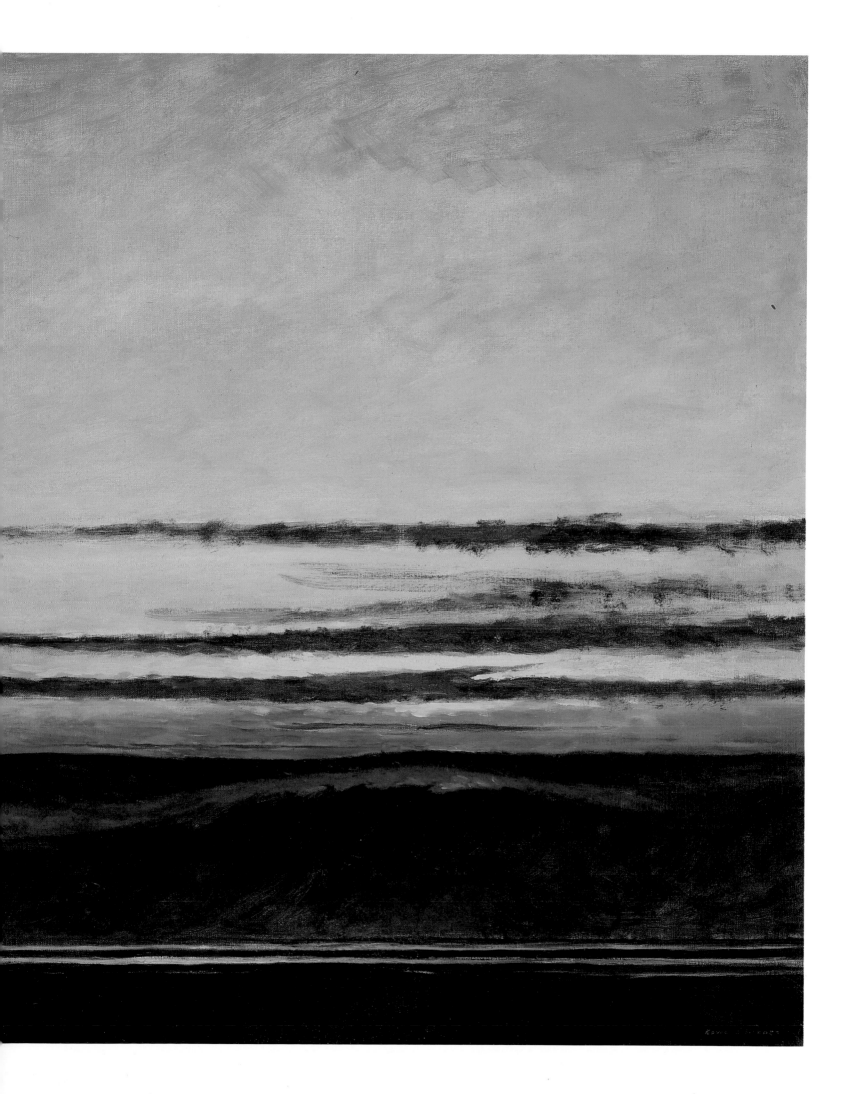

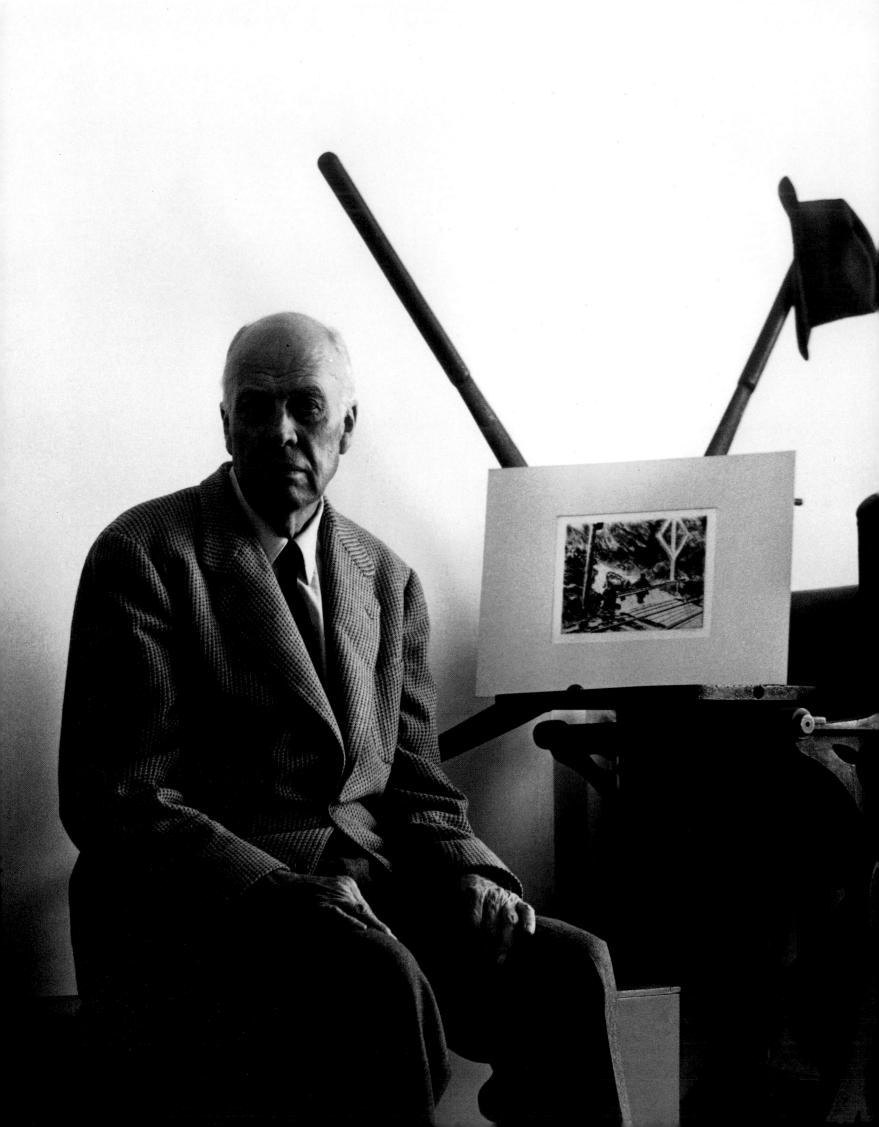

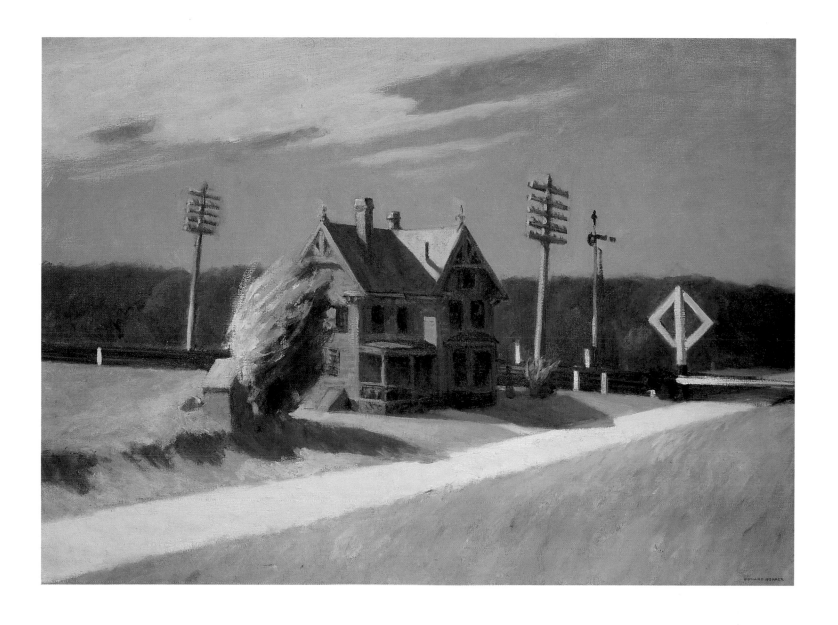

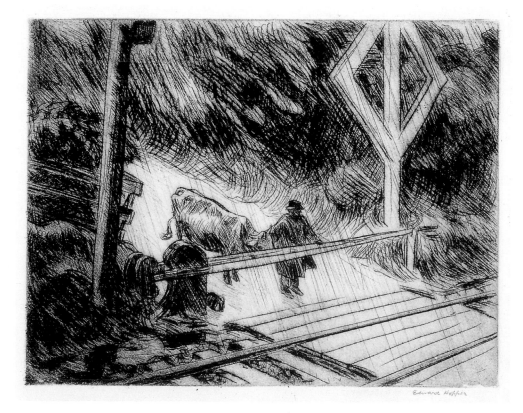

This naturally also holds for the employment of perspective, which in Hopper's hands was never random, and certainly not technically unskilled. *House by the Railroad* is characterized by the absence of a solid frame of reference. The horizon, in the shape of the rails, has been brought into the foreground and placed before the house, to which it normally would be subordinate. By comparison to this ersatz horizon, the house appears to lean slightly, despite the fact that all of its vertical lines are parallel to the picture edges. Horizontals do not occur at all, only diagonals. The impression that the house lies behind an assumed horizon lends it an eerie, chimerical look. Hopper's low vantage point and use of diagonals, in fact, may well have inspired Alfred Hitchcock, for the chilling events in his movie *Psycho* took place in a house with similar architecture, photographed from similar angles.

However, painting offered potentials of a kind very different from those of film. With perspective, as Erwin Panofsky observed, "a transposition of psycho-physiological space into mathematical space was achieved, or in other words, an objectification of the subjective."[7] From the fifteenth century onwards, this method of creating an effect of three-dimensional objectivity on a two-dimensional plane had become a standard device of art. But when Hopper took it up, it was with an eye to subtly undermining it. Not that he suspended the laws of perspective; he merely altered them a bit, just enough to discomfit the viewer. Trusting to the objectiveness of perspective, but discovering that the depiction, for all its conventionality, refuses to obey its laws, we are overcome by a sense of vertigo.

What is more, the *House by the Railroad* (p. 76) appears to have been torn bodily out of the real context. The image has the character of a snapshot taken from a moving train, except the rails themselves are visible in the picture. We have the impression of frozen motion, yet within the

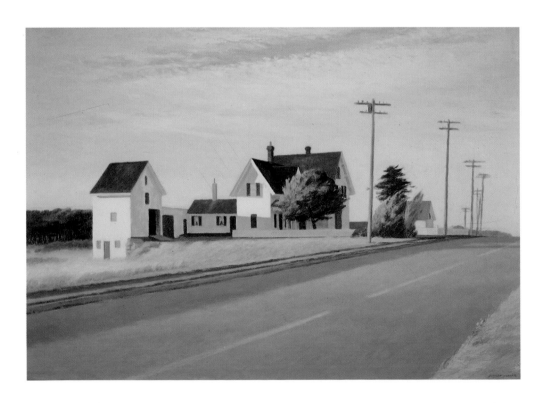

Route 6, Eastham, 1941
Oil on canvas, 68.6 x 96.5 cm
Terre Haute (IN), Sheldon Swope Art Museum

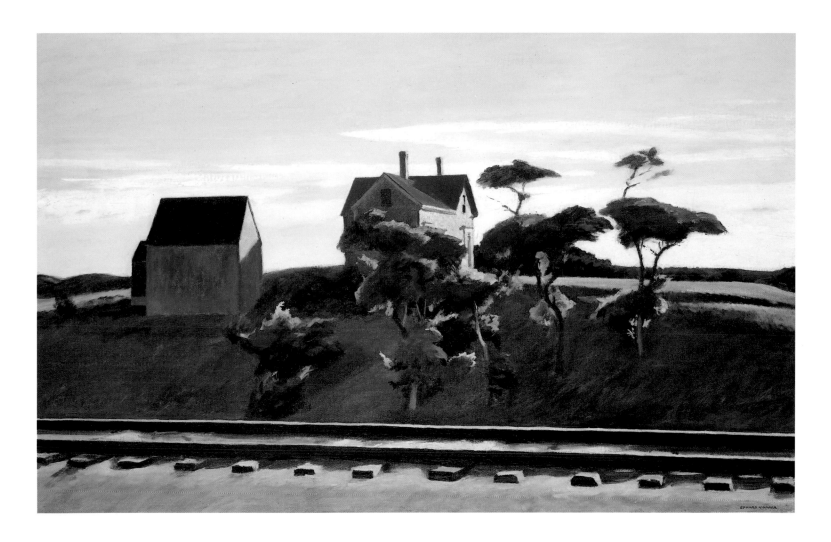

frame, within the actual image, there is no movement at all. It is as if we were standing on a camera dolly during the making of a film, watching the landscape roll past us.

The picture was acquired in 1930 by the Museum of Modern Art, New York, which three years later mounted a great retrospective of Hopper's work. *House by the Railroad* offers many points of comparison with *New York, New Haven and Hartford* (1931; p. 87). Here, too, we have the feeling of standing behind a moving camera eye, perhaps on the railroad line referred to in the title. The impression is not mistaken, but it had a different source. In 1927 the Hoppers had bought a car, and from then on the artist sketched many of his motifs from the moving vehicle. The cities of New Haven and Hartford lie in Connecticut, which Hopper passed through on the way from New York to Massachusetts, the location of the summer house he and his wife had rented in 1930. As the painting's title suggests, the fleeting glimpse of the scene, frozen into stillness, captures the landscape along the route as it were prototypically, by concentrating a protracted time period into a single image.

Many commentators have remarked the influence on Hopper of the writings of Ralph Waldo Emerson, whom the artist is known to have read and admired. Emerson was a leading representative of American Transcendentalism, a school of philosophy partially derived from Kant and German Idealism. Emerson emphasized the cultural independence of America, and he also exhibited a certain tendency to mysticism. In his

New York, New Haven und Hartford, 1931
Oil on canvas, 81.3 x 127 cm
Indianapolis (IN), © 1993 Indianapolis
Museum of Art, Emma Harter Sweetser Fund

The painting's title suggests the points of an extended journey which Hopper has concentrated into a single moment. What one might imagine as a sequence of cinematic images is reduced to an essential configuration.

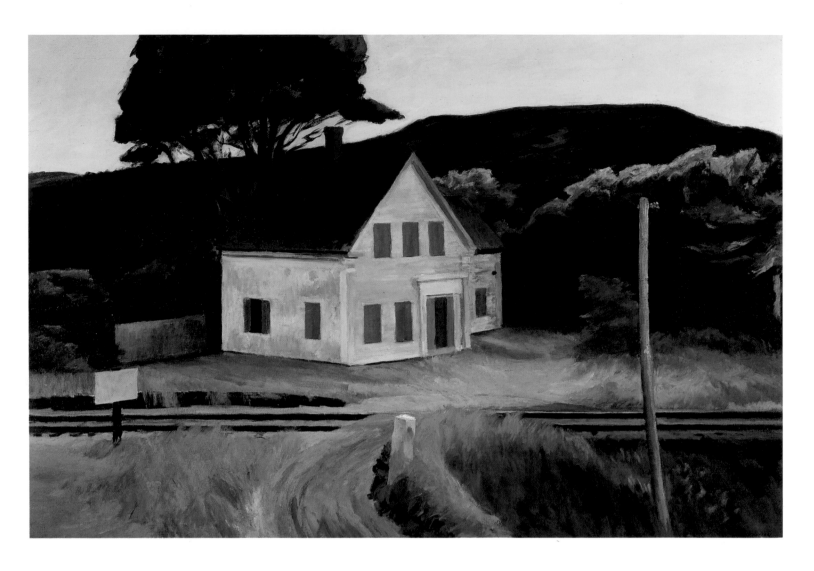

Cape Cod in October, 1946
Oil on canvas, 66 x 106.7 cm
Private collection

essay *The Over-Soul* he describes moments of mystical awareness which spirit a person out of mundane reality. "Our faith comes in moments; our vice is habitual. Yet there is a depth in those brief moments, which constrains us to ascribe more reality to them than to all other experiences."[8] Hopper's etching *Evening Wind* (p. 41) might in fact be associated with such a moment of mystical awareness.

On the surface, *New York, New Haven and Hartford* apparently conveys no such unusual, mystically or religiously inspired insight. The scene depicted is quite mundane, though it is not without a certain enigmatic quality, engendered, for instance, by the windowless, faceless appearance of one of the houses. Also, echoes of the religious experience in Hopper's earlier work still reverberate here: a negation of time and space, and, crucially, the desire to evoke a new reality, a spiritual reality that lies under the surface of things. As Emerson believed, facts, landscapes, human beings, the real world were fleeting, transient phenomena, and the soul transcended all.

Hopper remained a realist, even though he reduced reality to models, as if to subject it to laboratory testing. He was a pragmatic thinker who, as it were, attempted to verify the truth of Emerson's transcendentalism. Hopper's eye fastened itself on the reality before him. The title of *Route 6, Eastham* (1941; p. 86) suggests an actual, topographically localized road. Another painting that depicts a road and house is called *Solitude*

(1944; study, p. 89), a title alluding to a mood. The two canvases are separated by three years in time. Their means of depiction – one aimed at topographical exactitude, the other at evoking a mood – overlap, interlock, indeed are to some extent indistinguishable. What basically characterizes both images is a sense of frozen motion, a motion we as viewers mentally project into them.

While the Futurists attempted to depict motion in painting – Hopper was familiar at least with Duchamp's *Nude Descending a Staircase* – Hopper shifted this factor into a realm outside the painting. To return to the example of film, Hopper painted as if in an attempt to capture an individual frame of a film strip. He divided perception into distinct phases, as in the chronophotography of Muybridge or Marey, with which he was familiar. That perception is a continuous process is something he apparently did not care to represent. These paintings are informed by the same principle as the series of interiors with figures, where exterior space remains concealed from the viewer's gaze. Here, it is the dimension of time that remains concealed, but, as in the interiors, Hopper's allusion to it would seem to represent an attempt to overcome the opposition between intrinsic and extrinsic time.

"No one would seriously contest… that modern subjectivism is a product of cultural conditions: the inundation with external stimuli and the resulting emotional overstrain are coped with by means of internal mechanisms and a 'psychization' which are externally triggered without our being aware of it."[9] Hopper tries to restore perception to its primal state of simple, unreflected recognition; yet this reduction itself is posited on a high degree of reflection. In this regard, too, we find parallels with Emerson, particularly with his view of the Greek tragedy. Its charm, and the fascinating quality of all classical literature, Emerson states, derive from the circumstance that the factor of time is excluded. This brings us to the concept of myth, for as Ernesto Grassi says, "The roots of the term myth thus designate the space in which speech, discourse, action and thought

Study for **Solitude**, 1944
Chalk on paper, 38.3 x 56.2 cm
New York (NY), Collection of Whitney Museum
of American Art, Josephine N. Hopper Bequest
70.855

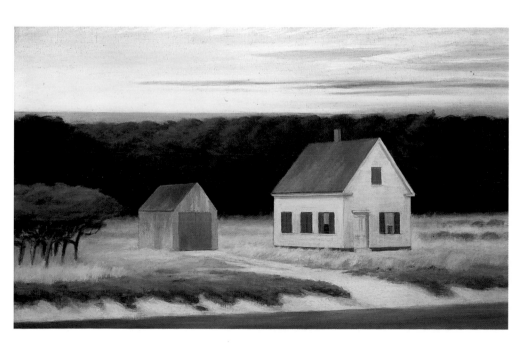

Dauphinée House, 1932
Oil on canvas, 86.4 x 127.6 cm
New York (NY), Courtesy of ACA Galleries,
New York/Munich

Hopper addressed various aspects of the relationship between architecture and nature, extending from alien body to an integration suggested by natural materials such as wood or adobe.

PAGE 90 TOP:
Adobes and Shed, New Mexico, 1925
Watercolor on paper, 35.2 x 50.6 cm
New York (NY), Collection of Whitney Museum
of American Art. Josephine N. Hopper Bequest
70.1121

PAGE 90 BOTTOM:
Adobe Houses, 1925
Watercolor on paper, 34.5 x 49.8 cm
Private collection

Cabin, Charleston, S.C., c. 1927
Watercolor on paper, 35.4 x 50.6 cm
New York (NY), Collection of Whitney Museum
of American Art. Josephine N. Hopper Bequest
70.1147

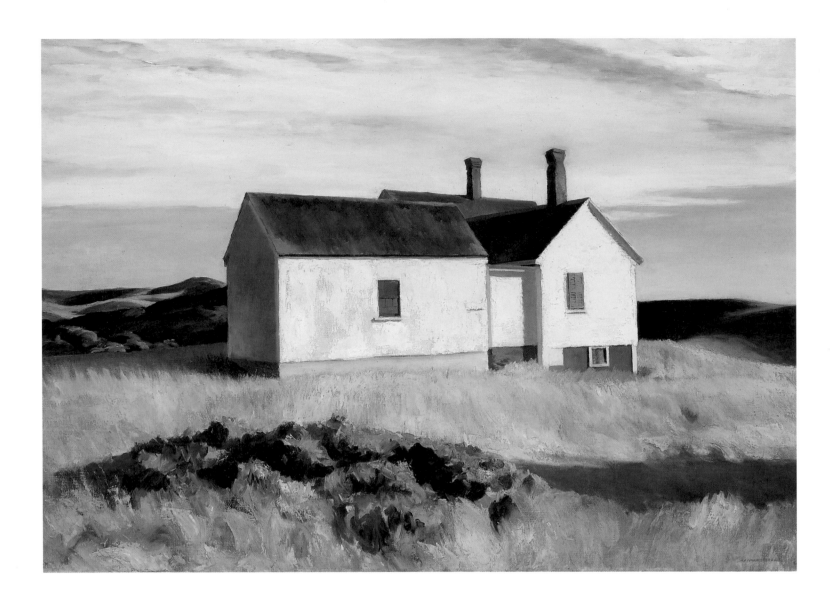

Ryder's House, 1933
Oil on canvas, 91.4 x 127 cm
Washington (DC), National Museum of American Art/Art Resource, New York (NY)

are not yet separated, and this not only as regards utterance *per se* – the invocation of the gods – but as regards everyday discourse as well. Only later was the meaning of discourse and speech separated from reality and deed."[10]

Hopper said he was never able to depict what he had intended to depict. The dilemma lies in the nature of a process of reflection in which thought is divorced from act, and it was not only Hopper's dilemma. It led Marcel Duchamp, for example, to give up artistic activity entirely in 1925 and play chess instead, a decision he held to with few exceptions until the end of his life. Arthur Rimbaud stopped writing poetry at the age of twenty, and began a vagabond's life. Paul Valéry did not write a word for twenty years, saying that while mind and language functioned in an almost identical way, language and literature, the idiomatic and artificial forms of speech, were entirely different. And this was one of Hopper's problems as well. His ideal, which he knew to be unachievable, was to make his statements "with such simple honesty and effacement of the mechanics of art as to give almost the shock of reality itself."[11] Hopper's paintings were to contain no trace of reflection; but a great deal of complex reflection was required in order even to approach this veritably mythical innocence.

In variation after variation Hopper addressed the theme of the relationship between nature and civilization, nature and man, or nature and artifact. The range extended from highly conceptual works such as *American Landscape* (p. 79) and *House by the Railroad* (p. 76) to almost naturalistic renderings like *Adobes and Shed, New Mexico* (1925; p. 90 top) and *Cabin, Charleston, S.C.* (c. 1927; p. 91). The realism of these works is not least a factor of their technique. Watercolor requires relatively rapid work, as the colors are applied to damp paper and the highlights, unlike oil painting, are created by letting the white of the paper shine through. The watercolor technique, in other words, is eminently suited to capturing an immediate impression.

When working in oils, Hopper took such impressions as points of departure, mentally simplified or abstracted them, and then proceeded to put them down on canvas with a certain methodicalness. *Rooms by the Sea* is a perfect example of this approach (1951; p. 176). Others are *House at Dusk* (1935; p. 95), *Seven a.m.* (1948; p. 94), and *South Ca-*

Cape Cod Sunset, 1934
Oil on canvas, 73.3 x 91.1 cm
New York (NY), Collection of Whitney Museum of American Art. Josephine N. Hopper Bequest
70.1166

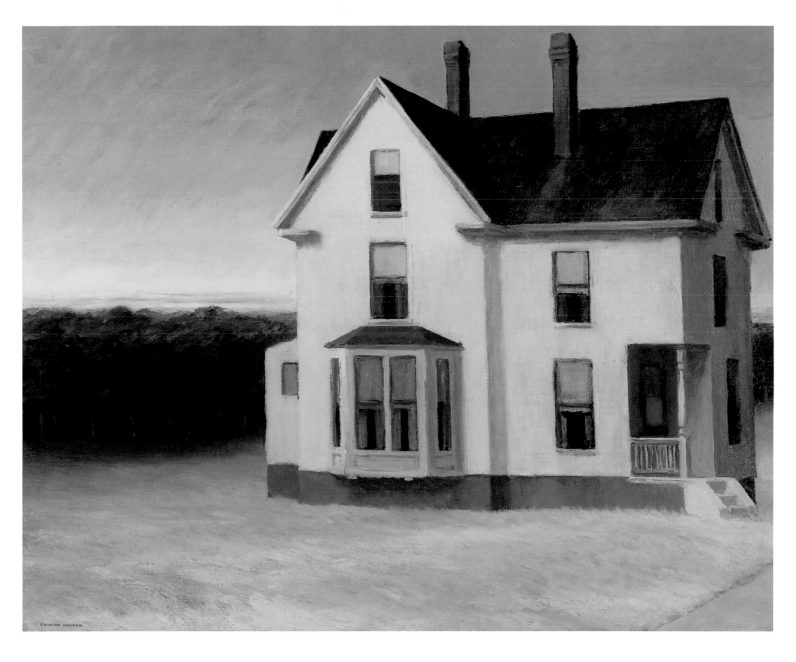

rolina Morning (1955; pp. 100–101). *House at Dusk* is another instance of the way Hopper often separates the two realms of the man-made and the natural by means of distinct perspectives. The contrast is obvious. The house is an urban building, an apartment block of which we see the upper floor in its entirety and the one below it only in part. Some of the windows are lighted; a woman is looking out of one of them, a situation frequently met with in Hopper's scenes. And here, too, he leaves us wondering about what has caught her attention. The viewer's vantage point is undefined; perhaps it is located in another, taller building opposite. Apart from the house, there is little indication of an urban setting, except perhaps for the streetlamp, which gives a suggestion of scale. The building calls to mind a ship with multiple funnels steaming into the picture. Behind it, a stairway leads into a forest or park. The path loses itself in the obscurity among the trees, which stand like a dark, solid, impenetrable wall, only their topmost branches illuminated by the last rays of the setting sun.

Similarities in composition are found in *Seven a.m.* (p. 94) and *Cape Cod Evening* (1939; pp. 96–97). In both cases, a house projects into the

Seven a.m., 1948
Oil on canvas, 76.2 x 101.6 cm
New York (NY), Collection of Whitney Museum of American Art. Purchase and Exchange 50.8

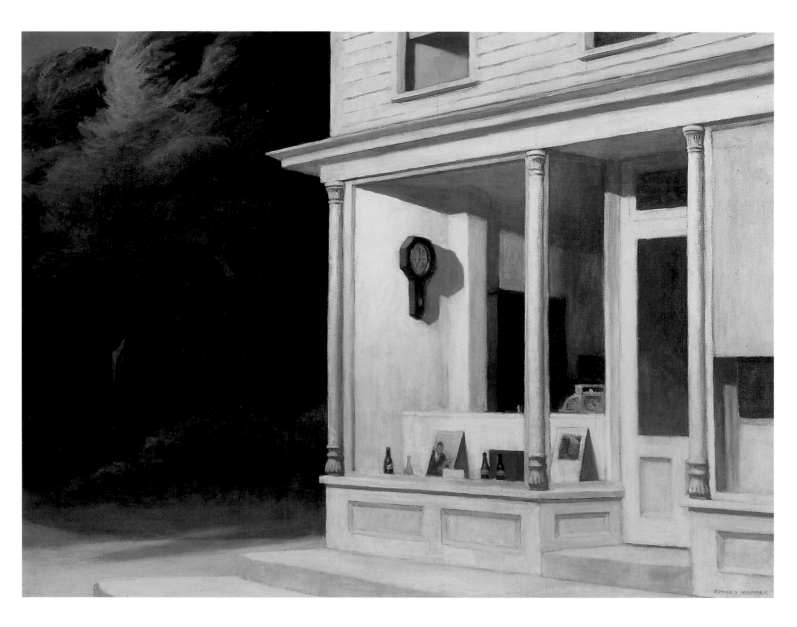

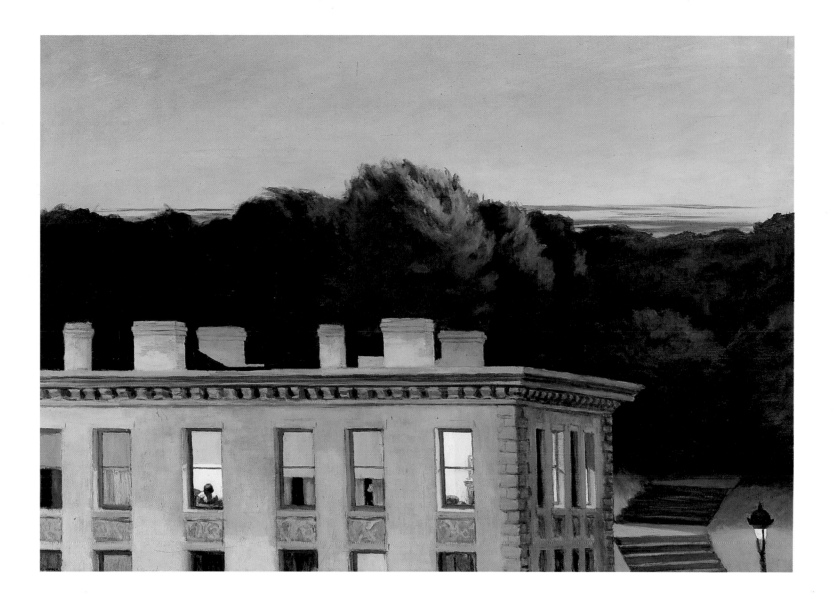

picture from the right, with woods behind it at the left. The former painting depicts the window of a shop that has not yet opened for the morning, and the nature of whose wares is not clearly evident. *Cape Cod Evening* shows the corner of a private house, with a man sitting on the doorstep, a woman standing next to him, and a dog standing in the deep grass, looking out of the picture to the left. Hopper described the painting as follows: "It is no exact transcription of a place but pieced together from sketches and mental impressions of things in the vicinity. The grove of locust trees was done from sketches of trees nearby. The doorway of the house comes from Orleans about twenty miles from here. The figures were done almost entirely without models, and the dry, blowing grass can be seen from my studio window in late summer or autumn… The dog is listening to something, probably a whippoorwill or some evening sound."[12] In this case the woods encroach upon the human realm, the foliage of the foremost tree overlapping the bay window (although this seems rather improbable considering the point at which the tree trunk stands). The people and animal show little interaction with one another, the woman seeming lost in thought, the man calling the dog, which, however, turns away from him. This threefold orientation is another good example of both the tension and the artificial, consciously constructed look of Hopper's compositions.

House at Dusk, 1935
Oil on canvas, 92.1 x 127 cm
Richmond (VA), Virginia Museum of Fine Arts,
The John Barton Payne Fund

Cape Cod Evening, 1939
Oil on canvas, 76.8 x 102.2 cm
Washington (DC), National Gallery of Art,
John Hay Whitney Collection

This is another picture based on contrasts, here
between architecture and nature, human beings
and animal. The relationships are multifarious. A
striking feature is the lack of interaction between
the two figures, and even between the man and
the dog. We gain a strong impression of what is
meant by insentient nature.

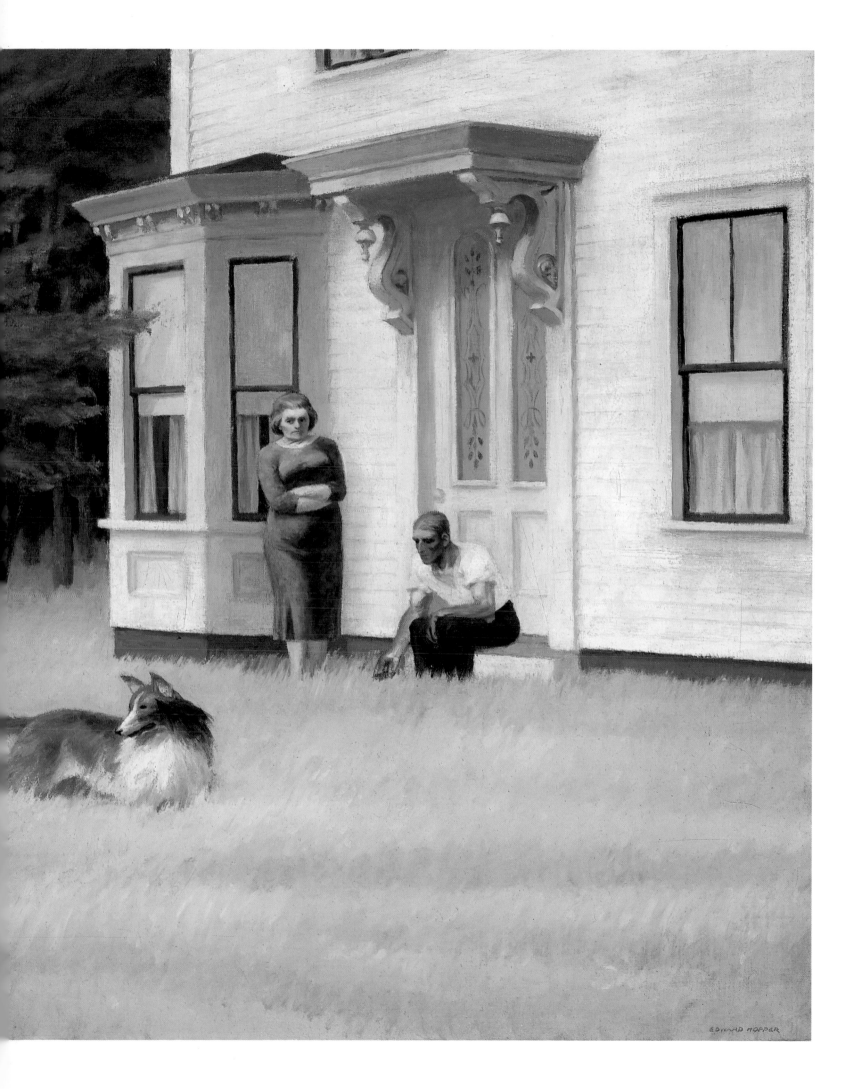

His procedure can be explained by reference to *High Noon* (1949;
p. 102). As Goodrich relates, Hopper made a cardboard model of the
house and put it in the sun to study the effects of light and shade. The
motif itself, in other words, is artificial, literally a mock-up. The land-
scape around the house has an equally unreal look. A sophisticated touch
is the visual parallel between the gaps in the curtains and the woman's
open bathrobe, which despite her demure gesture reveals her breasts.
Hardly ever did Hopper address more clearly the theme of voyeurism,
both as regards its place in his imagery and his attitude to sexuality *per se*.

Paintings like this wonderfully illustrate the experimental character of
Hopper's art. Reality is there (one imagines him thinking) in order to put
various aspects of it to the test in the laboratory of painting. Even his
figures tend to have a wooden, abstract look, being not so much individ-
uals as examples of a species, placed in various situations to see how they
will behave. This process is basically a literary one. We know that Hopper
was a great admirer of Ernest Hemingway. In 1927 *Scribner's Magazine*,
for which Hopper worked as an illustrator, published Hemingway's story
The Killers. Hopper wrote a letter to the editors, saying how refreshing it
was to find such an honest piece of work in an American magazine, after
wading through the endless, sugar-coated mush that was usually pub-
lished. And, he added, the story made no concessions to mass taste, con-

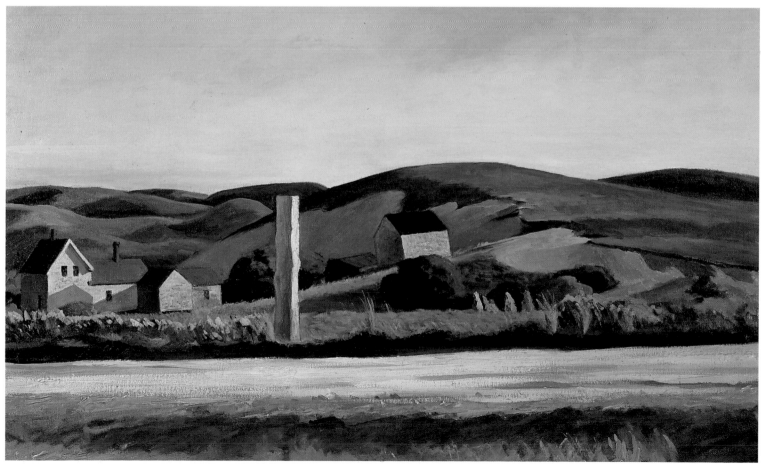

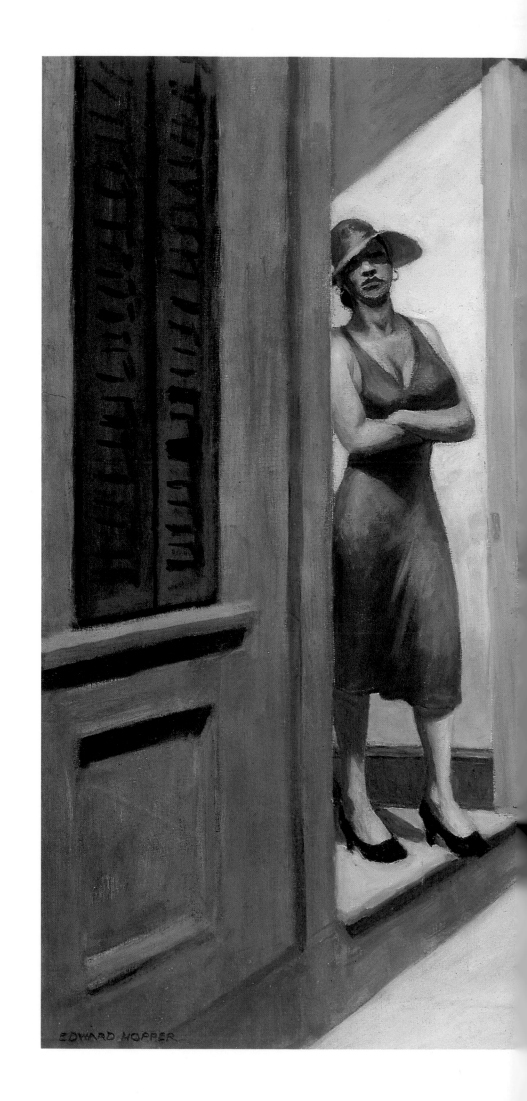

South Carolina Morning, 1955
Oil on canvas, 76.2 x 101.6 cm
New York (NY), Collection of Whitney Museum
of American Art. Given in memory of Otto L.
Spaeth by his family 67.13

The combination of an open landscape and a
house with closed shutters, as well as the woman
stepping out the door, show Hopper again ad-
dressing his favorite theme, the relationship be-
tween interior and exterior world.

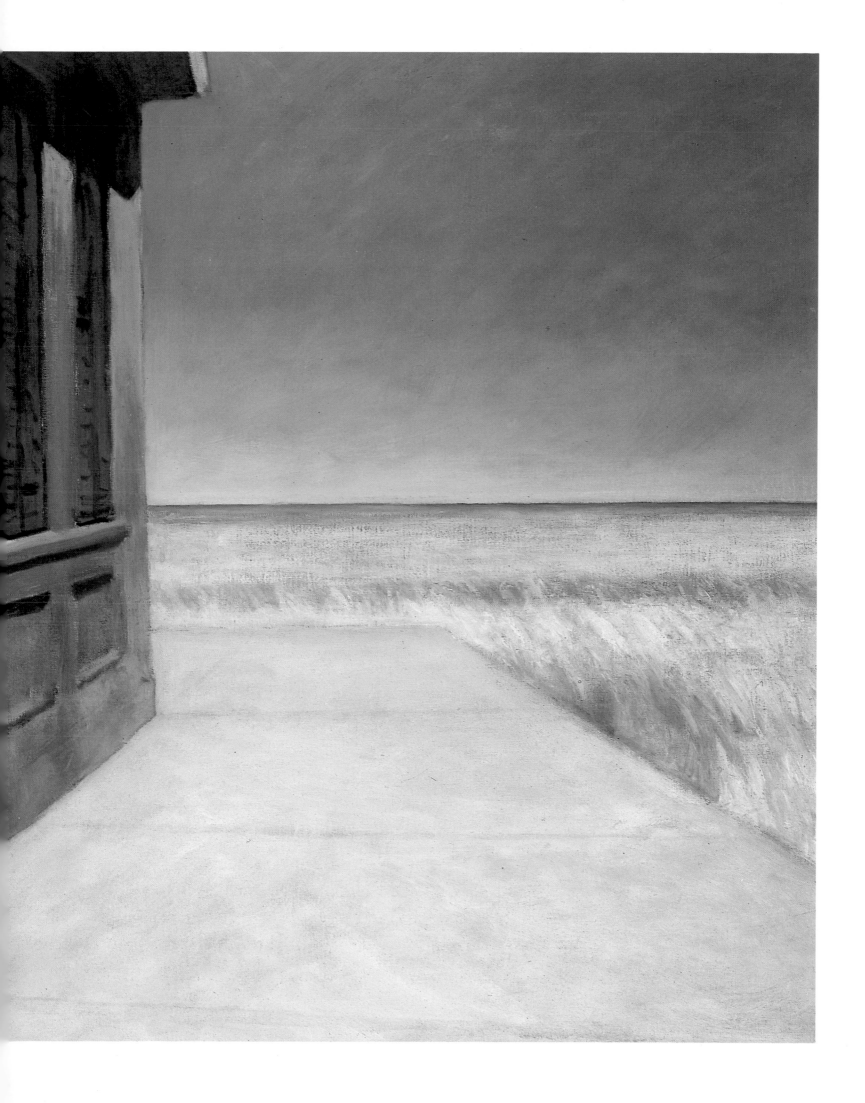

tained no divagations from reality, and had no spurious resolution at the end.[13]

Hopper's approach definitely bears parallels to Hemingway's style. The protagonist of Hemingway's story is an outsider who does not understand what he is observing – very much like the viewer of Hopper's pictures. This brings to mind Arnold Gehlen's observation about the "decreasing sensuousness of artistic and scientific disciplines" caused by the spread of technology, and the "reciprocal increase in primitiveness" that accompanies it. In disciplines that continue to rely heavily on descriptive illustration, such as history and the humanities, Gehlen notes, the procedures remain more traditional. "Similarly," he goes on, "the great majority of the reading public evidently continue to prefer Fontane, Rilke, or Hemingway to James Joyce, Ezra Pound, or Gottfried Benn." From this Gehlen draws an interesting conclusion: "This coexistence of cultural conservatism with *practical* progress in the same fields, which do not readily miss any technical-industrial improvement, is most remarkable. What this implies is an aesthetization of education, its translation into an inconsequential and also morally non-committal activity – in practice one acts within an entirely different frame of reference than one does in the interest of one's education."[14]

High Noon, 1949
Oil on canvas, 69.9 x 100.3 cm
Dayton (OH), The Dayton Art Institute,
Gift of Mr. and Mrs. Anthony Haswell

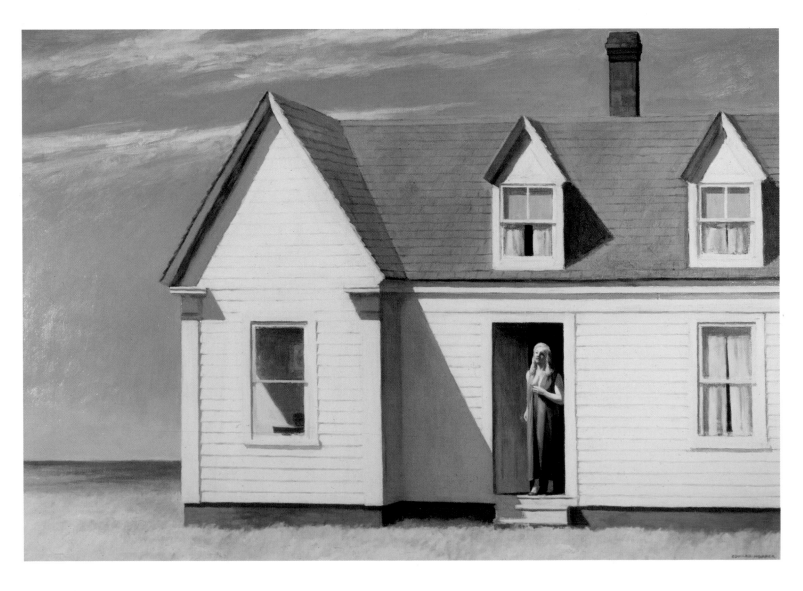

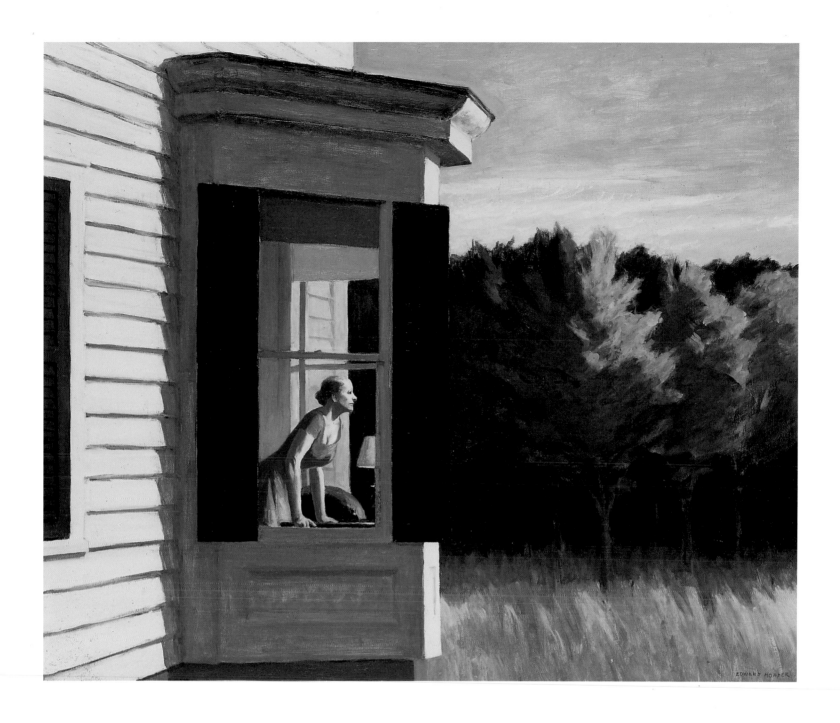

Cape Cod Morning, 1950
Oil on canvas, 86.7 x 101.9 cm
Washington (DC), National Museum of American Art/Art Resource, New York (NY)

Hopper and Hemingway, we might conclude, both have a penchant for modernization by conservative means. This would seem to be part of the reason for their success. However, it would be mistaken to overstress the parallels between the two. Bullfighting, for instance, Hemingway's favorite spectator sport, did not appeal to Hopper at all. During his visit to Spain in 1910, he wrote to his sister: "I went to a bull fight last Sunday and found it much worse than I thought it would be."[15] Certain similarities in Hopper's and Hemingway's techniques might have resulted from the medium they both initially worked for, the press, in the form of illustration and journalism respectively. Hemingway's heroism, however, was a far cry from Hopper's attitude, for he set little store by masculinity, bravery, or the satisfaction of physical desires – not to mention hunting, fishing, boxing, and drinking. None of the people in Hopper's paintings let themselves go, quite the contrary: they exhibit that self-control and sublimation of instinct which are a cornerstone of civilization.

Cobb's Barns, South Truro, 1930–33
Oil on canvas, 86.4 x 126.4 cm
New York (NY), Collection of Whitney Museum
of American Art. Josephine N. Hopper Bequest
70.1207

Another interesting motif in this connection is the lighthouse. In Hopper's depictions of lighthouses, the ocean is seldom visible. Often they are viewed from a low vantage point, and soar to monumental proportions. Yet when we think of lighthouses, we automatically think of the sea; that is, a structure created in an attempt to master nature calls up associations with nature herself. What is more – and this brings us back to Hemingway – the lighthouse, especially in the form given it by Hopper, is the phallic symbol *par excellence*. And this embodiment of virility and strength rises at particularly exposed and dangerous points where land meets sea.

While there are a number of Hopper watercolors that depict the natural landscape, devoid of man's works, only a very few of the oils are without reference to the contrast between nature and civilization. One of these is *The Camel's Hump* (1931; p. 99). Apparently Hopper found pure landscape not especially suited to his purposes. In the next chapter we will turn to the relationship in his work between center and periphery, city and country, metropolis and small town, a relationship that is closely linked with the theme of nature versus civilization.

Ground Swell, 1939
Oil on canvas, 92.7 x 127.6 cm
Washington (DC), in the Collection of the
Corcoran Gallery of Art, Museum Purchase,
William A. Clark Fund

Hopper frequently developed further in his paint-
ing which had first occurred in his commercial
illustrations. The pictorial problems remained
basically unchanged, but he sought different solu-
tions to them in variation after variation.

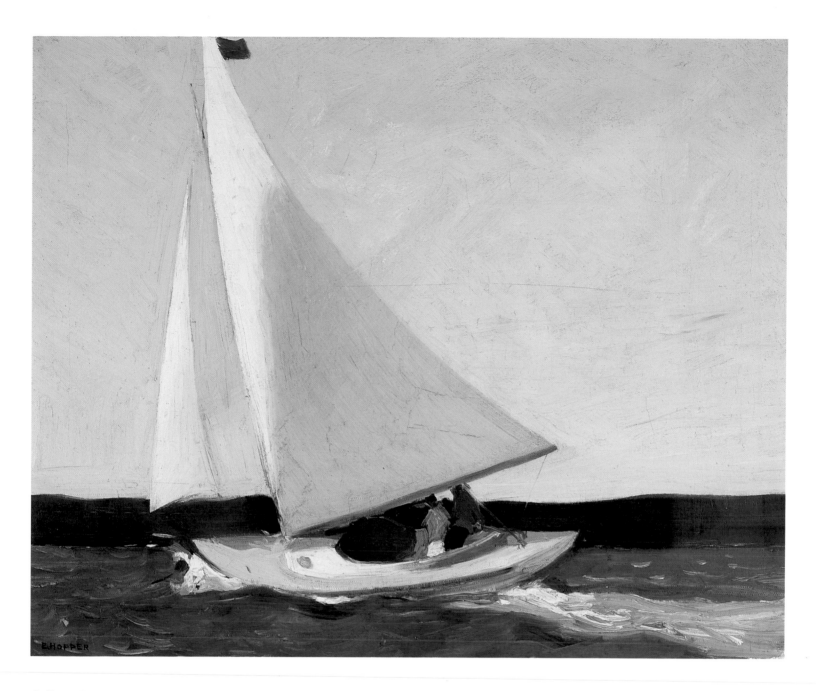

Sailing, 1911
Oil on canvas, 61 x 73.7 cm
Pittsburgh (PA), The Carnegie Museum of Art,
Gift of Mr. and Mrs. James H. Beal in honor of
the Sarah Scaife Gallery, 72.43

Originally the boat was sailing in the other direc-
tion, but Hopper painted over the first version
and depicted it with its bow pointing left instead.
Sailing was exhibited at the 1913 Armory Show
in New York, and was the first picture Hopper
ever sold.

PAGES 108–109:
The Lighthouse at Two Lights, 1929
Oil on canvas, 74.9 x 109.9 cm
New York (NY), The Metropolitan Museum of
Art, Hugo Kastor Fund, 1962 (62.95)

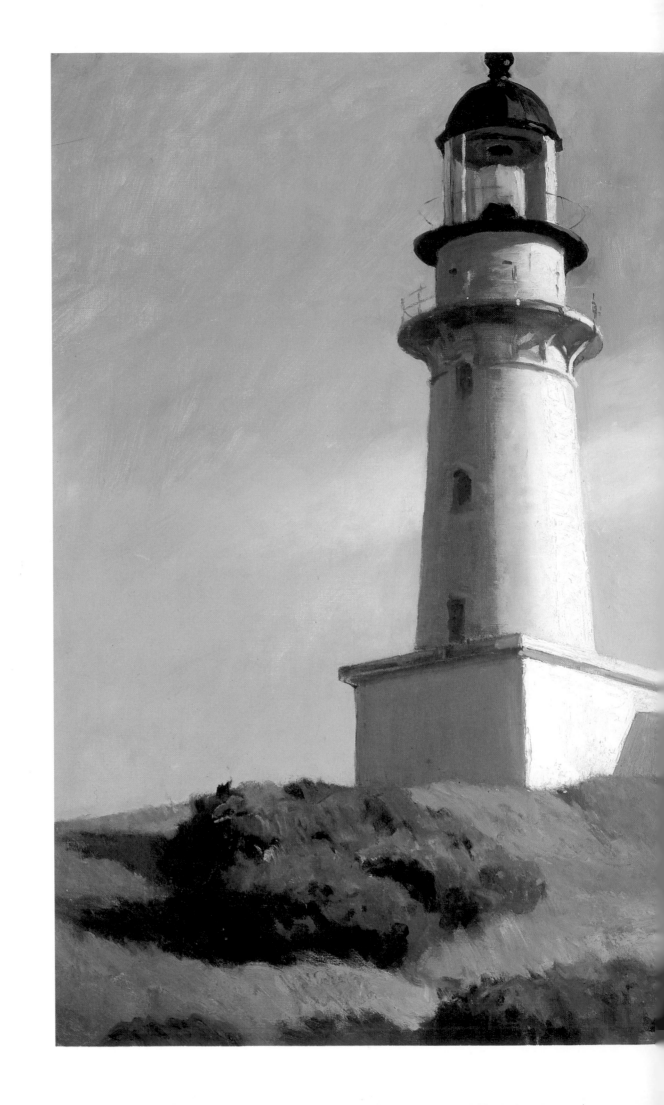

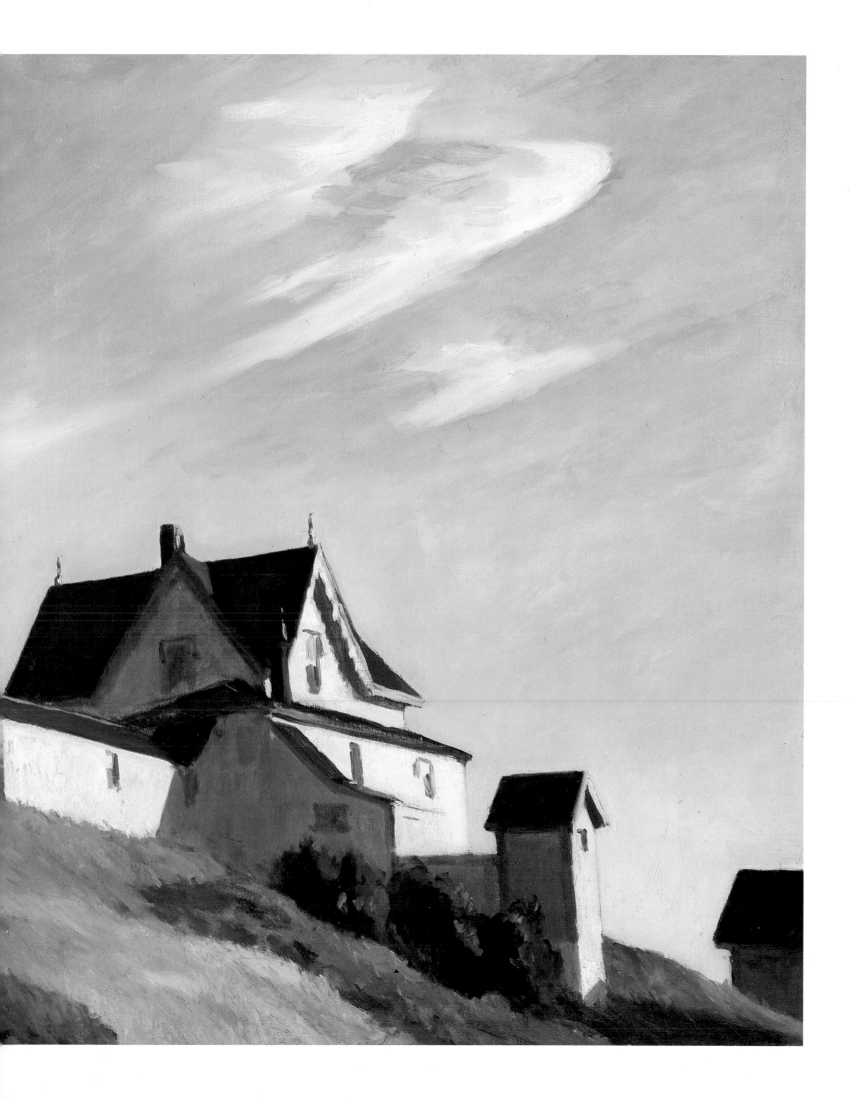

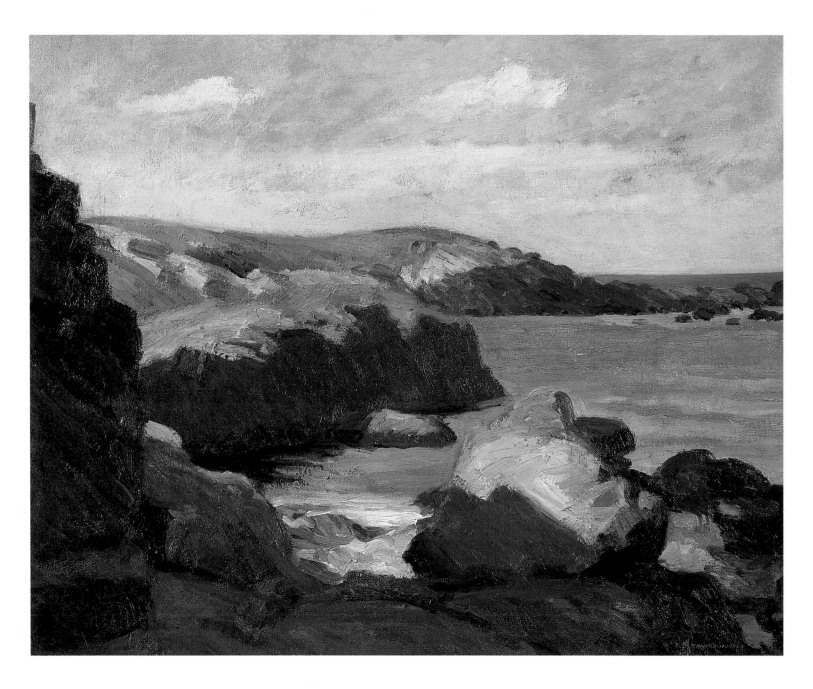

Sea at Ogunquit, 1914
Oil on canvas, 61.6 x 74 cm
New York (NY), Collection of Whitney Museum
of American Art. Josephine N. Hopper Bequest
70.1195

The meeting point of land and sea was a motif
that preoccupied Hopper from his earliest years.
As time went on, he depicted the sea itself
less and less frequently, replacing it by the light-
house, a symbol of human achievement and
mastery over the elements which Hopper appar-
ently felt sufficient to suggest the presence of
the ocean.

The Lighthouse (Maine Coast), 1921
Etching, 39.4 x 43.7 cm
Sheet 25.1 x 30 cm
New York (NY), Collection of Whitney Museum
of American Art. Josephine N. Hopper Bequest
70.1032

BELOW:
Lighthouse Hill, 1927
Oil on canvas, 71.8 x 100.3 cm
Dallas (TX), Dallas Museum of Fine Arts,
Gift of Mr. and Mrs. Maurice Purnell

Mass of Trees at Eastham, 1962
Watercolor on paper, 53.3 x 73 cm
New York (NY), Collection of Whitney Museum
of American Art. Josephine N. Hopper Bequest
70.1164

The watercolor technique permitted Hopper to
render his impressions of nature rapidly and to
capture brilliant effects of light. The subject-
matter reflects the motifs he carefully com-
bined in his oils.

California Hills, 1957
Watercolor on paper, 54.6 x 74.3 cm
Kansas City (MO), Reproduction Courtesy Hallmark Fine Arts Programs, Hallmark Cards, Inc.

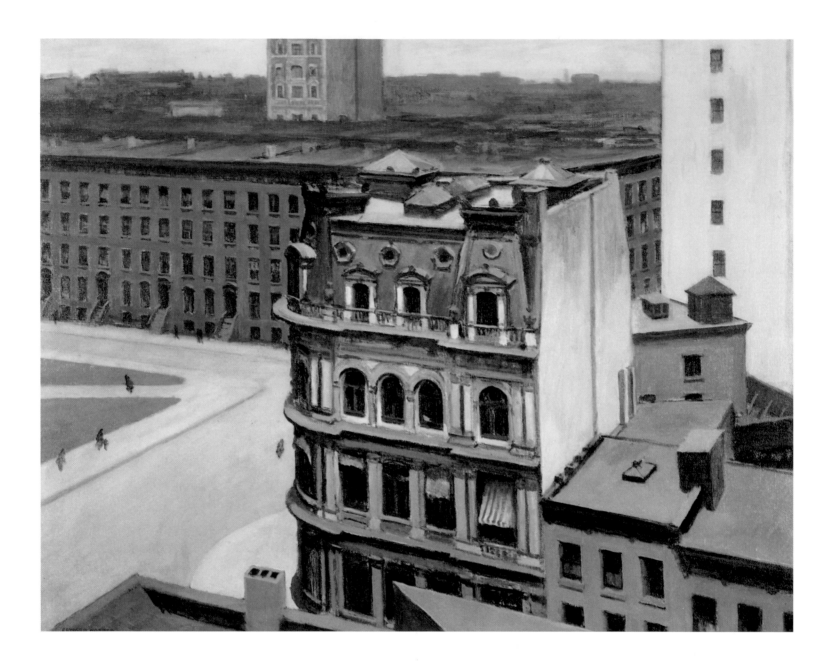

The City, 1927
Oil on canvas, 70 x 90.4 cm
Tucson (AZ), Collection of The University of
Arizona Museum of Art, Gift of C. Leonard
Pfeiffer

For Hopper the city was an arena of compet-
ing philosophies. He described the contrast be-
tween anonymous tenements and buildings
whose stylistic richness lends them something
akin to character.

Center and Periphery

Hopper generally spent half of the year in New York and the other half in South Truro, Massachusetts. The studio house where he and his wife lived during the summer months had been finished in 1934. The contrast between city and country soon became a fixed formula in Hopper's work, which tended to set idyllic country life against the impersonal aspects of life in the big city.

This topic almost automatically brings us back to the time Hopper spent in Paris, and the influence exerted on him by Impressionism. "The big city picture of the nineteenth century was born in spring 1873, when Claude Monet painted the view of Boulevard des Capucines, looking down from the studio window of the Paris photographer Félix Nadar."[1] Although many Impressionists were fascinated by the modern city, and especially by the new technology of iron construction – see Gustave Caillebotte in particular – most of them continued to gravitate to the suburbs, out into the country, or to the seaside. The Surrealists, at a later date, likewise preferred the periphery of Paris, where they browsed through the flea markets or explored back lanes in search of the miracles of the mundane.

Hopper's procedure was once described as a "mythicization of the banal," and the banality of his everyday scenes does in fact seem overlain by an enigmatic, almost surrealistic poetry. So the reference to Surrealism is not really far-fetched, as the juxtaposition of Hopper's pictures of gas stations with a quotation from Aragon has already suggested. The Surrealist principle, basically, involved bringing together apparently incommensurable, unrelated objects on a common plane, which functioned like a projection surface for a new and surprising image of reality. Hopper, like the Surrealists, had a special eye for trite, ordinary, supposedly insignificant things. Another trait they had in common was an interest in the phenomenon of voyeurism, although the Surrealists exploited the erotic and sexual connotations of the theme in an incomparably more direct way than Hopper.

More revealing than the similarities, however, are the differences that resulted from a related method. Hopper remained straightforward, concen-

House on a Hill or *The Buggy,* 1920
Etching, 20.3 x 25.4 cm
Philadelphia (PA), Philadelphia Museum of Art,
Puchased: Thomas Skelton Harrison Fund

trating not on the sensational aspects of his subjects but on their very normality. If one were to divide one of his images into its constituent parts and reassemble them in another combination, the result would not materially differ from the original. In Hopper's hands, a combination of disparate elements led to a realistic image, not a surrealistic one.

The tendency to imitate the superficial aspect of things was early described by de Tocqueville, in *Democracy in America*: "Diamonds are already so well imitated that it is easy to be taken in. As soon as sham diamonds can be made so well that they cannot be distinguished from real stones, it is probable that both will be disregarded and become mere pebbles again."[2] The issue addressed by de Tocqueville is that of levelling, and it probably had its roots in America's very diversity itself.

Hopper's painting *The City* (1927; p. 114) shows a view over the roofs of a city from an elevated vantage point. The city square visible at the left is bounded by a monotonous row of apartment houses. The building rising in the center – indeed, the center of interest – seems foreign to its rather dreary architectural surroundings, having a quite different character and style, including an elaborate mansard roof that recalls the buildings of Paris. It obviously dates from an earlier period than the surrounding tenements. By the time this picture was painted, America had had skyscrapers for forty years, including those of Louis H. Sullivan in Chicago and, a sensation in the year of Hopper's painting, 1927, William van Alen's Chrysler Building in New York. Yet this new American architecture apparently held little attraction for Hopper. What he focussed on were more subtle contrasts, such as those between round and angled, interesting and monotonous, or old and new.

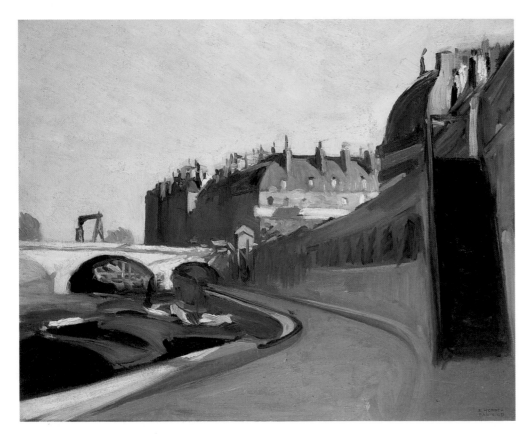

Le Quai des Grands Augustins, 1909
Oil on canvas, 59.7 x 72.4 cm
New York (NY), Collection of Whitney Museum of American Art. Josephine N. Hopper Bequest 70.1173

Hopper once remarked that a visit to Paris was *de rigueur* in his days, but that nowadays Hoboken would do as well.

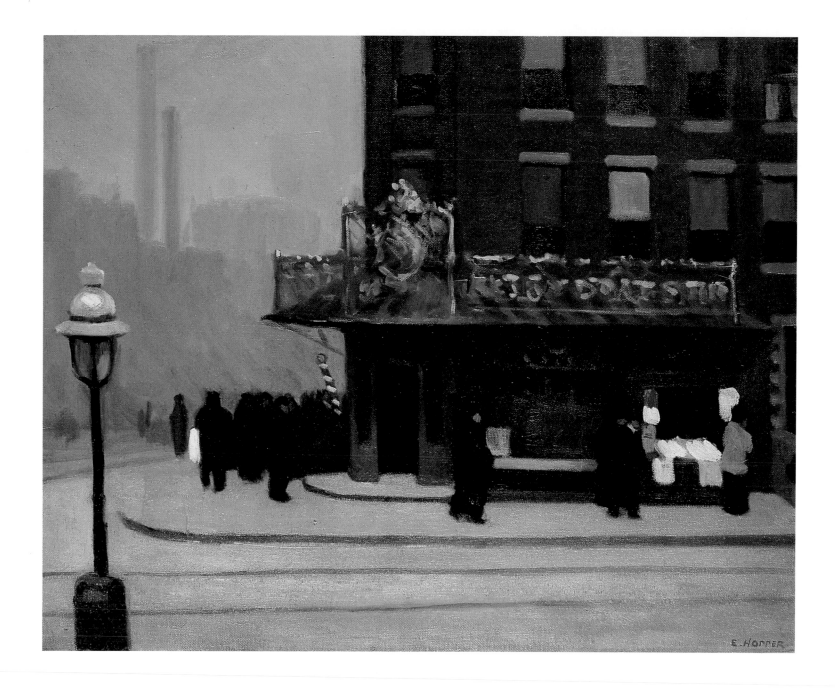

New York Corner (Corner Saloon), 1913
Oil on canvas, 61 x 73.7 cm
New York (NY), The Museum of Modern Art.
Abby Aldrich Rockefeller Fund

Although the forms of the central building are not so rounded and bio-morphic as those of the Victorian villa in *House by the Railroad* (1925; p. 76), it is still prominently adorned with columns, pilasters, and other articulating elements. Two buildings that are much higher than the others are visible in the picture. But Hopper has simply cut them off at the top. This implies a certain attitude to the scene on his part. On the one hand, he concentrates on the comparatively antiquated building, and on the other, he simply declines to perceive certain other structures that are inconsistent with his vision. As in previous paintings, we as viewers are again challenged to mentally complete the image beyond its borderlines. And again, Hopper emphasizes the contrast between nature and civilization, if on a different level from that of the country pictures just discussed. Here he addresses it within the context of the development of civilization itself.

Hopper's standpoint can be located by reference to various lines of thought which were gaining currency at the time. Walter Gropius, archi-

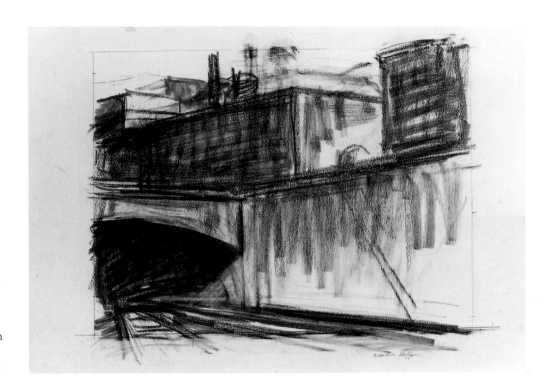

Study for *Approaching a City*, 1946
Chalk on paper, 38.3 x 56.2 cm
New York (NY), Collection of Whitney Museum
of American Art. Josephine N. Hopper Bequest
70.869

tect and founder of the Bauhaus, who left Germany for America shortly
after Hitler came to power, once described an experience he had in the
land of unlimited opportunity. "When I built my first house in the United
States – my own residence," Gropius wrote, "I made a point of embody-
ing in my personal design characteristics of the architectural tradition
of New England, which I felt to be still alive and apt. This amalgamation
of the *genius loci* with my modern architectural approach resulted in a
house of a type that I never would have built in Europe, with its com-
pletely different climatic, technical, and psychological conditions."[3]

This statement contains two references that are important in the pres-
ent context. First, Gropius' allusion to New England architecture points
up one of the reasons why Hopper became a quintessentially American
painter. Secondly, the statement refers to the influence of geographical
and social conditions on architectural design, a subject in which Hopper
took a definite interest. As *The City* indicates (p. 114), he viewed the
urban scene as an arena in which conflicting philosophies confronted one
another. A further example is found in *Approaching a City* (1946; p. 119).
What he wanted to express in this painting, Hopper himself said, were the
feelings of "interest, curiosity, fear" one experiences when first entering a
strange city by train.

As in his etching, *The Locomotive* (1922; p. 66), the entrance to a tun-
nel plays a prominent role in the composition. The retaining wall, tracks,
and buildings are rendered in an ocher tone shot through with dingy blues
and greens. Apparently the buildings at the left are commercial premises,
for we see few signs of life there, in contrast to the two apartment houses
at the right, one of which is rendered in a red that forms the only spot of
bright color in the composition. From this point the converging perspec-
tive lines lead the eye from the inhabited, as it were personal area to an
anonymous, impersonal one, whose disquietingly ambiguous effect is fur-

ther increased by the darkness under the overpass. The fragment of sky and the buildings cut off at the edge of the canvas lend the scene a literally oppressive atmosphere.

Hopper mistrusted the big city, and was apparently able to appreciate its vitality only when he reduced it to a slice of life, seen in close-up, in a similar way to his country scenes. *The City* and *Approaching a City* were to remain the exception in taking the big city as a subject in its own right.

In reaction to the Great Depression, an ambitious urban development program was launched by President Roosevelt under the auspices of the New Deal. Inspired by the English garden city idea, urban planner Lewis Mumford and others propagated the benefits of the New England Town, which had already so appealed to Walter Gropius. An infusion of rural idyll, they thought, would help revive and rejuvenate America's depressed cities. However, the project ultimately foundered over the objections of the Republican faction in Congress. The garden city movement was concurrent with the Federal Arts Project already mentioned, and both were borne up by a wave of heightened national purpose. Hopper fit into the picture to the extent that the provincial scene always interested him more

Approaching a City, 1946
Oil on canvas, 68.6 x 91.4 cm
Washington (DC), The Phillips Collection

His intention in this painting, Hopper said, was to express the "interest, curiosity, fear" one feels when entering a strange city by train for the first time. The color accents on the two buildings at the right are striking.

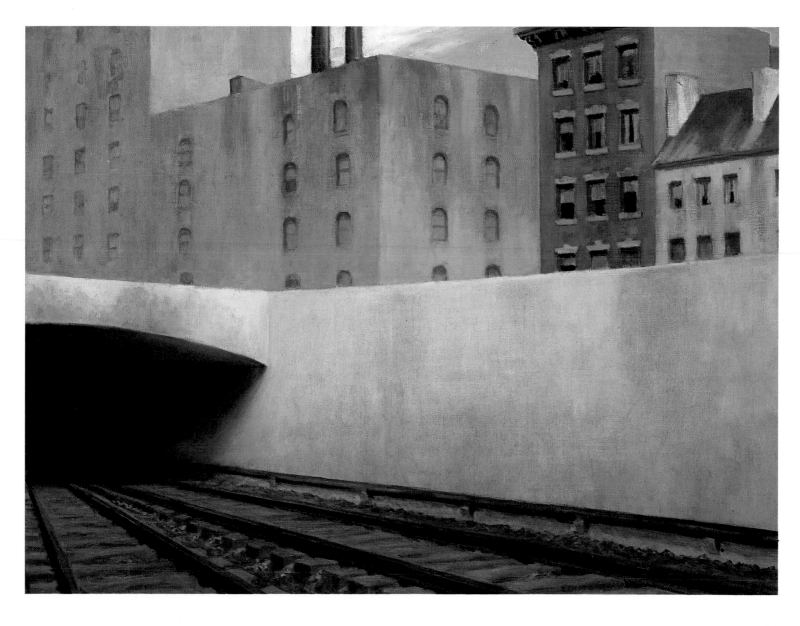

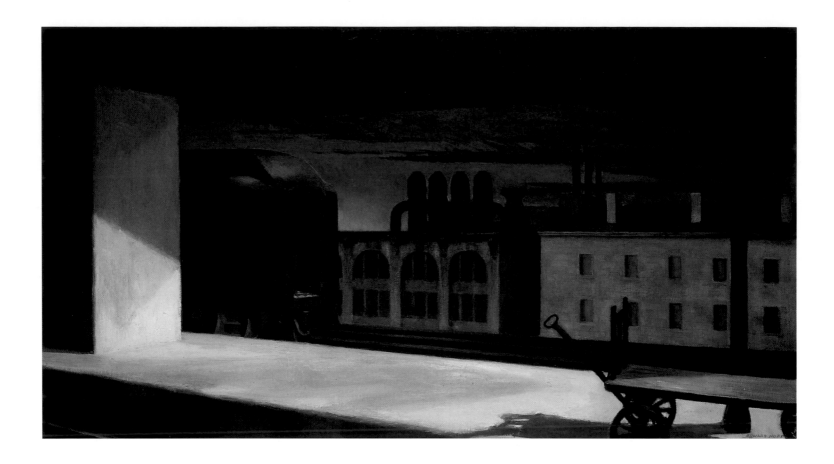

Dawn in Pennsylvania, 1942
Oil on canvas, 61.9 x 112.4 cm
Chicago (IL), Courtesy of Terra Museum of
American Art, Daniel J. Terra Collection,
18.1986. © All rights reserved

PAGE 121 TOP:

Study for **Summertime**, 1943
Chalk on paper, 22.5 x 30.2 cm
New York (NY), Collection of Whitney Museum
of American Art, Josephine N. Hopper Bequest
70.460

PAGE 121 BOTTOM:

Study for **Summertime**, 1943
Chalk on paper, 21.6 x 27.9 cm
New York (NY), Collection of Whitney Museum
of American Art, Josephine N. Hopper Bequest
70.458

than the metropolitan one. While many of his paintings, including the best known, do depict the city, the actual situations represented are very similar to those chosen from the rural environment. Compare, for instance, *Summertime* (1943; pp. 122–123) with *South Carolina Morning* (1955; pp. 100–101).

The idea of the city is generally associated in our minds with crowds of people, but in Hopper's pictures, we look for them in vain. *Summertime* is a further variation on the theme of the view from a window already discussed. One of the windows in the building depicted is closed; the other is open, admitting a breeze that blows the curtain inwards. This time the viewer's gaze is prevented not only from looking outside, but from looking inside as well. The same motif is varied in the treatment of the figure. The white dress is almost transparent, clearly revealing the forms of the woman's body; even the color of her skin shines through. Yet as in *Morning in a City*, painted the following year (1944; p. 51), there is little sensuality involved, despite the existence of conditions conducive to it. The contrast between concealing and revealing, for instance, which other artists might employ to evoke anything from subtle eroticism to overt sexuality, is treated by Hopper as a matter of course. He remains no less emotionally detached in this regard than in any other. The compositional interrelationships are nevertheless extremely subtle, as in the correspondence between the fluttering curtain and the dress, a visual link counterpointed by the obscuring function of the curtain as against the revealing nature of the dress. As in the painting *Morning in a City*, a transposition is detectable here from religious concerns in the widest sense to concrete, tangible, secular things. The image is linked with the city in the

$10\frac{1}{4} \times 6\frac{3}{4} = 65 \times 93$ 6 *Edward Hopper*

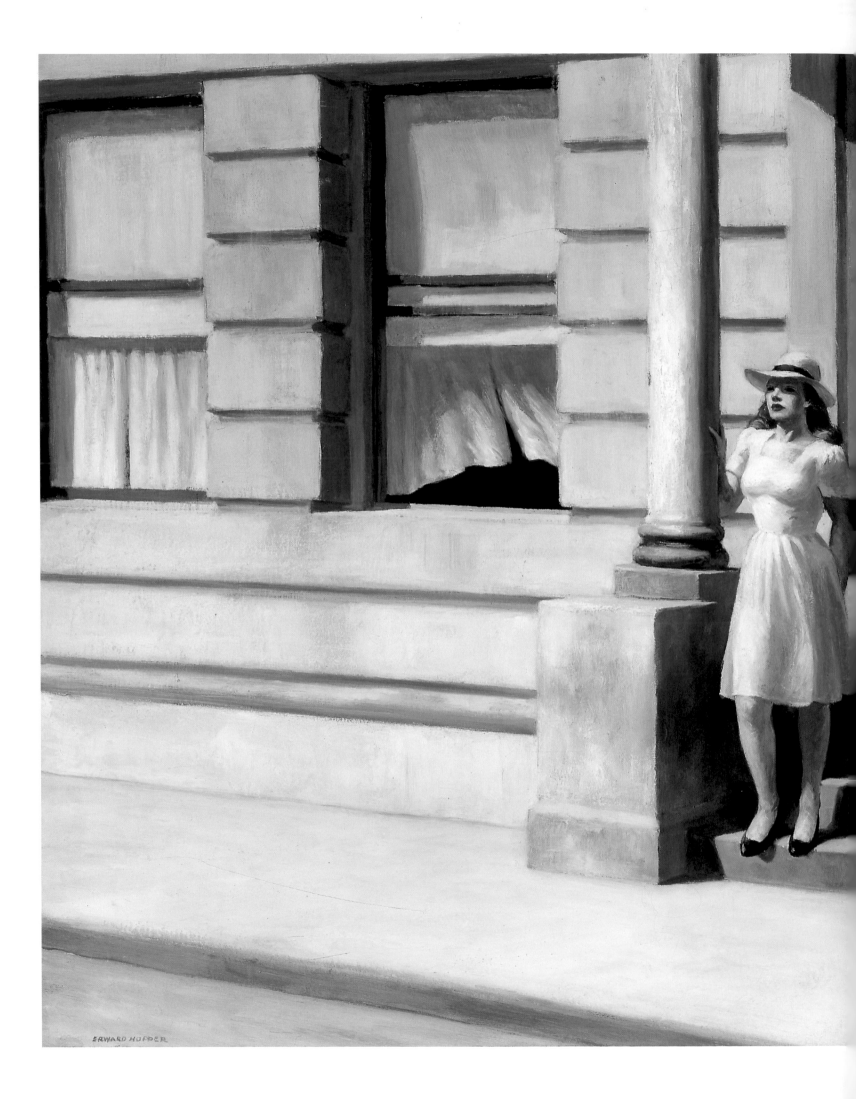

sense that the secularization Hopper envisaged occurs largely in just such urban situations. Might this indicate a certain moralizing tendency on Hopper's part?

In 1939, a group of city planners commissioned a documentary film based on Lewis Mumford's book *The Culture of Cities*. Entitled *The City*, the film propagated the advantages of the garden city over the metropolis: "In the service of this ideology, *The City* unfolds a black and white rhetoric that purposely exaggerates the contrasts," noted a latter-day reviewer. "Here, the sharp, geometric lines and angles of skyscrapers, factory buildings, and street prospects; there, the gentle natural curves of country hills. Pond, millwheel, and brook: accompanied by hymnal melodies, the sun-suffused idyll of New England rises before our eyes."[4]

New England was the cradle of American Puritanism. In his knowledgeable and amusing study *The American People*, Briton Geoffrey Gorer described New England in the seventeenth and eighteenth centuries, making a point that retained its cogency even in Hopper's day. Forsaking the good life placed high demands on the Puritans, Gorer noted, but as long as they obeyed the laws of God and man the integrity of the individual was respected, and certain idiosyncracies and eccentricities of character were permitted, even appreciated.[5] The New England soil was meager, and talent, understanding, and skill were necessary to earn a living from it. New Englanders turned the improvements of the Industrial Revolution rapidly to account, and played a key role in American industrial development. Gradually, however, New England was overtaken by other areas of the country. While the descendants of the Puritans and intellectuals still dominated good East Coast society, had an influence in the universities, and set the tone in small towns and villages, by the time Gorer came to publish his study, in 1948, they no longer held sway over politics and education in their own big cities.[6]

Summertime (pp. 122–123) might be described as the secular successor to *New York Pavements* (1924; p. 125). The situation is similar, if depicted from the opposite angle and from a lower vantage point. While the lighting and color in *Summertime* serve to emphasize the motif of the translucent dress, the illumination in *New York Pavements* is bright but diffuse, casting no sharp shadows. A nun is in the process of pushing a baby carriage from left to right, past the entrance to a building. Again, one window is closed and another open, with a curtain fluttering inwards. The nun's headdress is blown by the wind as well, emphasizing her direction of movement. The figure is closely cropped by the canvas edge, which underscores the momentary nature of the scene. While in the painting *Summertime*, the later of the two pictures, the wind helps to emphasize the contours of the woman's body, here its effect on the nun's voluminous habit only serves to make her look even more demure. Very rarely in Hopper's œuvre do we find the touch of humor seen here. On the whole, the picture represents the city as a rather dreary place, in con-

New York Pavements, 1924
Oil on canvas, 61 x 73.7 cm
Norfolk (VA), The Chrysler Museum, Gift of
Walter P. Chrysler Jr., 83.591

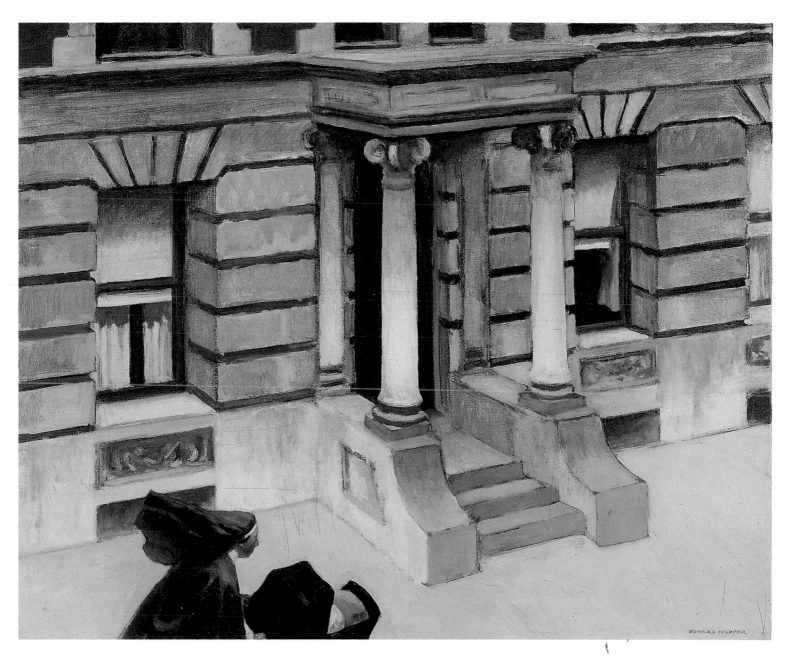

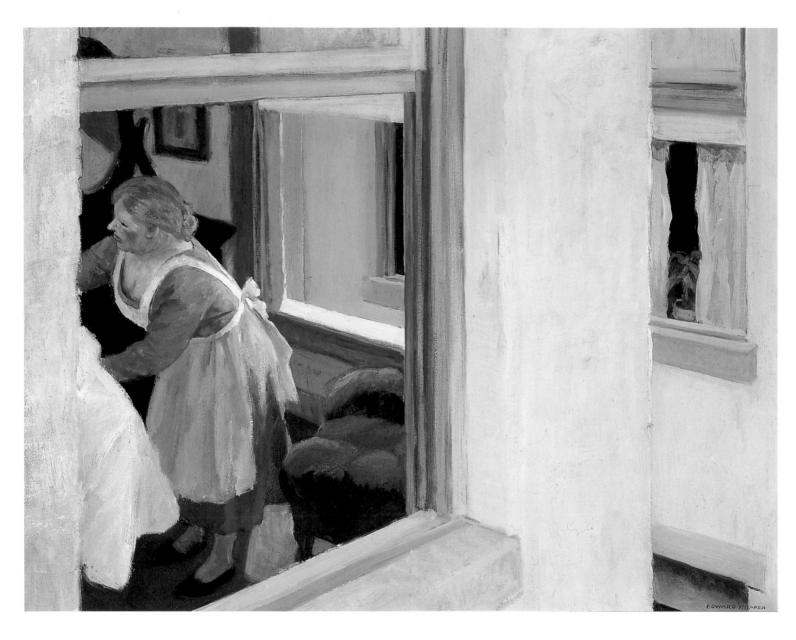

Apartment Houses, 1923
Oil on canvas, 61 x 73.5 cm
Philadelphia (PA), Courtesy of the Pennsylvania
Academy of the Fine Arts, John Lambert Fund

The unusual vantage point is not so typical of life
as it is of the cinema. As so often, Hopper puts us
in the position of voyeur, although there is not
much to see – just a housewife or maid going about
her daily chores. Hopper lends dignity to a slice
of life, or, in film jargon, to a still.

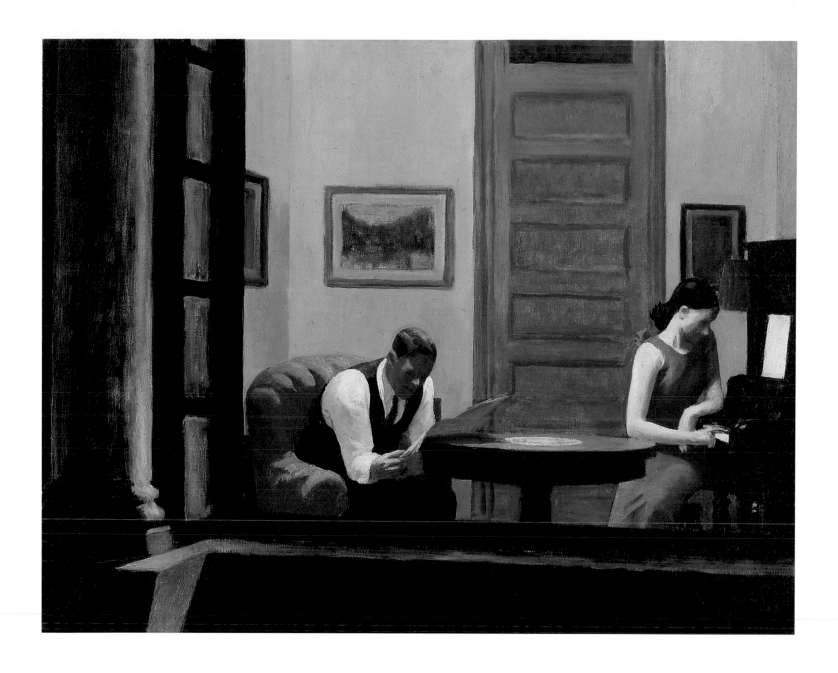

Room in New York, 1932
Oil on canvas, 73.7 x 91.4 cm
Lincoln (NE), UNL-F.M. Hall Collection,
Sheldon Memorial Art Gallery, University
of Nebraska-Lincoln, 1936.H-166

The influence on human relationships Hopper attributes to the city is not exactly propitious. As familiar and commonplace as the scene may appear, it has something oppressive about it. This results from a sense of ennui, which Hopper depicts in the form of a modern allegory.

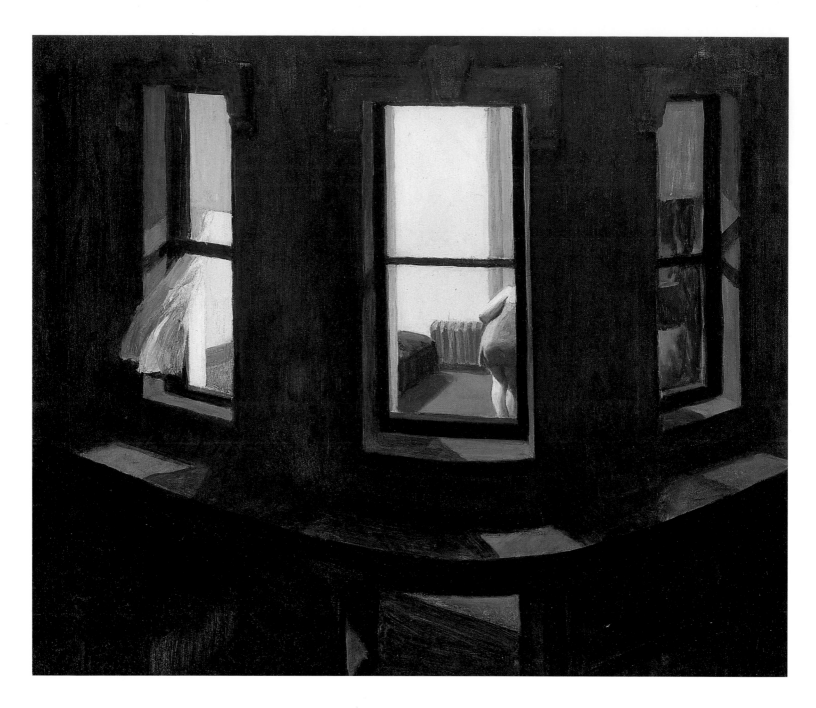

Night Windows, 1928
Oil on canvas, 73.7 x 86.4 cm
New York (NY), The Museum of Modern Art.
Gift of John Hay Whitney

The illuminated interior and the curtain flutter-
ing out the window imply that the events in the
picture are playing themselves out inside, but
what exactly they are, Hopper declines to tell us.
As so often, he leaves us to draw inferences from
fragmentary information.

trast to the somewhat more lascivious, bold character of the scene in *Summertime*.

Hopper's paintings often create the impression that he found the city not particularly conducive to human relationships, especially those between men and women. Let us take only two outstanding examples: *Room in New York* (1932; p. 127) and *Summer in the City* (1949; not illustrated). Although Hopper's figures usually appear mutually isolated, *Summer in the City* strikes a note of extreme tristesse. Not only does the relationship between the two protagonists seem disturbed, but their distress and despair are linked to the city by means of a generalized description of the urban ambience itself. Two windows provide a glimpse of apartment buildings, anonymous, faceless structures probably very like the one in which the scene takes place. By inviting us into an apartment that is entirely empty except for the bed, Hopper involves us as viewers in the drama. The man lying on his stomach with his head pressed into the pillow is naked; the woman, seated on the bed in a red summer dress, stares vacantly at the floor.

In Hopper's paintings, atmosphere and mood are rarely evoked by means of facial expression, but by the physical attitudes of the figures or

Sunlight on Brownstones, 1956
Oil on canvas, 75.6 x 101 cm
Wichita (KS), Wichita Art Museum, The Roland
P. Murdock Collection

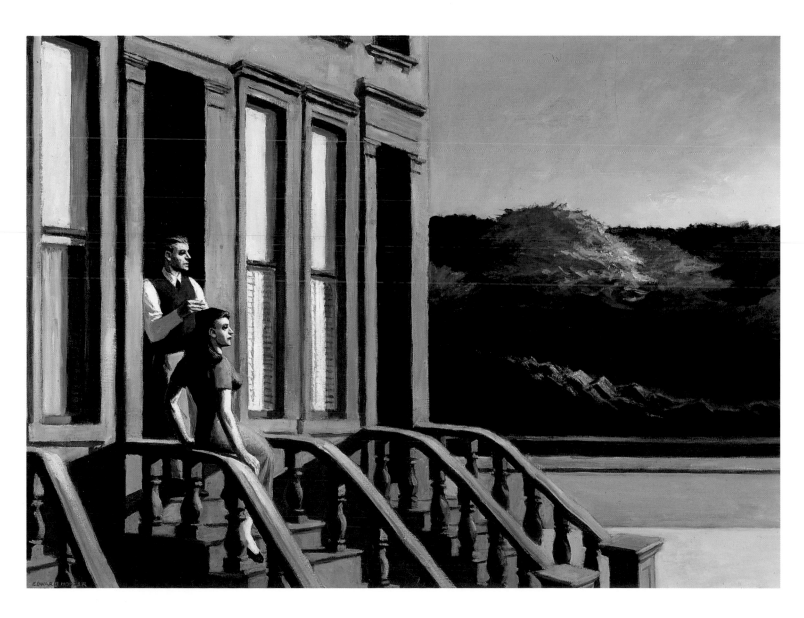

Walker Evans
Main Street Architecture, Selma, Alabama,
1935
Bromide, 21.6 x 26.6 cm
New York (NY), Romana Javitz Collection,
Miriam and Ira D. Wallach Divison of Art,
Prints and Photographs; The New York Public
Library; Astor, Lenox and Tilden Foundations

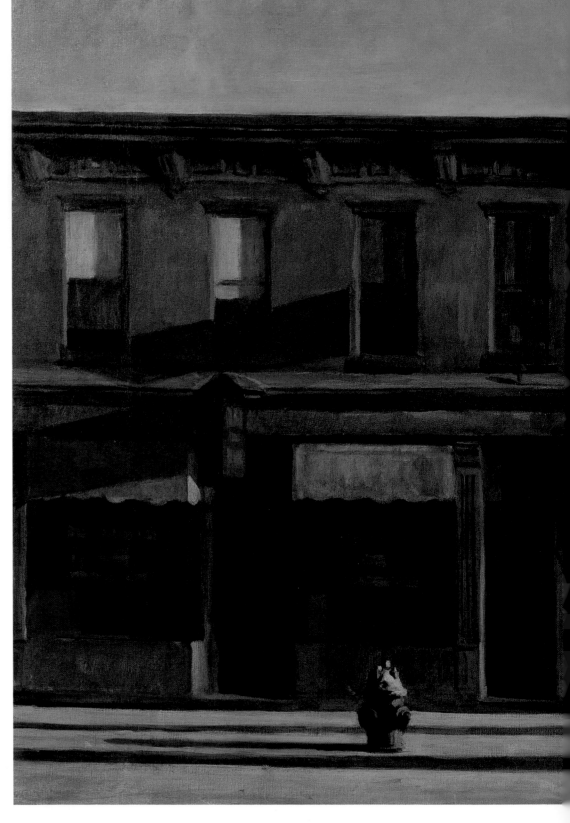

Early Sunday Morning, 1939
Oil on canvas, 88.9 x 152.4 cm
New York (NY), Collection of Whitney Museum
of American Art. Purchase with funds from Ger-
trude Vanderbilt Whitney 31.426

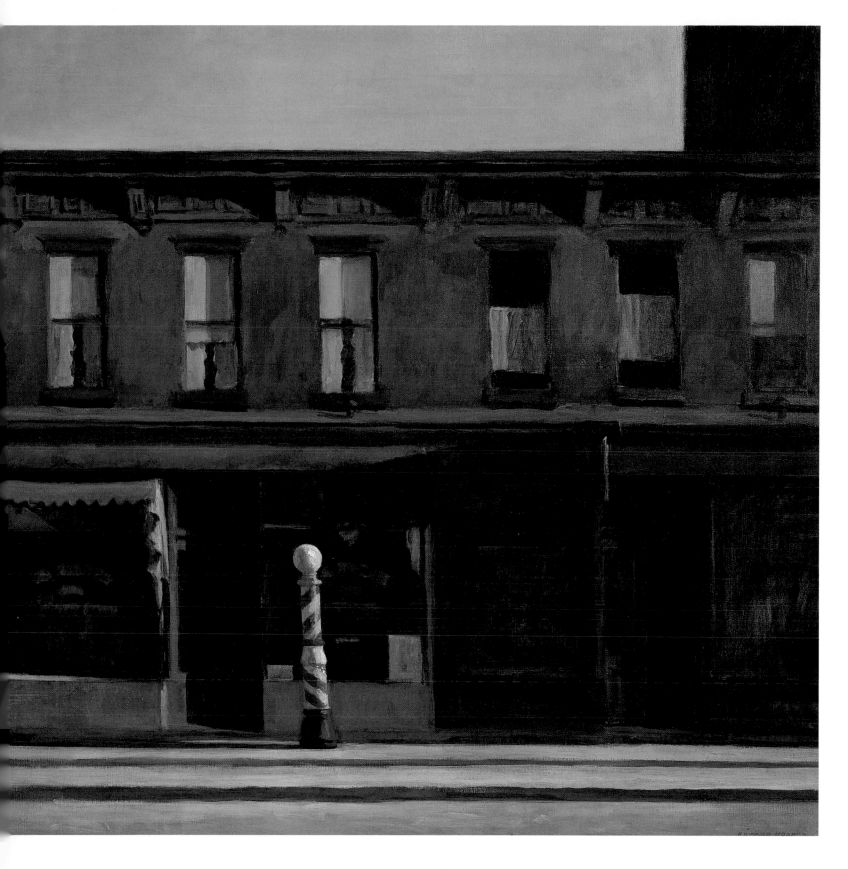

The extremely long horizontal format of the picture suggests a camera panning along the storefronts. The section Hopper depicts has no real beginning or end, with the dominant hori- zontals punctuated but not interrupted by verti- cals. The unreal character of this stage-set façade is increased by the long shadows cast by the low morning sun.

by the ambience itself. The human face – Hopper did very few portraits, if somewhat more self-portraits – plays little role in his depictions. *Room in New York* (p. 127) provides a voyeuristic view through an apartment window. We see a man sitting in an easy chair, bending over his newspaper. At the right, a woman is about to strike a note on the piano. Resting her left arm on its edge, she gazes musingly at the keys. There is an apparent reference here to Degas' *Bad Mood (Bouderie)*, although Hopper has reinterpreted the scene, which is suffused not so much with discord as with sheer ennui. "Ennui is what we feel when we do not know what we are waiting for," remarked Walter Benjamin. "Knowing or thinking that we know is almost always nothing but a reflection of our shallowness or muddleheadedness."[7]

If the faces of Hopper's figures are usually generalized, interchangeable, but nevertheless recognizably individual, those of the couple in *Room in New York* are blurred and simplified almost to the point of abstraction. Gerd Mattenklott, a literary historian, has remarked the "fading" or levelling of character that is one of the effects of city life. Focussing on males in "the prime of life," like the man in Hopper's picture, Mattenklott describes this phase as "the most vital, achieving, and socially

Drug Store, 1927
Oil on canvas, 73.6 x 101.6 cm
Boston (MA), Courtesy, Museum of Fine Arts,
Bequest of John T. Spaulding

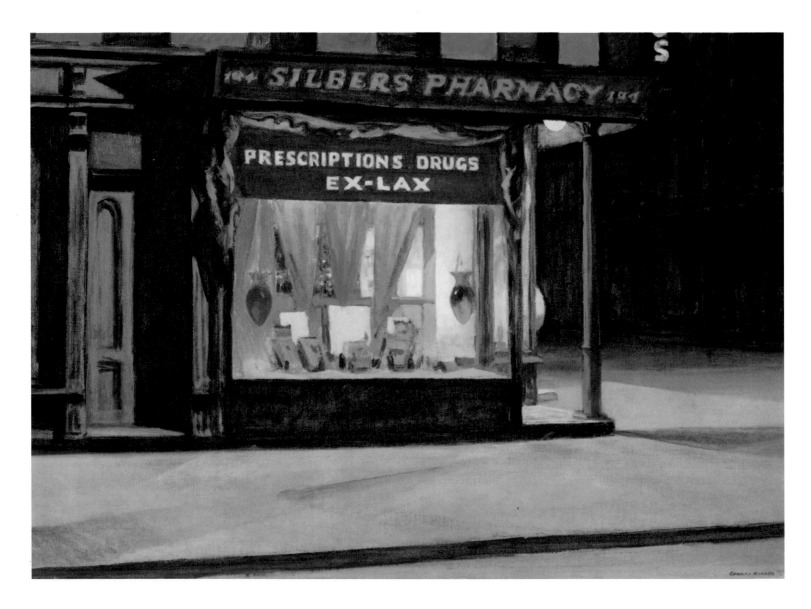

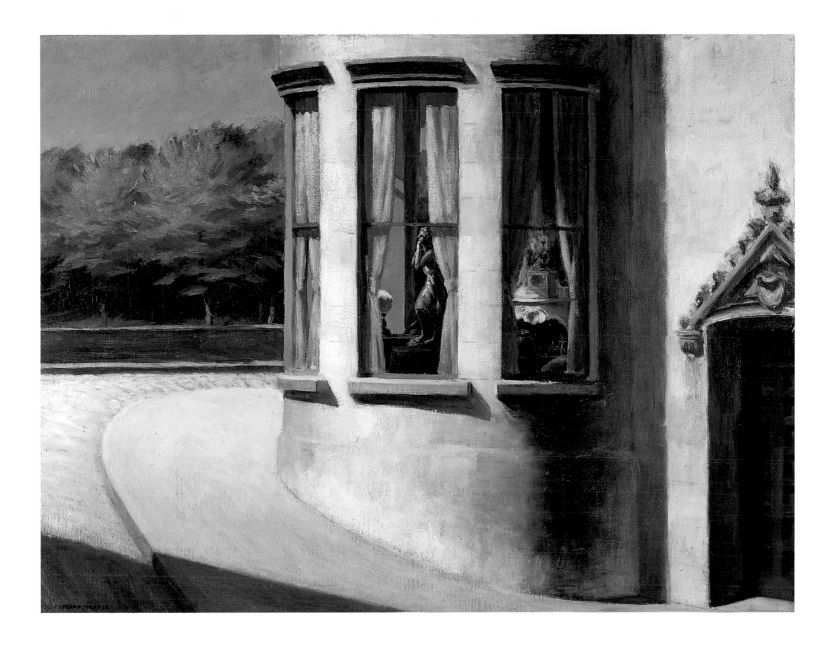

August in the City, 1945
Oil on canvas, 58.4 x 76.2 cm
West Palm Beach (FL), Collection of the
Norton Gallery of Art

determined…. An absorption by the demands of coping with day-to-day living stands at its zenith. When a man's performance reaches its peak, his character approaches zero, having the effect, at best, of an aura acquired at some earlier point during his upward trajectory. Anyone of this age who throws out his chest, brags about his independence, or gives himself airs, must either be rather obtuse or incapable of self-judgement. Middle age in the city is the period of absolute indistinction with regard to character."[8]

Hopper would not have been the pessimist he described himself as if he had depicted the country as an idyllic place, in contrast to the city. In principle, the same mechanisms are at work in both, if in less potent form in the small town than in the metropolis. Interestingly, Hopper rarely allows us to look inside specifically small-town interiors, almost invariably depicting the houses from outside. While in many urban scenes a causal relationship is established between environment and human events, the similar situations that take place in small-town settings rely less on an architectural background for their effect. They tend to be self-sufficient. Interiors evoking inward mental states or emotions, and detailed depic-

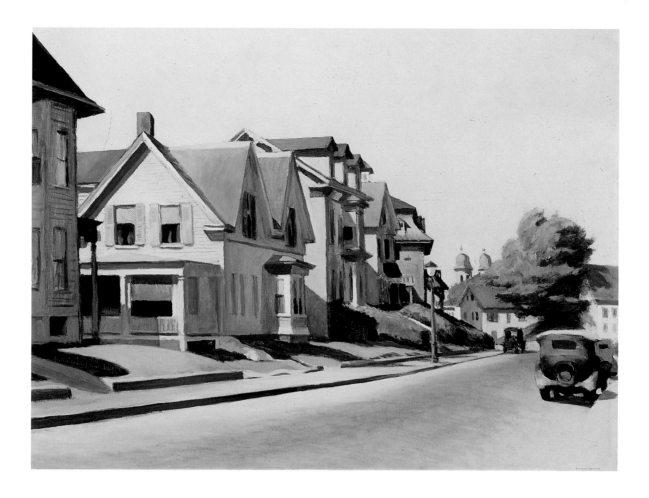

PAGE 134 TOP:
House on Pamet River, 1934
Watercolor on paper, 50.2 x 63.5 cm
Sheet 55.4 x 68.1 cm
New York (NY), Collection of Whitney Museum
of American Art. Purchase 36.20

PAGE 134 BOTTOM:
Italian Quarter, Gloucester, 1912
Oil on canvas, 59.4 x 72.4 cm
New York (NY), Collection of Whitney Museum
of American Art. Josephine N. Hopper Bequest
70.1214

Street Scene, Gloucester, 1934
Oil on canvas, 71.7 x 91.4 cm
Cincinnati (OH), Cincinnati Art Museum, The
Edwin and Virginia Irwin Memorial, 1959.49

tions of setting, play a smaller role in Hopper's rural scenes than in his urban depictions.

Sunday (1926; p. 136) shows certain compositional similarities with *New York Pavements* of two years before (p. 125). Here the houses are built of wood instead of masonry, and the figure in this case is a man in shirtsleeves smoking a cigar, seated on what appears to be a wooden sidewalk. The shop behind him is empty, and the shutters are down in the one next door. These details, by the way, need not necessarily indicate a reference to the Depression – that goods are scarce and the country in the economic doldrums. No, it is simply Sunday in a small town, and the stores are closed. Hopper did not wish to see his work interpreted in the sense of the Ash Can School and its social commitment, and there is no reason to contradict him. His message was much more universal in nature.

Sunday is the day of rest, a respite from weekday cares and the business of making a living. Some commentators have concluded that the

Sunday, 1926
Oil on canvas, 73.7 x 86.3 cm
Washington (DC), The Phillips Collection

The wooden buildings indicate that the scene is set in a small, provincial town. The title suggests a respite from the week's work. From Hopper's Protestant point of view, leisure might be an ambiguous thing, because it tempts people to give their natural impulses free rein.

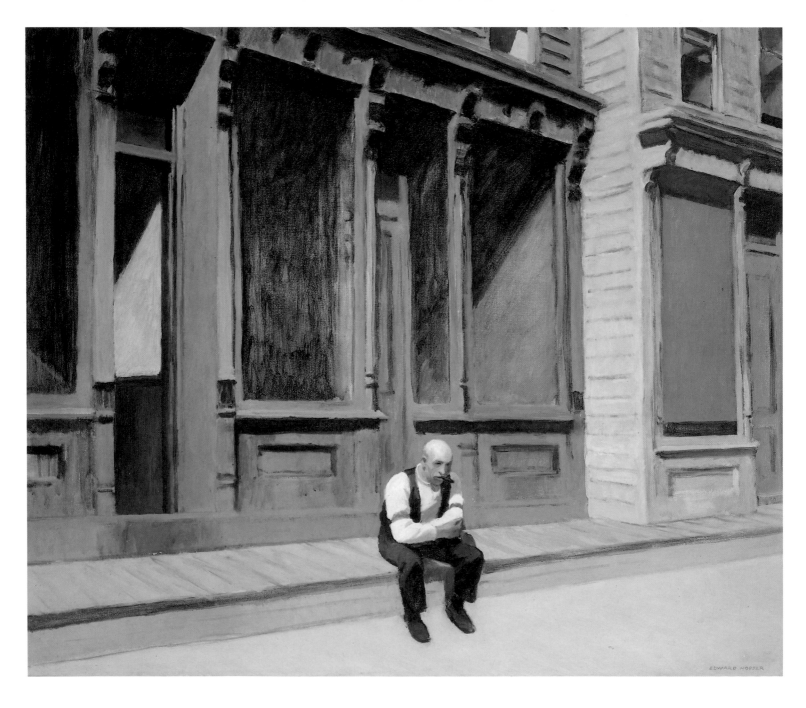

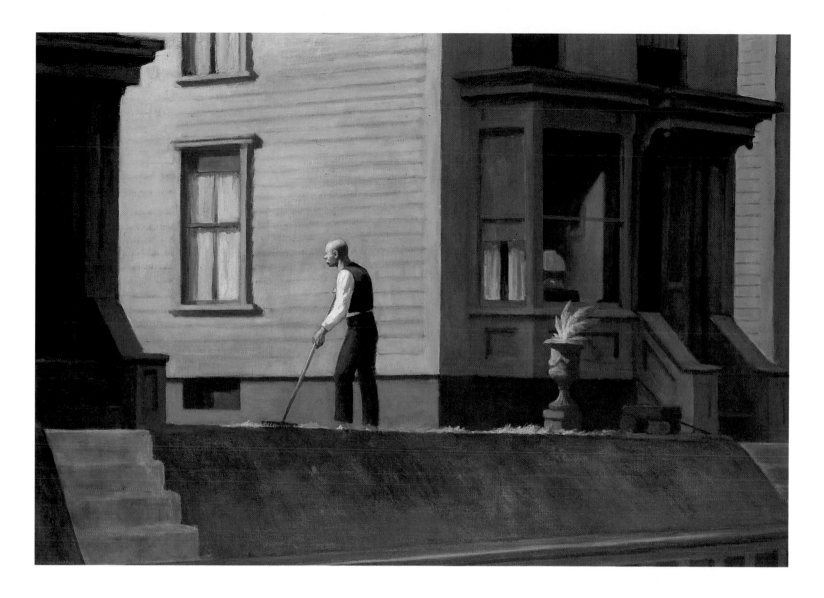

man in the picture is a man in despair, but there is really no visual evidence to corroborate this. Despair might be the later theme of *Summer in the City*, but this man is simply sitting in front of a shop, perhaps his own, in the sun. He has nothing particular to do. Once again, Hopper seems to be speculating with the viewer's expectations. To some people, the man's idleness may be irritating. Protestants of the Puritan variety, for instance, might tend to think that "when men have no necessary duties pressing on them, they give way to their natural passions, which are evil".[9]

What Hopper wrote of Charles Burchfield was also true of himself: "No mood has been so mean as to seem unworthy of interpretation; the look of an asphalt road as it lies in the broiling sun at noon, cars and locomotives lying in God-forsaken railway yards, the steaming summer rain that can fill us with such hopeless boredom… all the sweltering, tawdry life of the American small town, and behind all, the sad desolation of our suburban landscape. He derives daily stimulus from these, that others flee from or pass with indifference."[10] Hopper, like Burchfield, found his inspiration in the boredom of the small town, and he found it too in the monotony of the great city.

Pennsylvania Coal Town, 1947
Oil on canvas, 71.1 x 101.6 cm
Youngstown (OH), The Butler Institute of American Art

<u>Rooms for Tourists</u>

 30 x 48 Finished in S. Truro studio. Sept. 1945. To Rehn Gallery
 Nov. 8"
 1945
Windsor & Newton colors, flake white, linseed oil, turpentine.
Linen canvas double prime, prepared by Toinet.

 White house (gray) in black night, seen by electric street lamp (9/stage R.)
Sign "Rooms", lower shafts of door stoop, bit of railing extreme lower L. bright white.
Top of hedge under sign, bit of lawn inside hedge bright green. Lit windows yellow.
Blue black sky, side of house blue black, hedge greenish black. Dark green awnings,
green shutters, frame of screen door & little post light R. side of door blue green. Inside
room bright, case curtain pink, white window curtain blowing, bright pale yellow shades/lower
 lamps

Stephen Clark - Nov. '45. 3000
Stephen Clark. check from Rehn Gal. Ap.4", 46." 3000 - 1/3 Com. = 2000
Now owned by Griswold of Yale

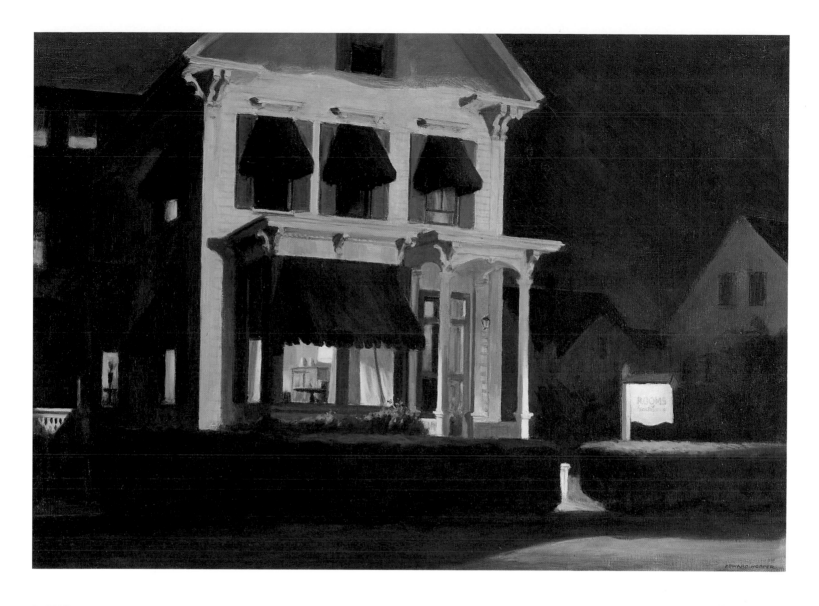

PAGE 138:

Rooms for Tourists, September 1945
Page from Edward Hopper's record book, vol.
III, p. 13. Ink and pencil on paper, 30.2 x 18.4 cm
New York (NY), Collection of Whitney Museum
of American Art. Special Collection, Library;
Gift of Lloyd Goodrich

Rooms for Tourists, 1945
Oil on canvas, 76.8 x 107 cm
New Haven (CT), Yale University Art Gallery,
Bequest of Stephen Carlton Clark, B.A. 1903.

Two factors are emphasized in this painting.
First, the viewpoint suggests that gained from a
moving car, as seen in the perspective rendering
of the house and the way the gable is cut off at
the top. Second, the house has an inviting look,
tempting the traveller with a peace and quiet not
to be found in the big city.

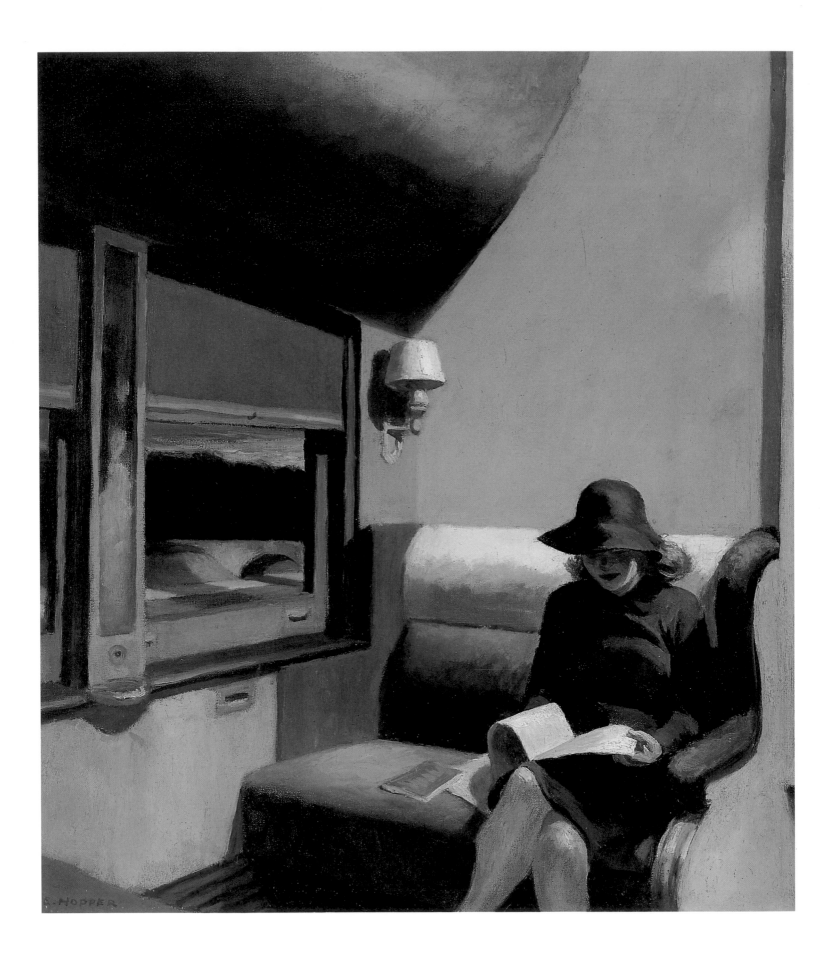

The Tyranny of Intimacy

In the mid 1970s the American sociologist Richard Sennett published a seminal study with the title *The Fall of Public Man*, where he states: "It is the generation born after World War II which has turned inward as it has liberated itself from sexual constraints; it is in this same generation that most of the physical destruction of the public domain has occurred. The thesis of this book, however, is that these blatant signs of an unbalanced personal life and empty public life have been a long time in the making. They are the results of a change that began with the fall of the *ancien régime* and the formation of a new capitalist, secular, urban culture."[1]

Edward Hopper was perhaps the one twentieth-century artist to give cogent and valid expression to the end of public life in the country where this transformation has been most evident. Sennett's book reads like a scholarly counterpart to Hopper's paintings. While Hopper may have been less conscious of the processes that helped shape his vision, he, like Sennett, certainly took both historical and contemporary realities as his point of departure. In what follows I shall give several examples of the remarkable and exciting parallels between the two men's work. Interestingly Sennett, who was born in 1943, even apparently lived for a time in Hopper's former Washington Square studio in New York.

Although he does not mention Hopper by name, Sennett's analysis of American society is immediately pertinent to the artist's concerns. "The reigning belief today," Sennett says, "is that closeness between persons is a moral good. The reigning aspiration today is to develop individual personality through experiences of closeness and warmth with others. The reigning myth today is that the evils of society can all be understood as evils of impersonality, alienation, and coldness. The sum of these three is an ideology of intimacy: social relationships of all kinds are real, believable, and authentic the closer they approach the inner psychological concerns of each person. This ideology transmutes political categories into psychological categories. This ideology of intimacy defines the humanitarian spirit of a society without gods: warmth is our god. The history of the rise and fall of public culture at the very least calls this humanitarian spirit into question."[2]

Study for *Nighthawks*, 1942
Chalk on paper, 19.7 x 35.6 cm
Collection Mr. and Mrs. R. Blum

Compartment C, Car 193, 1938
Oil on canvas, 50.8 x 45.7 cm
Armonk (NY), Collection IBM Corporation

The separation of closed, intimate interior from the world passing by outside is the true subject here. Experience no longer takes place in its simple, original form but as it were second hand, through illustrated magazines or printed matter. The impression is increased by the fact that the woman has chosen a seat away from the window.

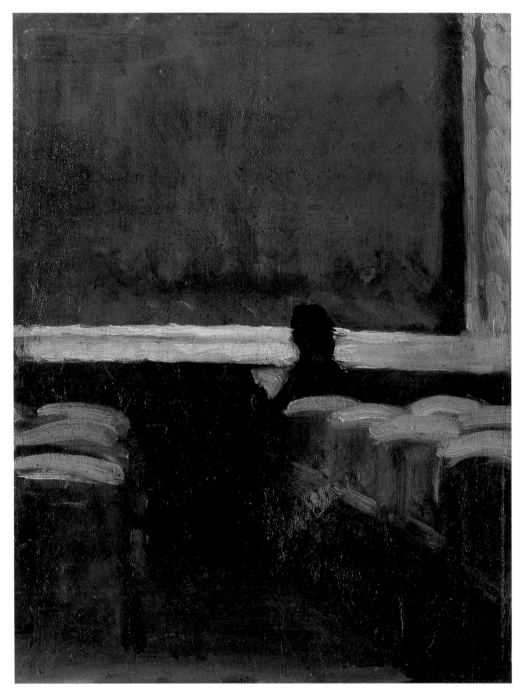

Solitary Figure in a Theatre, c. 1902–04
Oil on cardboard, 31.8 x 23.3 cm
New York (NY), Collection of Whitney Museum
of American Art. Josephine N. Hopper Bequest
70.1418

Honoré Daumier
The Drama, c. 1860
Drame
Oil on canvas, 97.5 x 90.4 cm
Munich, Neue Pinakothek

Daumier shows both the scene on the stage and
the spellbound audience. Hopper, in contrast,
shifts the happenings into the auditorium; the
stage is empty, or at any rate the curtain is down.

Now human warmth, as we have seen, was certainly not Hopper's
theme. Sennett goes on to compare society with the theater. His main
point is the way in which modern developments have led to a split be-
tween a person's self, or human essence, and his or her social behavior.
Then Sennett mentions the emergence of illusion and deception as fun-
damental problems of social life, and finally, the notion of human behav-
ior as role-playing. The same metaphor of life as a *theatrum mundi*, or
universal theater, is found in many of Hopper's paintings.

This holds most obviously for the series of works in which the stage,
or movie theater, actually appear. The theme was already anticipated by a
canvas of Hopper's student days, *Solitary Figure in a Theatre* (c. 1902–04;
p. 142). The curtain is down, and the entire scene is suffused by a homo-
geneous color that, making no distinction between stage and audito-

rium, suggests that the audience is an integral part of the scene. The very latest counterpart to this early painting is found in *Intermission* (1963; p. 146), which evidently represents a movie theater. While the *Solitary Figure* appears to be reading something – a program or a play, which brings a literary element into the picture, linking written play, stage, and viewer – the situation in *Intermission* is more complex. By depicting a pause in the show, where the curtain is drawn, Hopper transforms the auditorium itself into a stage. His oblique vantage point, and hence ours, lies outside the picture, which makes us relatively uninvolved observers. When life is compared to a theater in which men and women have their roles to play, we are at last on the verge of detecting that much-quoted "feeling" in Hopper's work. As in the case of other pictures, he and his wife even gave the figure in *Intermission* a name – Norah, they called her – and invented stories around her.

The picture in many respects recalls *Sunday* (1926; p. 136). To shed light on the two works, let us return to Sennett and his recapitulation of

New York Movie, 1939
Oil on canvas, 81.9 x 101.9 cm
New York (NY), The Museum of Modern Art.
Given Anonymously

Girlie Show, 1941
Oil on canvas, 81.3 x 96.5 cm
Private collection

This picture shows Hopper addressing the
theme of voyeurism in the most direct form.
Here the painting has indeed become a stage,
and the striptease takes place expressly for the
viewer, challenging him or her to consider the
reactions elicited by the performance.

Jean-Jacques Rousseau's critique of the big city: "Rousseau began with
the paradigm of virtue/work, vice/leisure. Obviously the big city bustles;
it has an electric energy which the sleepy everyday round of home, work,
church, home can scarcely have had in Geneva. In the middle of the *Let-
ter*, a new scale of action is introduced: frenetic coming and going, ac-
tions without meaning characterize the great city, because without the
pressures of survival, man spins crazily. In the small city, action proceeds
at a slower pace; this permits leisure to reflect on the true nature of one's
actions and self."[3]

This brings us back to the etching *Evening Wind* (1921; p. 41). With
reference to de Tocqueville, we mentioned Hopper's belief that the cares
and worries of daily life prevent people from reflecting on their situation.
Now, Rousseau views the city as a theater, its inhabitants as actors on the
stage, and public life as a performance. The actors do not actually feel
emotions, but feign them. In this sense, the feelings seemingly triggered

by Hopper's paintings are pure fiction; neither the emotions of the protagonists nor those of the viewer who sees them are real. Denis Diderot, the eighteenth-century writer and philosopher, once inquired into the difference between tears shed over a tragic event and tears elicited by reading a sad story. He concluded that crying in real life was directly related to the cause, while crying over a work of art was a gradual and, above all, a conscious reaction.

One striking feature of Hopper's paintings is their strangely vacant appearance, seemingly devoid of expression. With reference to Sennett, this might be explained as a result of a heightened introspection on the one hand, and a decrease in social empathy on the other. The two phenomena are linked, because privacy and intimacy increase in relation to a decline in the public sphere. In Hopper's *Intermission* (p. 146) the public space of the movie theater has indeed become a private space. Its function of showing moving pictures has been abrogated by the closed curtain, the exit door is shut, the room sealed to the outside. And as the empty seats indicate, this privateness might potentially be retained even in the presence of a crowd.

First Row Orchestra, 1951
Oil on canvas, 79.1 x 101.9 cm
Washington (DC), Hirshhorn Museum and
Sculpture Garden, Smithsonian Institution, Gift
of the Joseph H. Hirshhorn Foundation, 1966

Mary Cassatt
At the Opera, 1879
Oil on canvas, 80 x 64.8 cm
Boston (MA) Courtesy, Museum of Fine Arts,
The Hayden Collection

Like other Impressionists, such as Degas, Cassatt treats the spectator's gaze as the theme of the painting. Hopper's achievement consisted in expanding the Impressionist viewpoint by making us, as viewers, the spectators of the scene, and tranforming the painting itself into a stage set.

This holds in a similar way for Hopper's depictions of cafeterias and restaurants. Such subjects in Impressionism, as we know, were intended among other things to evoke the isolation of individuals in the big city – recall Degas' *The Absinth Drinker* (p. 150, right) or Manet's *Plum Brandy* (p. 150, left). Hopper took up the motif and treated it in terms of his own, American environment. *New York Restaurant* (c. 1922; p. 153) still shows an impressionistic, rather arbitrarily cropped view, while the later *Automat* (1927; p. 151) concentrates on a single person. But in neither case is Hopper's theme necessarily individual loneliness in the lonely crowd, as is so frequently assumed, for as he himself said, "The loneliness thing is overdone."[4] Again the theme is more general, alluding to the decline of the public sphere. Although the places depicted are nominally public, they do not create the impression of actually being so. The woman seated in the *Automat*, a place of social contact, appears entirely turned inward upon herself, and her isolation is increased by a suggestion of hurry and unrest, conveyed by the coat and glove she still has on.

Sunlight in a Cafeteria (1958; p. 160), done thirty-one years later, seems even more artificial in character, evoking a communication that consists solely of desultory, vague gestures. A plate glass window separates the room from the street, on the opposite side of which the storefronts and first-floor windows of a building are visible. The contrast between brightly lit window and shadowed façade is strongly emphasized. The woman toys dreamily with some object in her hands, as the man turns, not so much towards her as towards the street. The two people occupy the same room, but have no relationship to one another. Their gestures seem artificial, as if expressing emotion at second hand.

Gesture, emotion, expression: these are the true domain of art. In *Nighthawks* (1942; pp. 148–49), one of Hopper's most famous and widely reproduced paintings, we find the same basic situation as in *Sunlight in a Cafeteria*. Except this time we are not looking through a window into the

Intermission, 1963
Oil on canvas, 101.6 x 152.4 cm
Mr. and Mrs. R. Crosby Kemper

In this, one of the four last pictures he painted, Hopper once again underscored his principal concern. Rather than spectacular moments or events in life, he was interested in the moments that preceded or followed them, and that normally go unremarked.

street outside, but vice versa, from the street through the window of a cheap all-night restaurant. The interior revealed to view has something of a showcase or aquarium about it, which increases the model-like effect of the sccnc. The expanse of glass in fact plays a dominant role in *Nighthawks*. Despite its transparency, the window separates inside from out, functioning both as a visual link and a physical barrier. It also perfectly illustrates what Hopper meant when he remarked how difficult it was to paint inside and outside at the same time. As Sennett notes, "walls almost entirely of glass, framed with thin steel supports, allow the inside and the outside of a building to be dissolved to the least point of differentiation."[5]

The glass of the restaurant window finds a correspondence in the display windows of the storefronts. Those towards the right shimmer darkly through the back restaurant window, suggesting inside and outside simultaneously. A further opposition is seen between the transparency of the glass and the half-closed shutters of the first-floor windows. Hopper has rendered the interior with great attention to detail, painstakingly delineating

Two on the Aisle, 1927
Oil on canvas, 101.9 x 122.6 cm
Toledo (OH), The Toledo Museum of Art, Purchased with funds from the Libbey Endowment, Gift of Edward Drummond Libbey

PAGES 148–149:
Nighthawks, 1942
Oil on canvas, 76.2 x 144 cm
Chicago (IL), The Art Institute of Chicago, Friends of American Art Collection, 1942.51

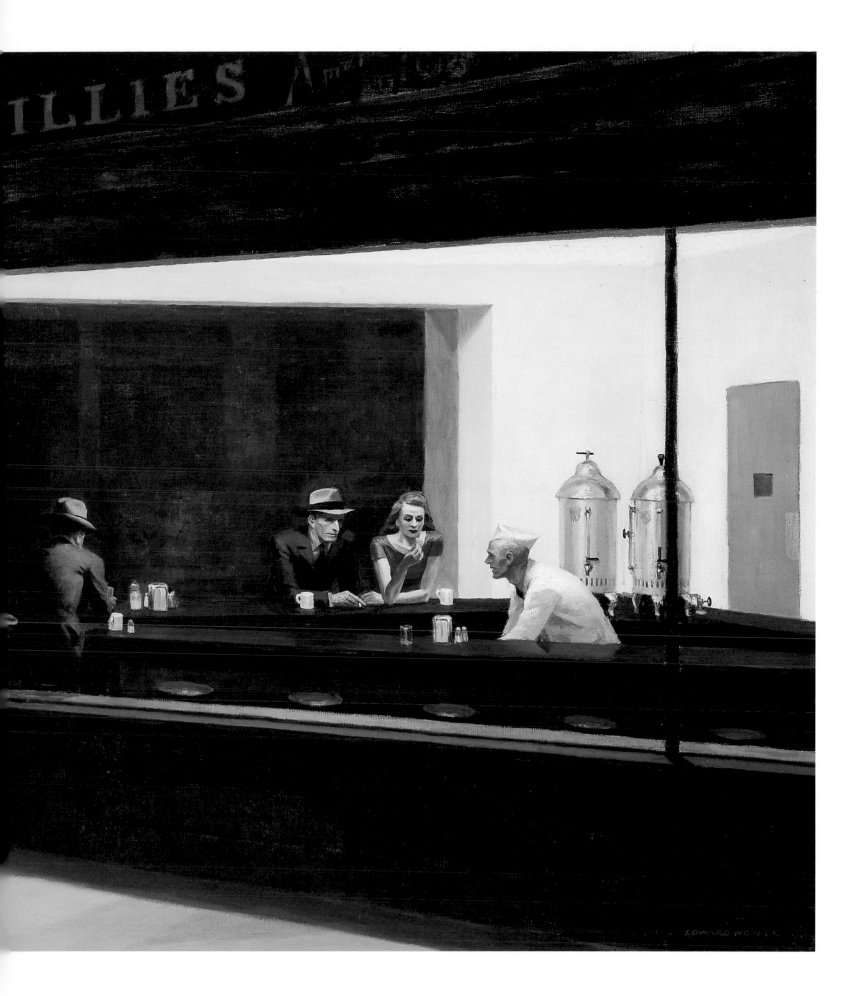

salt and pepper shakers, napkin dispensers, cups, and coffee machines. The arrangement recalls a lab set-up, spread out for perusal by an observer, whether passerby or viewer. Again we are presented with no story-line or action, merely a situation, a slice of life. The people in the scene seem isolated from each other, as well as from the outside world. There is no direct communication taking place between the couple inside their glass cage.

A related compositional scheme is found in *New York Office* (1962; p. 159), particularly as regards the contrast between the transparent office window and the dark, anonymous window apertures of the apartment house. One reason for the demise of the public realm, says Sennett, is that large windows make rooms visually transparent while still erecting a barrier to the outside – what he calls "the paradox of isolation in the midst of visibility"[6]. Hopper evokes privacy, even anonymity, by means of the apartment house windows, and contrasts these with the transparency of the public sphere of the office, which is illuminated both from outside and from within, while the building opposite lies in shadow. The female figure, in turn, is comparable to the figure in *Summertime* (pp. 122–23). Her dress, too, simultaneously reveals and conceals, and reveals precisely because it conceals, as in the way its material clings to the woman's buttocks. By means of a clever device Hopper transposes this message from the larger context into a detail, the opening of the letter, which echoes the revelatory character of both the dress and the plate glass window.

Senett notes that "the design idea of the permeable wall is applied by many architects within their buildings as well as on the skin. Visual barriers are destroyed by doing away with office walls, so that whole floors will become one vast open space, or there will be a set of private offices on the perimeter with a large open area within. This destruction of walls, office planners are quick to say, increases office efficiency, because when

LEFT:
Edouard Manet
Plum Brandy, c. 1877
La prune
Oil on canvas, 73.6 x 50.2 cm
Washington (DC), National Gallery of Art,
Collection of Mr. and Mrs. Paul Mellon

The influence of Impressionism on Hopper is evident from many of his paintings. He derived the theme of the solitary person in a restaurant from Manet and Degas, transposing it into his own American environment.

RIGHT:
Edgar Degas:
The Absinth Drinker, 1875–76
L'absinthe
Oil on canvas, 92 x 68 cm
Paris, Musée d'Orsay

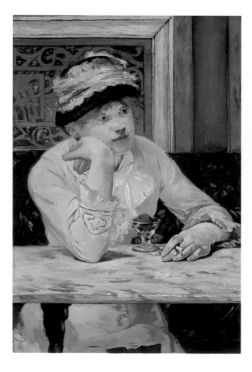 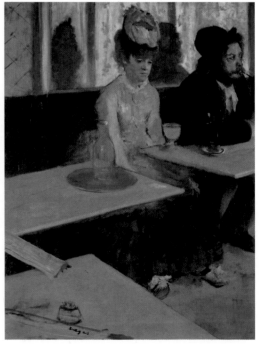

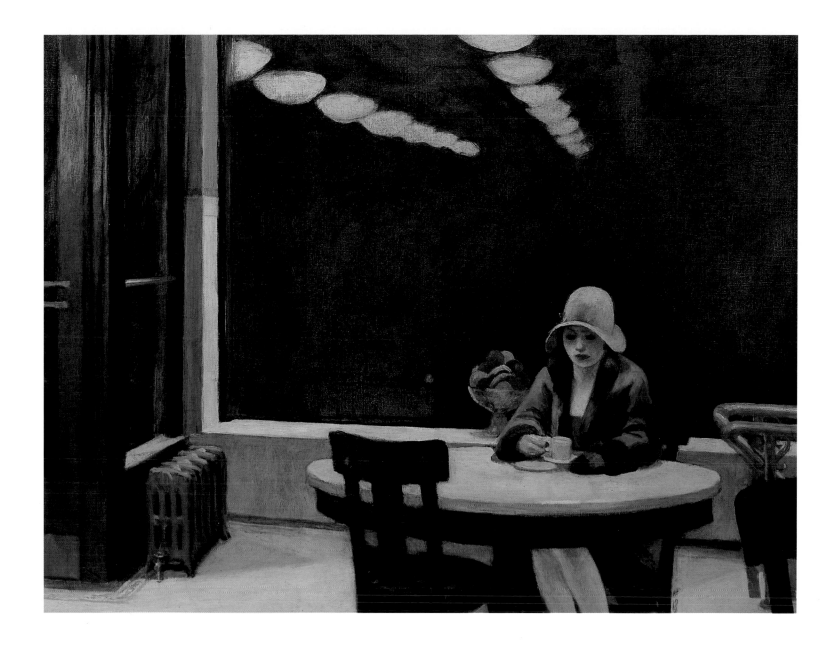

Automat, 1927
Oil on canvas, 72.4 x 91.4 cm
Des Moines (IA), Des Moines Art Center Permanent Collection, 1958.2

people are all day long visually exposed to one another, they are less likely to gossip and chat, more likely to keep to themselves. When everyone has each other under surveillance, sociability decreases, silence being the only form of protection."[7]

In Hopper's *Office at Night* (1940; p. 163) this total transparency is still a thing of the future. A woman standing at a filing cabinet turns towards a man seated at his desk, engrossed in work. Here again, the curves of the woman's body are strongly emphasized, especially by means of the extreme torsion of her pose. The illumination serves to increase the mood of suspense. The desk lamp is on, and additional light impinges from outside, casting a bright patch on the wall that extends between the figures. This visual link anticipates a potential physical link between the two, which, however, is only vaguely suggested by their demeanor. The way the woman turns towards the man, who still seems uninvolved, and the prominence of her buttocks and breasts, convey a subliminal sexual tension.

A breeze is blowing in through the window. But as a comparison with the earlier *Evening Wind* indicates (p. 41), the significance of this element

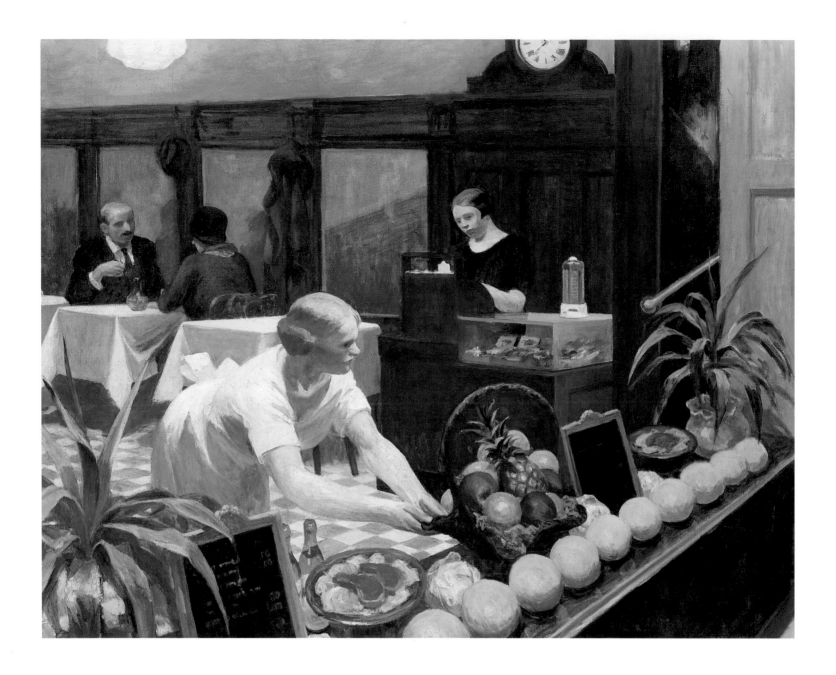

Tables for Ladies, 1930
Oil on canvas, 122.5 x 153 cm
New York (NY), The Metropolitan Museum
of Art, George A. Hearn Fund, 1931 (31.62)

That our vantage point as viewers lies outside the restaurant window may not be apparent on first glance. As in *Nighthawks*, the scene seems to take place in a showcase, isolated and yet revealed to view. Glass is a motif that permits Hopper to play on the interpenetration of interior and exterior space in the painting medium.

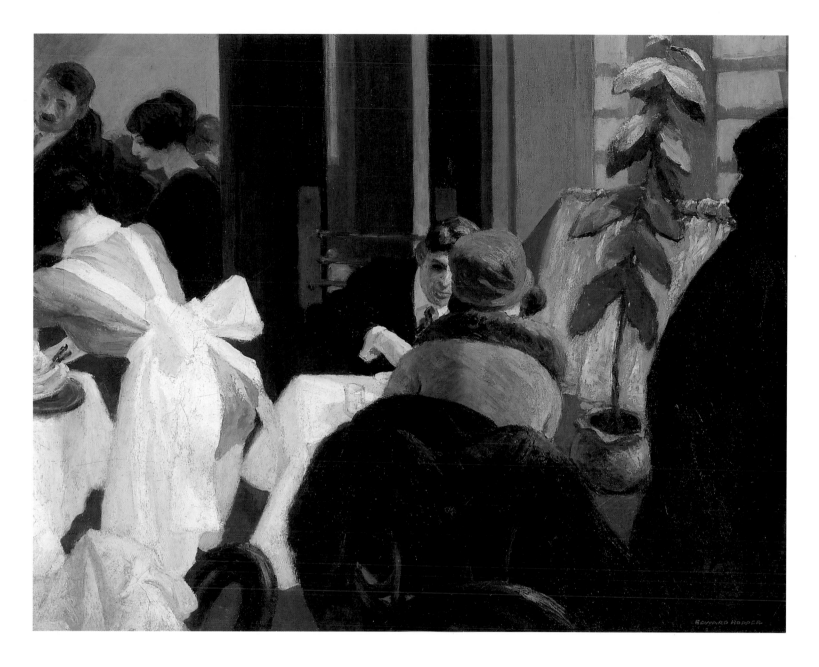

New York Restaurant, c. 1922
Oil on canvas, 61 x 76.2 cm
Muskegon (MI), Muskegon Museum of Art,
Hackley Picture Fund

The number of figures here, and their move-
ment, are rather untypical of Hopper's art.
Typical, however, is the lack of communica-
tion among them. As in other paintings, the
scene is suffused with an unusual stillness,
perhaps as a result of the extreme cropping,
which produces the impression of a subjec-
tive, introverted point of view.

has changed in *Office at Night*. Here, a private, intimate moment has been transposed into the public realm, into the sphere of visibility – a fact we tend to overlook from our vantage point fifty years distant in time. "In a society where intimate feeling is an all-purpose standard of reality, experience is organized in two forms which lead to this unintended destructiveness [i.e. the robbing of sexuality of its social aspect; I.K.]. In such a society, the basic human energies of narcissism are so mobilized that they enter systematically and perversely into human relationships. In such a society, the test of whether people are being authentic and 'straight' with each other is a peculiar standard market exchange in intimate relations."[8]

While in *Office at Night* (p. 163) the personal interaction takes place within the picture, in *New York Office* (p. 159) it takes place between female figure and viewer. Hopper puts us into the voyeur's role in various ways, sometimes including us in the event depicted, but more often letting us look on from outside. Besides his paintings of workplaces – of which an outstanding example, in terms of unusually large format alone, is *The Barber Shop* (1931; p. 154) – Hopper devoted an extensive series of paintings to leisure activities. And here, too, one finds various combi-

The Barber Shop, 1931
Oil on canvas, 152.4 x 198.1 cm
Purchase (NY), Collection of Neuberger
Museum, State University of New York at
Purchase, gift of Roy R. Neuberger

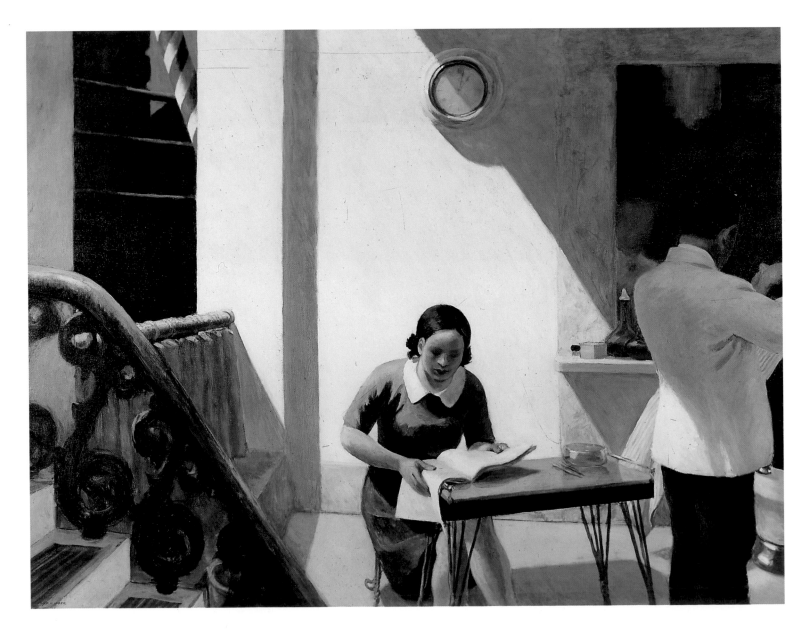

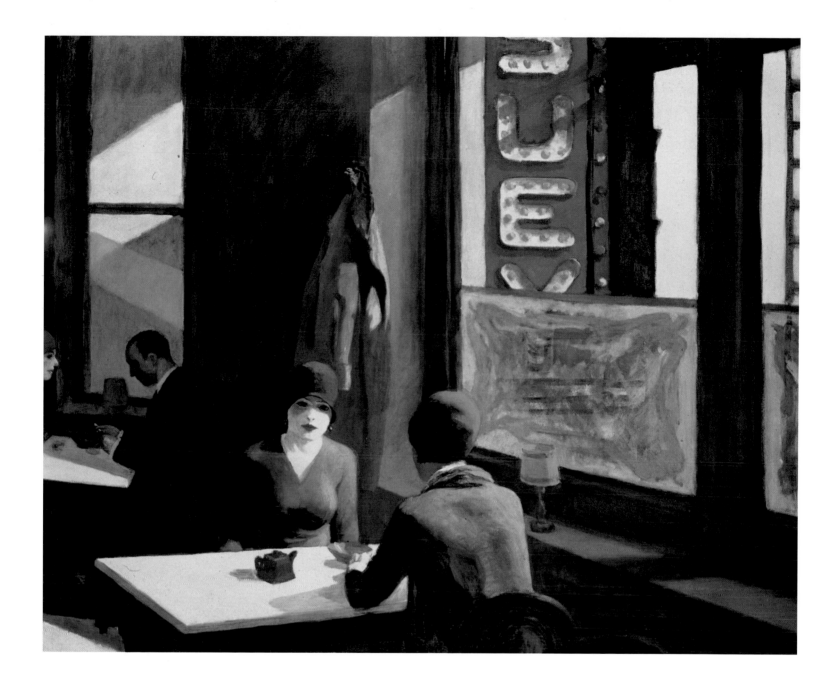

Chop Suey, 1929
Oil on canvas, 81.6 x 96.8 cm
From the Collection of Mr. and Mrs. Barney A.
Ebsworth

nations of the artist's characteristic and invariable pictorial elements and principles. *Summer Evening*, for instance (1947; pp. 156–157), reverses the role of male and female seen in *Office at Night*, and the woman's light, clinging dress is by now a familiar attribute.

What distinction did Hopper draw between work and leisure? Comparing *Office at Night* with *Summer Evening*, it would appear that he made little distinction at all. The relationship between the two people in the office, implicit but quite obvious to the viewer, corresponds to the explicit relationship of the couple on the lighted veranda. The gaps in the curtains and the open window establish a visual link with the woman's pose and attire, which, again, simultaneously conceal and reveal. And the illumination, finally, transforms what is actually an intimate scene into a public one. "To the extent, for instance, that a person feels he must protect himself from the surveillance of others in the public realm by silent isolation, he compensates by baring himself to those with whom he wants to make contact,"[9] writes Sennett. In Hopper's eyes, the results were apparently

Summer Evening, 1947
Oil on canvas, 76.2 x 106.7 cm
Private collection

Thanks to the lighting, the outside space of the
veranda is transformed into an intimate place.
Factors familiar from other paintings play a role
here as well – an interplay between concealing
and revealing, the emergence of sexual tension.
The curtains figure as a formal echo of the
woman's attire.

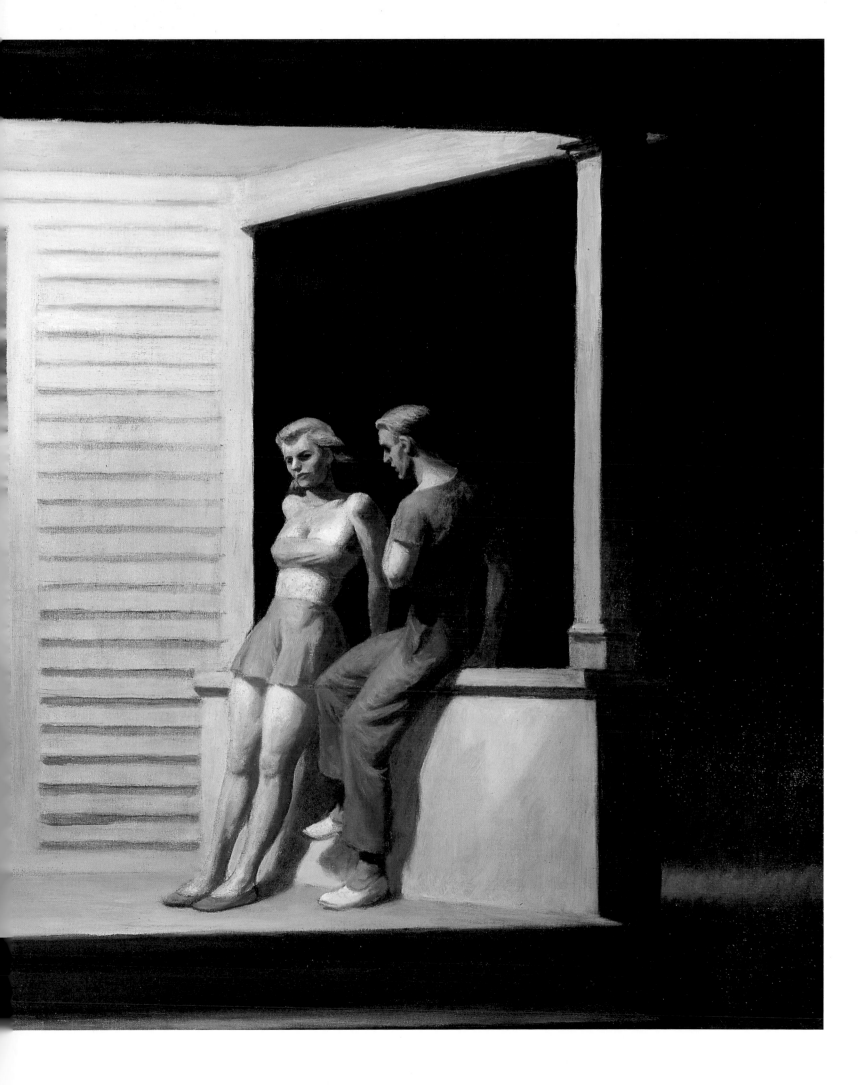

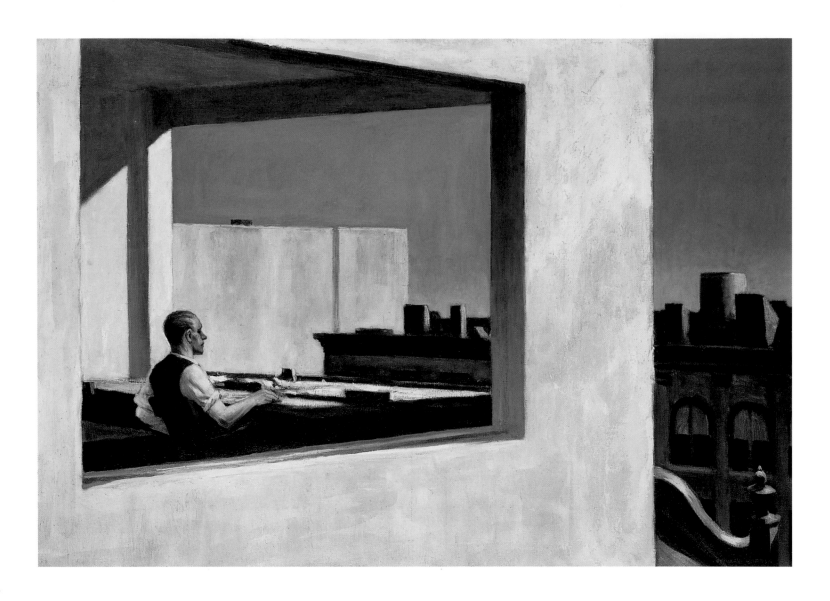

Office in a Small City, 1953
Oil on canvas, 71.7 x 101.6 cm
New York (NY), The Metropolitan Museum
of Art, George A Hearn Fund, 1953 (53.183)

As so frequently, the title here is purely suggest-
ive, because the buildings in the painting
might just as well be in a large city as a small
one. The point of view is again artificial, like
that of a camera installed on a crane outside
an upper floor of the building. The man at the
desk gazes through one of two large windows
in the concrete wall towards a building whose
color and elaborate design form a strong
contrast to the modern office structure.

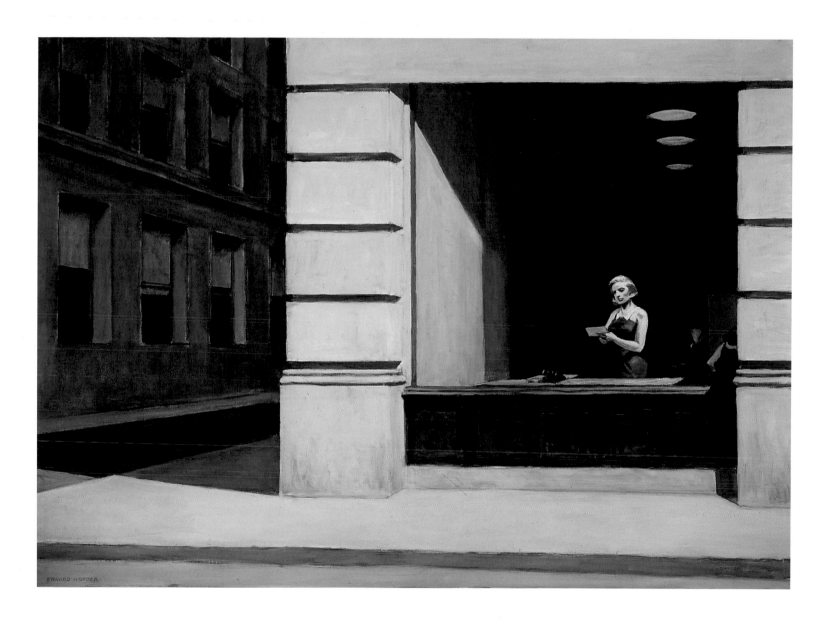

New York Office, 1962
Oil on canvas, 101.6 x 139.7 cm
Montgomery (AL), Collection of the Montgomery
Museum of Fine Arts, The Blount Collection

Here Hopper describes a phenomenon which
the American sociologist Richard Sennett has
termed "the paradox of isolation in the midst
of visibility". While the office space is visu-
ally transparent, the plate glass still repre-
sents a barrier that custom leads us to respect.
Hopper also contrasts the illuminated room to
the dark windows opposite.

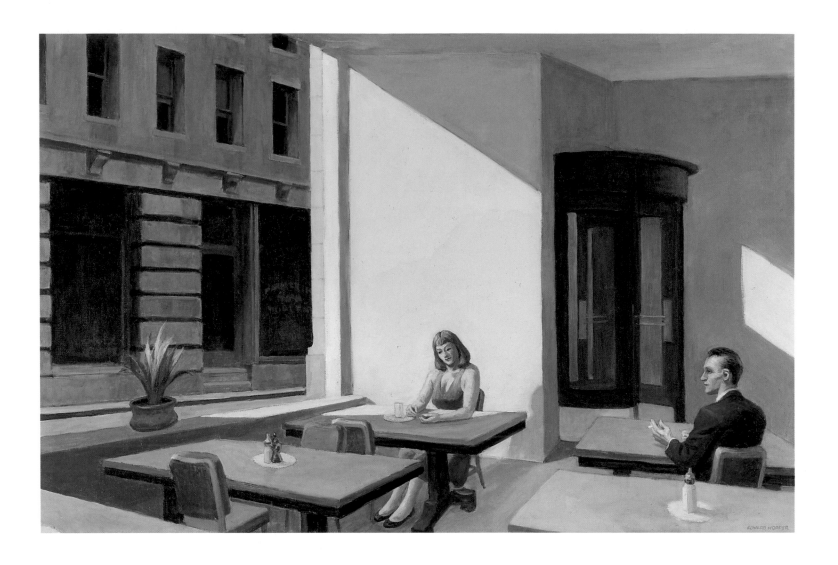

Sunlight in a Cafeteria, 1958
Oil on canvas, 102.2 x 152.7 cm
New Haven (CT), Yale University Art Gallery,
Bequest of Stephen Carlton Clark, B.A. 1903

George Segal
The Restaurant Window I, 1967
Various materials, 243 x 335 cm
Cologne, Museum Ludwig

Glass, a key motif in Hopper's paintings, is only
suggested, not really there. Segal's glass is quite
real, and his people have become artificial, plas-
ter casts. Hopper's figures likewise have a cer-
tain wooden, artificial appearance.

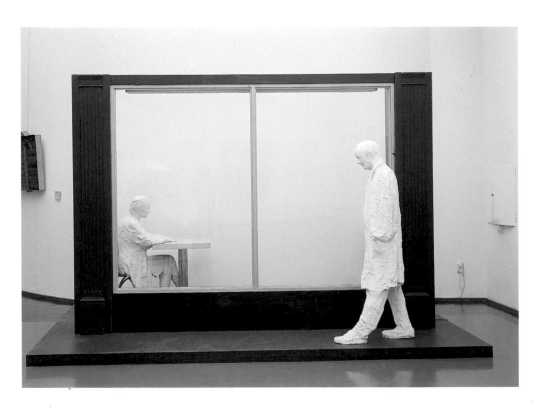

just as unsatisfying during leisure time as at work, and human relationships as desolate as most of the landscapes and townscapes he depicted. And the later the date of the picture is, the more depressing its mood seems to be.

Hopper's "recreationists," to use the term in Max Horkheimer and Theodor W. Adorno's 1947 *Dialektik der Aufklärung (Dialectic of the Enlightenment)*, appear to be trapped in the absurdity of their own activity or lack of it. This impression is heightened by the limited context in which we see them. His *People in the Sun*, for instance (1960; pp. 164–165), sit in rows of deck chairs on the patio of a building in the midst of a wide plain, with a mountain range in the background. A corner of the building, the figures, a landscape – that is all we see. Whether the building is a hotel, a recreation center, or a private residence remains unclear. Even Hopper's explicit depictions of hotels evoke a similar, intermediate zone in which work and leisure blend. It is as if he were implying that the difference between recreation and labor is non-existent, a fiction, for the people in his pictures behave in much the same way no matter where they happen to be. Further visual references to the interchangeability of workplace and recreation spot might be seen in the pictures on the wall in *Hotel Lobby* (1942; p. 168), the mirror in *Hotel by the Railroad* (1952;

Conference at Night, 1949
Oil on canvas, 70.5 x 101.6 cm
Wichita (KS), Courtesy Wichita Art Museum,
The Roland P. Murdock Collection

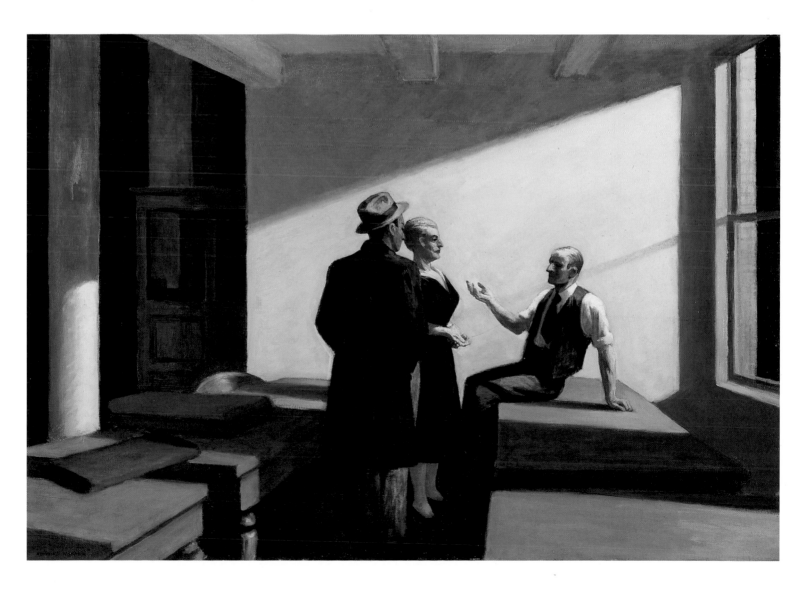

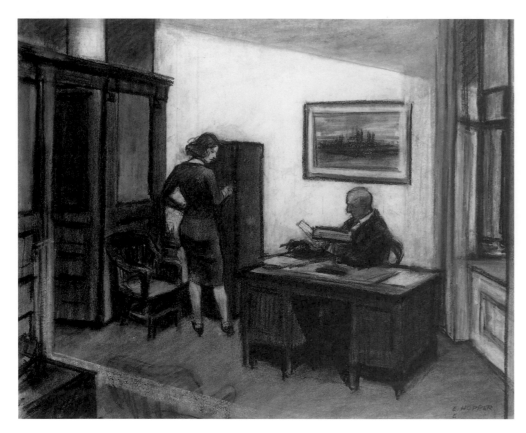

Study for *Office at Night*, 1940
Chalk and charcoal, heightened with white, on
paper, 38.1 x 49.2 cm
New York (NY), Collection of Whitney Museum
of American Art. Josephine N. Hopper Bequest
70.340

Study for *Office at Night*, 1940
Chalk and charcoal, heightened with white, on
paper, 38.4 x 46.6 cm
New York (NY), Collection of Whitney Museum
of American Art. Josephine N. Hopper Bequest
70.341

PAGES 164–165:
People in the Sun, 1960
Oil on canvas, 102.6 x 153.4 cm
Washington (DC), National Museum of Amer-
ican Art, Smithsonian Institution, Gift of S.C.
Johnson & Son, Inc./Art Resource, New York
(NY)

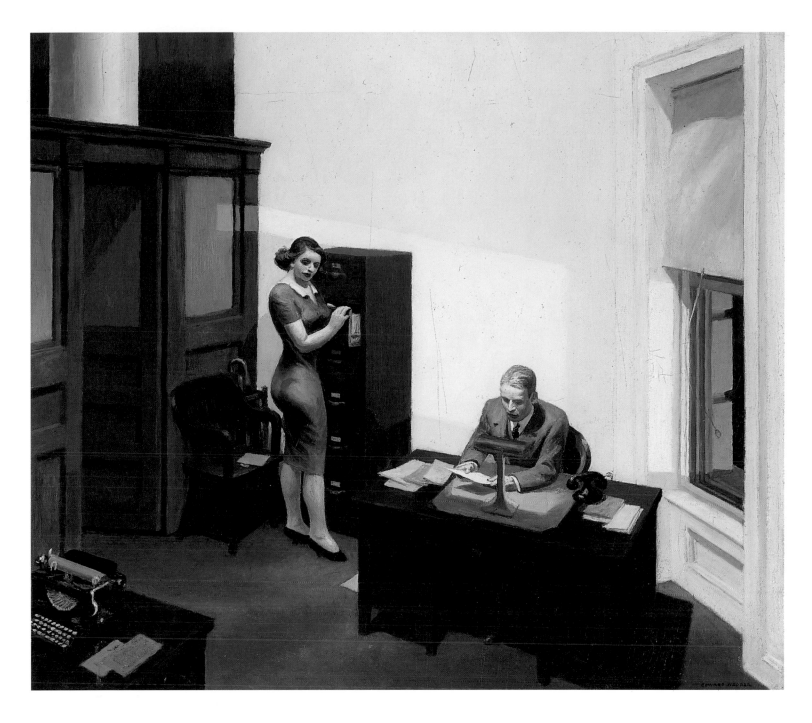

Office at Night, 1940
Oil on canvas, 56.4 x 64 cm
Minneapolis (MN), Collection Walker Art
Center, Gift of the T. B. Walker Foundation,
Gilbert M. Walker Fund, 1948

Hopper depicts an intimate scene in a public
space. The emphasis on the woman's figure
creates a sensual tension which is underscored
by the patch of light on the wall touching both
figures. Window and door are open, and the
woman is just opening the filing cabinet
drawer.

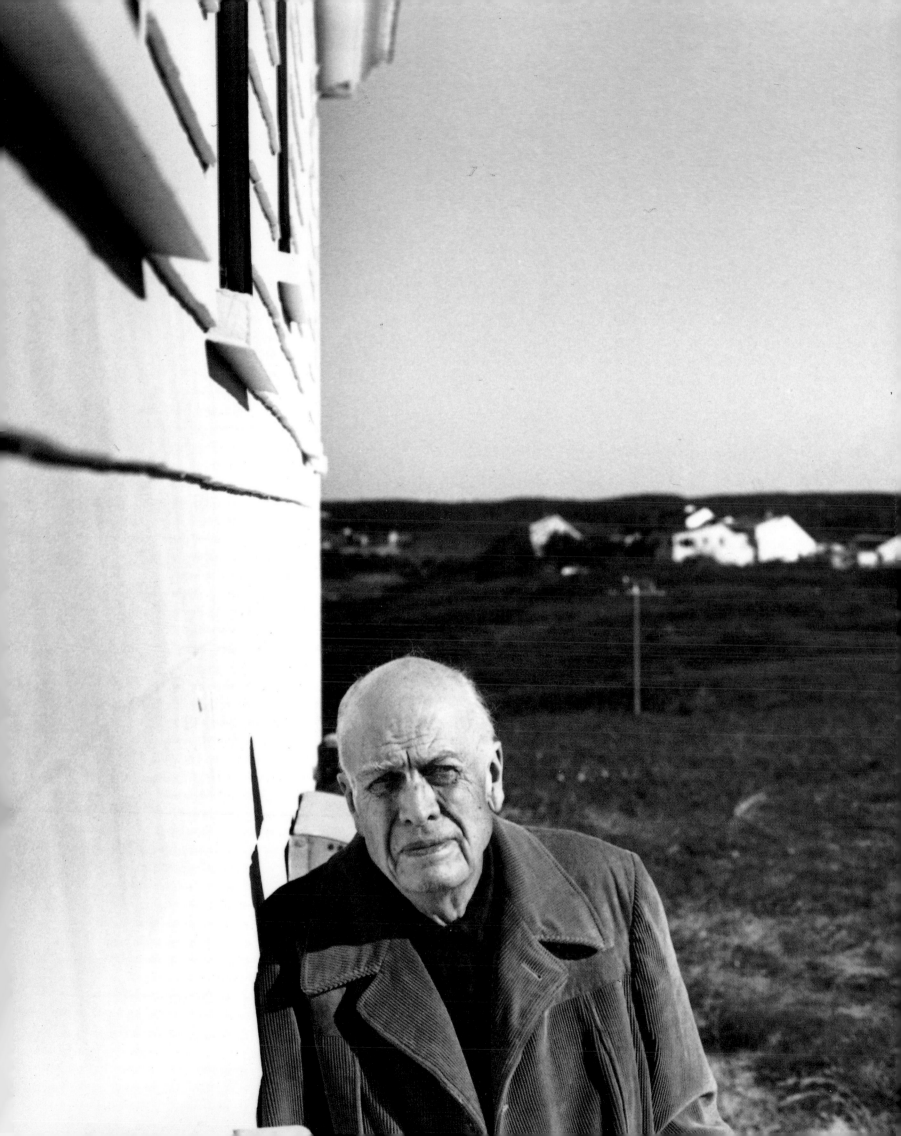

Hotel Lobby, 1942
Oil on canvas, 81.9 x 103.5 cm
Indianapolis (IN), Indianapolis Museum of
Art, William Ray Adams Memorial Collection

As in *Compartment C, Car 193* (p. 140), Hop-
per is concerned here with vicarious experi-
ence, as indicated by the landscape painting
on the wall and the magazine being read by
the woman at the right. Hotels in Hopper's
work suggest purely functional sojourns, in
which experience is determined by a set pur-
pose.

Excursion into Philosophy, 1959
Oil on canvas, 76.2 x 101.6 cm
Private collection

168

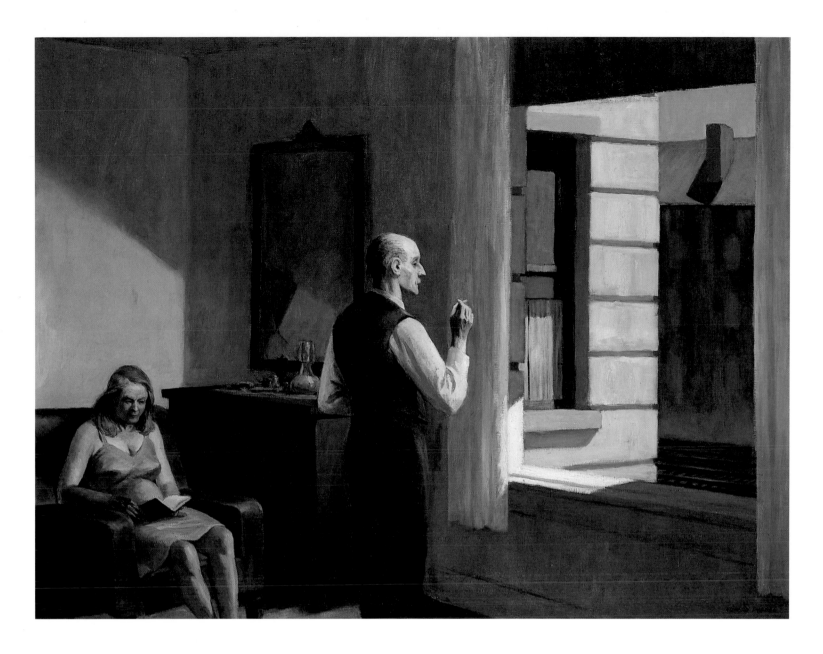

p. 169), or, in more direct form, in the views through windows so often employed as pictures within the picture. A change of place, Hopper seems to say, is impossible, an illusion. The human condition is unalterable and omnipresent.

The demise of public life under the tyranny of intimacy is a theme which Hopper addressed again and again, in countless variations. The woman seated in *Compartment C, Car 193* (1938; p. 140, detail p. 172) is paying no attention to the scenery outside, preferring to leaf through a magazine. Moreover, she has chosen the aisle seat, away from the window, away from a view of the outside world, fragmentary and blurred as it may be due to the speed of the train. The experience of overcoming the distance between two points is no longer conscious; space has become a function of movement, and the train compartment an intimate, hermetic realm. In *Chair Car* (1965; p. 173), done twenty-seven years later, these factors are even more strongly emphasized. The confined compartment has expanded into an entire seating car, occupied, again, by a woman reading. But this time she is not alone. Opposite her sits another woman, apparently observing her, and two other people are seated farther away,

Hotel by the Railroad, 1952
Oil on canvas, 72.2 x 101.9 cm
Washington (DC), Hirshhorn Museum and Sculpture Garden, Smithsonian Institution, Gift of the Joseph H. Hirshhorn Foundation, 1966

The lack of connection between the couple corresponds to a type of travel limited to trains and railroad hotels. The mirror refers to the self-contained character of the situation, and the view through the window to its limited nature.

PAGES 170–171:
Western Motel, 1957
Oil on canvas, 76.8 x 127.3 cm
New Haven (CT), Yale University Art Gallery, Bequest of Stephen Carlton Clark, B.A. 1903

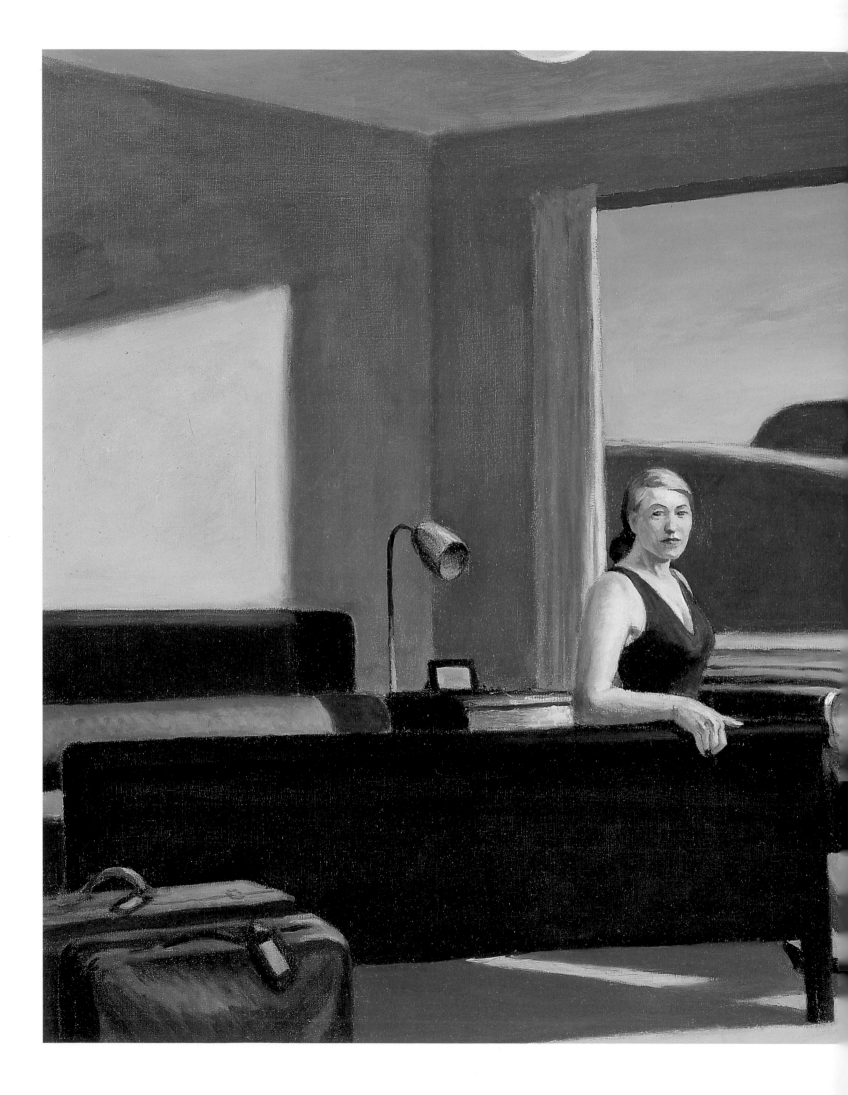

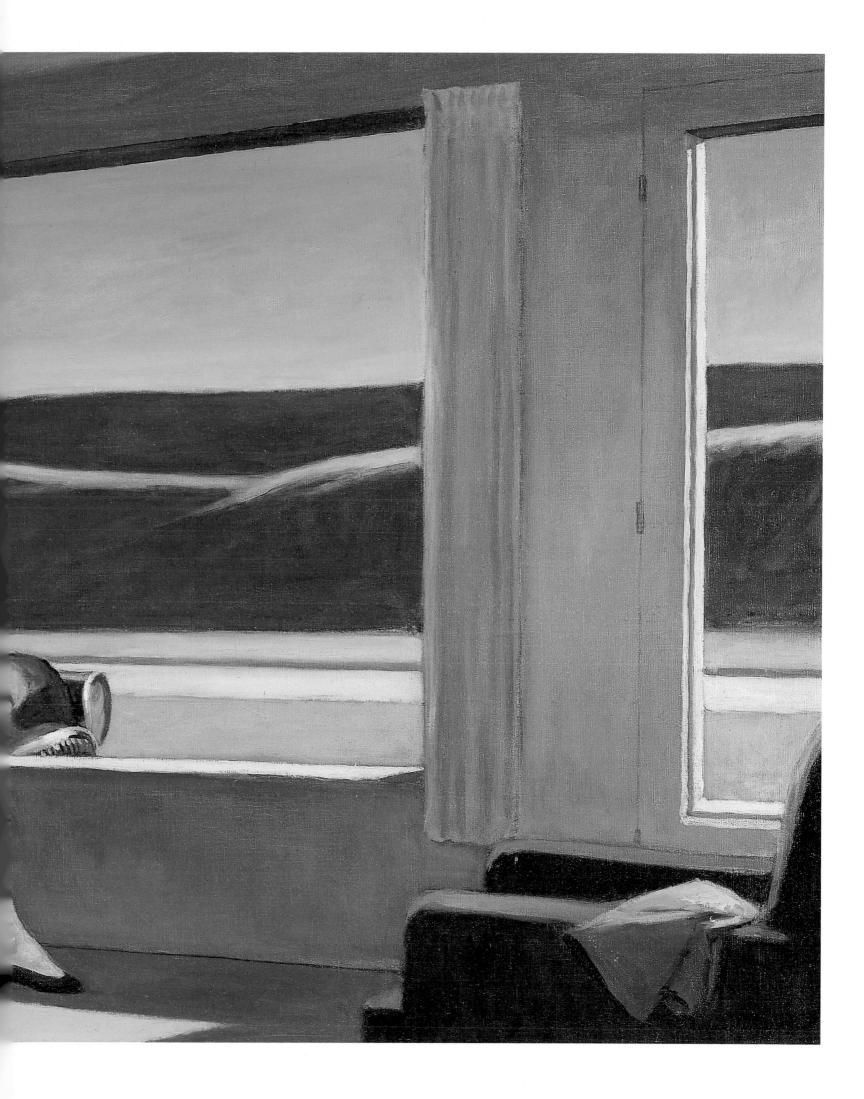

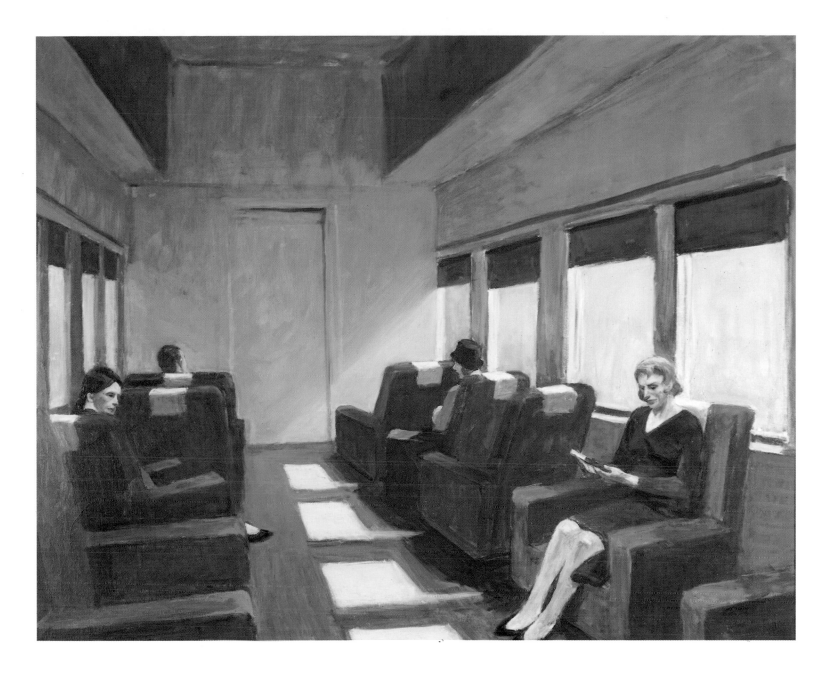

with their backs turned. If it were not for the title, we might not realize that the setting was actually a train. The process alluded to in the earlier painting has become fully obvious in *Chair Car*, where intimacy in fact supplants the public sphere.

As Sennett remarks, "to fantasize that physical objects had psychological dimensions became logical in this new secular order. When belief was governed by the principle of immanence, there broke down distinctions between perceiver and perceived, inside and outside, subject and object. If everything counts potentially, how am I to draw a line between what relates to my personal needs and what is impersonal, unrelated to the immediate realm of my experience? It may all matter, nothing may matter, but how am I to know? I must therefore draw no distinction between categories of objects and sensations, because in distinguishing them I may be creating a false barrier. The celebration of objectivity and hardheaded commitment to fact so prominent a century ago, all in the name of Science, was in reality an unwitting preparation for the present era of radical subjectivity."[10]

Chair Car, 1965
Oil on canvas, 101.6 x 127 cm
Private collection

The woman seated in the foreground turns her back on the outside world, which has been reduced to an indeterminate blur. The privacy of *Compartment C, Car 193* has given way to a public space with several occupants, but no communication among them ensues.

PAGE 172:
Detail from:
Compartment C, Car 193, 1938
(see p. 140)

173

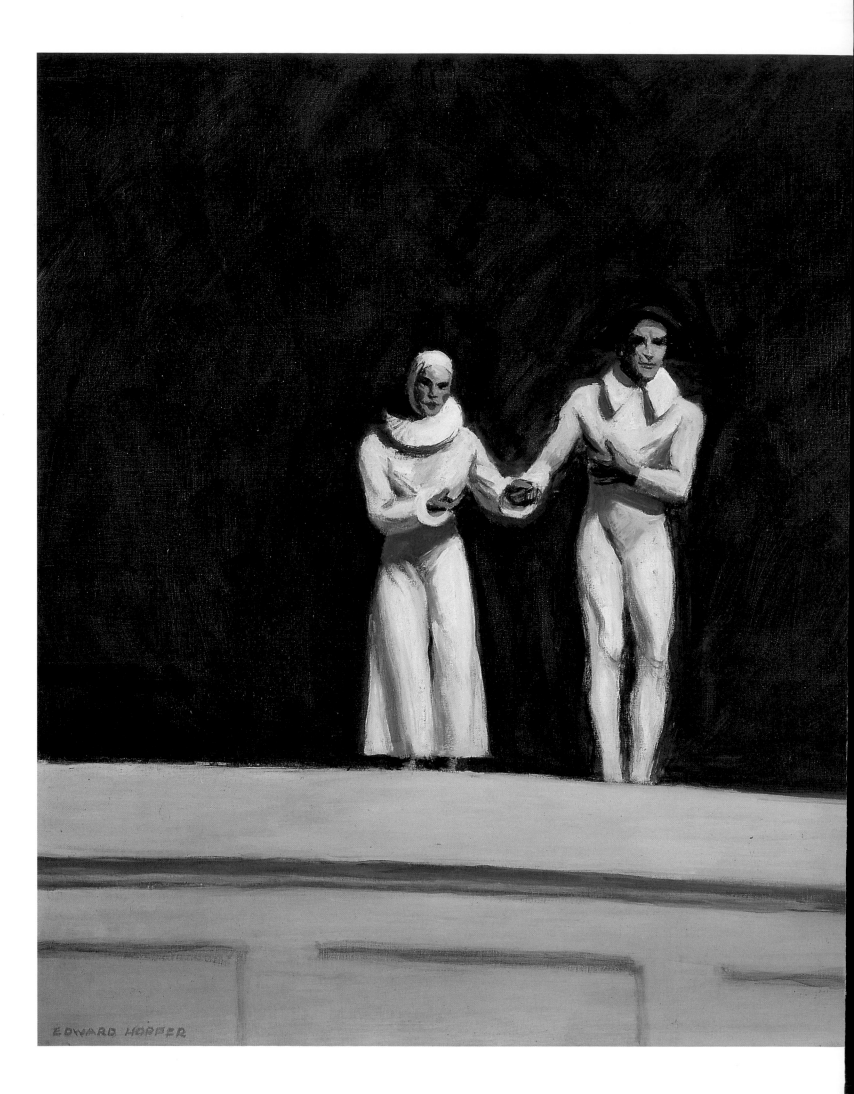

Two Comedians, 1965
Oil on canvas, 73.7 x 101.6 cm
Collection Mr. and Mrs. Frank Sinatra

The painting for which this is a study was one of
the last Hopper executed. It shows him and his
wife taking leave of an imaginary audience, and
clearly indicates how he wished to have his art
understood – as a performance on the stage of
painting.

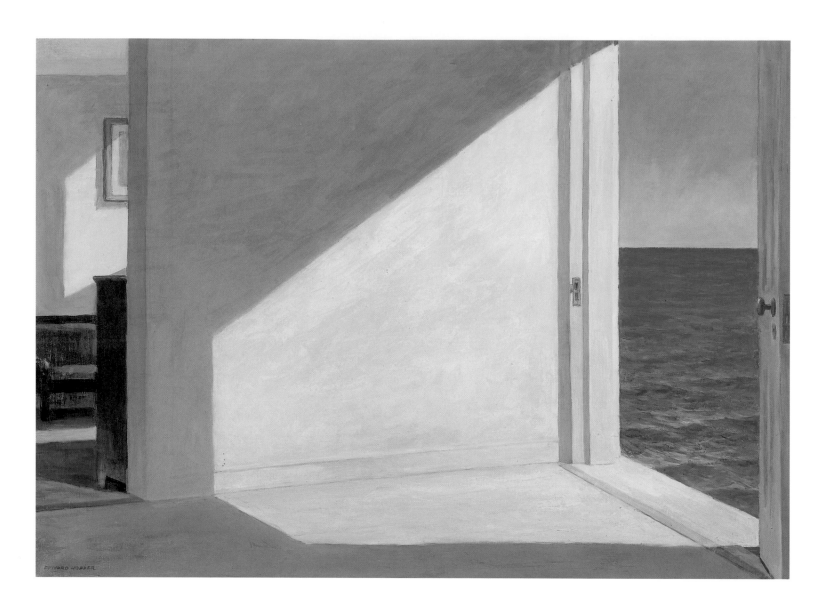

Rooms by the Sea, 1951
Oil on canvas, 73.7 x 101.6 cm
New Haven (CT), Yale University Art Gallery

Hopper addresses the contrast between a pristine, intrinsically anti-human nature and a civilization abandoned by humanity, the empty rooms. This direct confrontation between the two realms has an almost surreal effect.

Continuity in Painting –
Influences and Effects

Brian O'Doherty, who has studied Hopper's œuvre closely, calls him "the major twentieth-century American 'realist' and one of the giants of American painting."[1] Many other American art historians and critics concur with O'Doherty's view. John I.H. Baur describes Hopper as "the foremost realist in 20-century art"[2] and Hilton Kramer declared that Hopper had a "firm position as the leading realist painter of his generation."[3]

Clement Greenberg, perhaps America's greatest contemporary art critic, thought differently. Writing about Hopper on the occasion of the Whitney Annual at the Whitney Museum of American Art in December 1946, Greenberg stated that a new artistic category should be invented for Hopper's achievement. His means were epigonal, paltry, and impersonal; but his sense of composition offered an insight into the state of American life not found in its literature. Hopper was simply a bad painter, Greenberg concluded, but if he were a better one, he probably would not be such a great artist.[4]

This rather belittling opinion becomes more understandable in light of a passage, not explicitly related to Hopper, in Greenberg's classic 1939 essay, "Avant-Garde and Kitsch." It is a cliché that art becomes caviar for the people, he writes, when the reality it imitates does not conform in the least with reality as generally perceived.[5] Advocating an aesthetically "pure" art, Greenberg could not help but consider 1960s Pop a form of kitsch. The Pop artists, in turn, revered Hopper as one of their forbears. Greenberg was in a dilemma with regard to Hopper, seeing both the poverty of his means and his fine sense of composition. In the course of our discussion we shall continually be confronted with just this dilemma.

Hopper had his first one-man show in America in 1920, at the age of thirty-eight. The first retrospective of his work took place at the Museum of Modern Art in 1933. From that point on, Hopper's reputation in the United States continually grew. In Germany, his painting was not comprehensively presented until 1981, thirty years after he had been chosen, as one of four artists, to represent the United States at the 1951 Venice Biennale. In the meantime, Hopper has become an extremely popular artist, and posters and reproductions of his paintings adorn private homes and

Hans Namuth
Edward Hopper, 1963
Hans Namuth © 1990

177

public places worldwide. Yet the reasons for the fascination Hopper's pictures exert on people of all ages and walks of life remain to be analyzed.

The helplessness with which Hopper's exegetes react to his paintings seems quite strange. While most American critics tend to limit themselves to hagiography, the Europeans, and especially Germans, often attempt to read a kind of transcendence into Hopper's imagery, using nebulous terminology for which it is difficult to find corroboration in the pictures themselves.[6] Hopper's painting is philosophical, states one reviewer.[7] And, inevitably, his works have been elevated to "icons of Post-Modernism."[8] Opinions about Hopper thus cover an enormous range. Some class him as a socially critical painter in the broadest sense, with affinities, say, to the Ash Can School; others call him the greatest realist of his epoch, from the turn of the century to the 1960s; still others apply the essentially meaningless term "Post-Modern" to Hopper's work.

The fact that this work has been judged so variously and contradictorily surely has something to do with its laconic quality, the stupendous stylistic and substantial sameness of Hopper's paintings over the decades. The changes in his personal style are truly marginal by comparison to the political, societal, and artistic changes that took place during his career.

Hopper's reluctance to change might tempt us to conclude that his art was provincial, of solely national interest – typically American, in other words – and therefore somehow outside the stream of international modernism. In fact, most general histories of modern art pass Hopper over. Herbert Read, in his *Concise History of Modern Painting*, explains why this is so. Like the so-called primitives, Read says, realist artists had no influence on modern painting because they continued the academic tradi-

Church in Eastham, c. 1934–35
Watercolor on paper, 50.5 x 63.4 cm
Sheet 54.8 x 67.5 cm
New York (NY), Collection of Whitney Museum of American Art. Josephine N. Hopper Bequest 70.1086

Hopper was deeply interested in the landscapes and townscapes of his New England home. He did many watercolor studies with an eye to employing certain elements in his oils.

tion of the nineteenth century. While recognizing the artistic perfection and lasting value of the achievement of painters like Hopper, Balthus, Christian Bérard, or Stanley Spencer, and saying they deserve mention in histories covering every stream of painting in our time, Read asserts that they have no place in a history of modern painting.[9]

An essential ingredient in the definition of modernism has always been its international character. Now, although it is sometimes maintained that Hopper had his roots in France, during his stays in Paris he was obviously indifferent to, if not ignorant of, the European avant-garde. He developed a genuinely and thoroughly American style which, for the European observer, presents certain difficulties. Apart from the fundamental problem of understanding a different mentality and history, the actual topography of Hopper's art is a crucial issue. Hopper spent much of his life outside the metropolis. What needs to be investigated is the nature of the relationship between his chosen sojourn and the motifs – and motives – of his art. The importance of the "periphery," the states of Maine and Massachusetts, where Hopper had a studio in South Truro, cannot be overlooked. He painted both city subjects, in New York and before that, in Paris – if from a point of view quite different from that of most contemporaneous American artists – and he painted provincial life in the small town. This contrast, I think, is one of the sources of the fascination we feel in face of Hopper's paintings.

Rooftops, 1926
Watercolor on paper, 32.7 x 50.5 cm
New York (NY), Collection of Whitney Museum of American Art. Josephine N. Hopper Bequest 70.1114

Whether big city or small town, Hopper sought out similar motifs, which fascinated him more than typically urban themes such as traffic, crowds, or the fast pace of life.

179

Despite the fact that Hopper's means of depiction were essentially his own, numerous links with concurrent developments in art can be detected. In France he had seen the Impressionists, especially Manet and Degas, while taking no notice of Picasso. During the 1920s, Hopper's painting exhibited certain parallels with realistic streams in Europe, such as Neue Sachlichkeit and the variant of that style that came to be known as Magic Realism. In the postwar period, finally, the artists of Pop claimed him for a forefather, and one audacious critic even discovered parallels in his work with American color-field painting.

Lloyd Goodrich, for many years director of the Whitney Museum of American Art, once compared Hopper's *High Noon* (p. 102) with a Mondrian. When he told him of this, Hopper said, "You kill me."[10] In drawing the parallel, of course, Goodrich had only compositional aspects in mind. Still, the tendency to associate Hopper with abstract painting, which younger authors continue to do, rests on a misunderstanding. The discovery of an abstract idea underlying a realistic picture by no means makes it a non-objective work. Yet misguided as it may be, this approach to art, idealistic and concentrating on form at the expense of content, continues to dominate the discussion on Edward Hopper.

The concept of reception necessarily plays an important part in any analysis of Hopper's work. The concept can be defined to include, firstly, Hopper's own reception of certain themes and motifs, particularly in nineteenth-century French painting; secondly, the reception of his work by a hypothetical viewer, that is, the general aesthetic effect produced by Hopper's paintings; and thirdly, certain subsequent phenomena in art that can be related to his work, such as Pop.

Hopper oriented himself eclectically to various European, especially French, artists of the nineteenth century, including Manet and Degas, but also Courbet and Daumier. What he adopted from French Impressionism was above all a number of themes, whose significance he altered and adapted to a specifically American iconography. Such statements as "The only real influence I've ever had was myself" cannot, of course, be taken at face value.[11] The nature and content of the various traditions Hopper absorbed have become clear in the course of the discussion. Written or oral statements of his own in this regard are rare. Hopper's silence and taciturnity in fact tend to be considered something quite special. The artist was known for his momentous silences, Goodrich reports, but when he did speak his words were the product of long meditation. The depth and profundity of Hopper's thinking are often emphasized.

Beyond, or rather, this side of such notions of genius, critics have naturally focussed on Hopper's paintings themselves, and the external circumstances of their making. These factors in turn are involved with the effect of Hopper's imagery, its intense and fascinating character. Now, the aesthetic of making and the aesthetic of viewing are closely interrelated, and not only in Hopper's case. The imaginative process set underway in the viewer's mind by a painting has its source in the artist's own imagination. The fact that Hopper was a realist does not mean that he restricted himself to pure imitation. Quite the contrary: he combined motifs from na-

Standing Female Nude with Painter in Background, c. 1902–04
Oil on canvas, 76.2 x 45.4 cm
New York (NY), Collection of Whitney Museum of American Art. Josephine N. Hopper Bequest 70.1258

Hopper reverses the emphasis of the traditional painter and model theme, concentrating on the model and rendering the artist as a tiny background figure.

Painter and Model, c. 1902–04
Oil on cardboard, 26 x 20.5 cm
New York (NY), Collection of Whitney Museum of American Art. Josephine N. Hopper Bequest 70.1420

This early oil sketch from Hopper's student days addresses a fundamental problem of painting that he would continually emphasize throughout his career – that of convincingly translating an idea into a painted image.

181

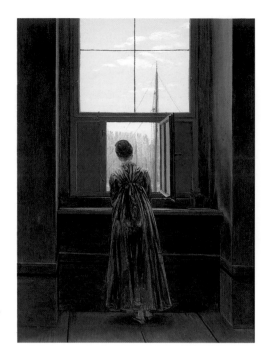

Caspar David Friedrich
Woman at a Window, 1822
Frau am Fenster
Oil on canvas, 44 x 37cm
Berlin, Staatliche Museen zu Berlin –
Preußischer Kulturbesitz, Nationalgalerie

In terms of both form and content, objective
painting in the twentieth century must meas-
ure itself against earlier styles, that of German
Romanticism in particular. Here, the window
symbolizes a view from the mundane world
into another, transcendental realm, a theme
found in many variations in Hopper's work.

Room in Brooklyn (Detail), 1932
Oil on canvas, 73.6 x 86.3cm
Boston (MA), Courtesy, Museum of Fine Arts,
The Hayden Collection

ture with his own inventions, wove external and internal impressions into
a single fabric. His aim was to find the most concise expression of a
given pictorial idea.

As long ago as the eighteenth century, Gotthold Ephraim Lessing
defined vitality in art as a reflection of the artist's inward thoughts and
feelings. The combination of visualization and vision has a long tradition
in representational art, as opposed to purely naturalistic or imitative art.
When Hopper is repeatedly credited with the achievement of having ad-
vanced from slavish naturalism to original invention, we must say that for
an artist of his rank, this was nothing unusual.

German Romantic painters, for example, placed great emphasis on the
"inward view" or introspection, convinced as they were that the human
mind or soul reflected the universe. This belief was quintessentially ex-
pressed by Caspar David Friedrich: "The artist should not merely paint
what he sees before him, but also what he sees within himself. But if he
sees nothing inside himself, let him desist painting what he sees outside.
Otherwise, his paintings will resemble those hospital screens behind
which one expects to find only sick people, or even dead ones."[12] Fried-
rich's view had its critics, however. Ludwig Richter, in a diary entry of
1825, remarked something that holds for Hopper as well: "It would ap-
pear to me that Friedrich's approach is leading in a wrong direction that,
in times like ours, could well become epidemic. Most of his pictures
breathe that sick melancholy, that feverishness, which powerfully grips
any sensitive spectator, but which always produces a disconsolate feeling.
This is not the earnestness, nor the character or spirit or significance of
nature – it is stiff and forced. Friedrich fetters us to an abstract idea, uses
natural forms merely allegorically, as symbols and hieroglyphs intended
to mean this, that or the other; but in nature, every thing speaks for itself,
and her spirit, her language reside in every form and color."[13] It is pre-
cisely here, at the point at which aesthetic subjectivity begins to develop
at the cost of traditional form, that the problem of Hopper's modernity
lies, in terms of both form and content.

Hopper was thinking very much along Friedrich's lines when he
stated that his aim in painting "has always been the most exact transcrip-
tion possible of my most intimate impressions of nature."[14] The proce-
dure he adopted to this end was one of combination, of bringing
together elements which, although all taken from reality, appear dis-
parate when integrated into their new context of a work of art. This was
also the Surrealist principle, which likewise derived from Romanticism.
As Max Ernst once said, the painter's role was to discern and to depict
what he saw within himself.

The significance of Friedrich's work for the development of abstract,
non-objective painting in the twentieth century was great, but it has also
exerted a signal influence on contemporary realistic, figurative art. As
one commentator notes, "Modern realists of the American and European
schools must needs ask themselves what Friedrich would have thought
about the substance of their approaches and works."[15] At about the same
time as Friedrich in Germany, J.M.W. Turner was working in England.

182

The purpose of Turner's art, wrote his great admirer John Ruskin in the middle of the nineteenth century, was to represent the force of nature, but also the hardships and cares of human life, on the sea and on land, in the fields and in the city. Particularly with respect to Turner's depictions of light, Ruskin waxed enthusiastic, comparing one of his sunsets to the invincible apparition of a white and eerie Aphrodite, emerging from the sea foam to spread her pale, tattered wings over the clouds.[16]

Turner was a predecessor of the Impressionists, but their choice and treatment of subjects brought such ambitious metaphysical aims back to solid ground. Turner's concern, as Werner Hofmann notes, was "a graphic amalgamation of natural forces and technological power – not an explicit synthesis, but an ambivalent unity, full of the promise and threat which Turner (like Marx) perceived in the nineteenth century."[17]

The Impressionists turned their attention to modern life, scenes witnessed in cafés, theaters, or the ballet. They also painted seascapes and railroads, in depictions revealing an entirely different thrust from Turner. They were fascinated by the play of light and shade on white snow, but not interested in the divine or metaphysical forces discoverable in such effects. Nor were the Impressionists particularly concerned with technological progress as such, as a means, say, of criticizing developments in society.

With Hopper we are on different, more romantic ground. A quasi-religious tendency in many of his pictures has already been remarked. But he combined this with the matter-of-fact stance of the Impressionists to produce a blend that touched the right chord in audiences, and continues to do so to this day. Certain key traits of Hopper's style can be explained by his work as an illustrator. As Barbara Rose has remarked, Americans do not draw such a strong distinction between fine and applied art as Euro-

J.M.W. Turner
Rain, Steam and Speed – The Great Western Railway, 1844
Oil on canvas, 90.8 x 122 cm
London, The National Gallery

In addition to Friedrich's influence, Turner contributed a great deal to the thinking behind Hopper's painting. The relationship between nature and technology, marked both by promise and threat, played a central role in Hopper's approach.

peans do. Many American artists who earned their living as illustrators, commercial artists, billboard painters, or house painters made free use of their professional skills when they turned to fine art.[18] Not that this phenomenon has been limited to America, however. From the Italian Renaissance we know that many an artist who now stands on a pedestal in art history also worked in the equivalent of visual communication, or at any rate for commercial ends, just as several of them earned their living in such commonplace occupations as butcher or innkeeper.

Another example, this time from the nineteenth century, is an artist known and admired by Hopper – Honoré Daumier. Daumier's popularity rests mainly on his caricatures, which are just as topical today as they have ever been. As regards Daumier's place in the history of fine art, opinions differ: "When Daumier is called a major artist, mistrustful people suspect an intention to muffle the social critic's voice," notes Werner Hofmann. But "if one were to evaluate Daumier solely in terms of his contribution to the mundane business of satire, one would surely be accused of denigrating him, putting him in a ghetto."[19]

This issue does not even arise in Hopper's case, because he has long since taken his place in the pantheon of artistic heroes. But it was an issue that deeply concerned Hopper himself. An indication may be

Bridge in Paris, 1906
Oil on wood, 24.4 x 33 cm
New York (NY), Collection of Whitney Museum of American Art. Josephine N. Hopper Bequest 70.1305

This early picture already gives an idea of what fascinated the Pop artists about Hopper's imagery – elements such as the bright red shipping signal integrated in the composition.

found in a number of early works on the theme of artist and model, but most pointedly in a small picture from his student days: *Don Quixote on Horseback* (c. 1902–04; p. 187). The painting was obviously based on a composition by Daumier (*Don Quixote*, c. 1868; p. 186). In this phase Hopper was experimenting with tone-in-tone painting on a dark ground. Despite the evident compositional similarity between the two pictures, they differ in terms of palette, pose, and treatment of both horse and rider. But the most obvious difference is that while Hopper has defined the errant knight's facial features, Daumier has declined to do so, and for good reason.

Don Quixote stands for "the artist as outsider, misused in the role of the clown by whom the well-adjusted let themselves be entertained. Don Quixote stands for the artist who refuses to comply with the demands of the marketplace and proclaims his right to self-determination."[20] Beyond this, the Don Quixote theme alludes to the fundamental contradiction of which art of any type partakes – that between dream and reality, with Don Quixote standing for the dreamer and Sancho Panza for the realist. It is not a matter of determining who is right, not – to return to Hopper's case – a matter of gauging the degree to which an artist's pictures conform with reality, if there even is such a thing as reality objectively defined. It is not a matter of testing, as has actually and absurdly been done, by taking photographs of the scenes Hopper painted and comparing them with his pictures. Which are the more true, the more real?

"Having imagination," Thomas Mann once remarked, "does not mean thinking up something; it means making something out of things." In this regard, the chimerical apparition of Daumier's *Don Quixote* is perfectly appropriate to the fictional figure in Cervantes's novel. Hopper's figure, despite the limited palette that emphasizes the unreal character of the scene, is treated in a much more concrete way. Hopper brings Daumier's indeterminate painterly evocation back down to the level of distinct statement. This type of simplification is something met with throughout Hopper's œuvre, and indeed he himself described it as part of his approach to design. Giving form to perceptions and sensations, he said, was perhaps limited by the technical obstacles of painting, as well as by the artist's own personality, adding "Of such may be the simplifications that I have attempted."[21]

Hopper's entire œuvre is held together by the thread of a fundamental idea, some variation on which is present in every painting, no matter how different it may look from the next. Let us go back to the years 1916 to 1919, to Monhegan Island, where Hopper spent the summers and painted a number of small-format landscape sketches in oil on wood (*Rocky Sea Shore*, 1916–19, p. 188; *Rocks and Sea*, 1916–19, p. 189). The paint is applied in thick impasto; little attention is given to perspective, everything in the scenes being reduced to flat planes. The theme of the sketches is the meeting of land and sea – land as the element on which humans live, sea as that inimical to human life, a Romantic motif *par excellence*. A key feature of *Rocky Sea Shore* is the fact that no sky is visible. Instead of depicting the horizon, Hopper has simply cut the water surface off at the

Don Quixote on Horseback, c. 1902–04
Oil on cardboard, 43.2 x 31 cm
New York (NY), Collection of Whitney Museum
of American Art. Josephine N. Hopper Bequest
70.1404

In contrast to Daumier, Hopper gives his *Don
Quixote* facial features, and treats the entire
scene in a more realistic manner. In this regard,
the picture can be considered programmatic des-
pite its early date.

upper edge of the panel. This marks a difference from the Romantic view
of landscape, indicating a concentration solely on this world and an un-
concern for the world beyond. By comparison to Friedrich's approach,
Hopper's illustrates exactly where the distinction lies between a twentieth-
century American Puritan and a nineteenth-century Romantic European
Protestant.

Hopper set out to paint light, but what he actually painted, for the most
part, was illumination. As late as 1962 he was still unsure in his own
mind about his own approach, saying he thought he was still an Impress-
ionist after all. He used light as a stylistic means, invariably placing the
light sources outside the picture, and hardly ever treating light, as Turner
did, as a phenomenon in itself. Nor was Hopper especially interested in
the atmosphere engendered by the effects of light reflecting off various

surfaces, a study which was crucial to the Impressionist venture. Two late paintings may serve to explain what I mean.

Rooms by the Sea (1951; p. 176) shows an interior with an open door revealing a view of sea and sky outside. To the left is a passageway into another room. The foreground room, into which we as viewers look from below as into a stage set, is unfurnished, its only striking feature being the bright patch cast by the impinging light on wall and floor. Behind the wall separating the two rooms stands a chest of drawers, of which only the side is visible, and opposite it we see a chair or sofa, but again, only a section of it. The picture on the wall is likewise cut off. The composition is articulated by means of three distinct gradations of light and shade: the brilliant, directly illuminated surfaces of wall and floor in both front and back room (where the light presumably enters through a window); diffusely illuminated surfaces outside these bright zones; and dark shadows, cast by the furniture.

The composition has a number of disquieting features. One is the contrast between interior and exterior space, and that between the two rooms themselves. A second is the indeterminate position of the light source and the strange shape cast by its rays. Third and finally, the perspective has seemingly gone all askew, leading to a sense of insecurity as to where we, as viewers, actually stand. The light source in *Rooms by the Sea* cannot be precisely located. Apparently it is not in the plane of the picture but in the plane occupied by a hypothetical observer, as may be concluded from the angles of the borderlines between light and shadow. While the illumination appears logical at first sight, closer scrutiny reveals it to be deceptive. In fact, Hopper has once again played tricks with the laws of perspective. Although the room is depicted from an elevated vantage point, we as viewers have the sense of standing below floor level. In addition,

Rocky Sea Shore, 1916–19
Oil on canvas, 24.1 x 32.9 cm
New York (NY), Collection of Whitney Museum of American Art. Josephine N. Hopper Bequest 70.1666

two different vanishing points have been established, the ceiling of the foreground room has been left out, and the horizontals of the interior have been transformed into slight diagonals.

While the view through the door at the left evokes an inhabited room, potential human presence, the view at the right reveals uninhabited nature. The intermediate zone, which occupies the greatest area of the picture, literally mediates between these two poles. The sea, seemingly extending right to the door of the apartment, takes on symbolic significance. What we have here is a three-step model, with nature in a romantic, apparently pristine state at the one pole and civilization at the other – or vice versa. At the same time, the picture presents a pair of opposites, a dialectical situation in which light stands for the realm of nature, penetrating a building erected by man, an achievement of culture – only to form a hard-edged shape that seems entirely indifferent to human concerns. Hopper is far from suggesting any reconciliation between mankind and nature, as is borne out again and again throughout his œuvre.

Hopper was familiar with some of the writings of Sigmund Freud. One of best-known works of the founder of psychoanalysis is the essay *Das Unbehagen in der Kultur (Civilization and its Discontents),* published in

Rocks and Sea, 1916–19
Oil on wood, 29.8 x 40.6 cm
New York (NY), Collection of Whitney Museum of American Art. Josephine N. Hopper Bequest 70.1292

The oil sketches Hopper did at Monhegan Island concentrate on the meeting point of land and sea. Often, no horizon is visible: Hopper restricts himself to the real, concrete world.

Sun in an Empty Room, 1963
Oil on canvas, 73 x 100 cm
Private collection

It was very difficult to paint inside and outside at
the same time, Hopper once said in connection
with this picture. The contrast between exterior
and interior, nature and culture, is treated in a
highly and consciously ambiguous way, which
the figure he had originally planned to include in
the composition would have disturbed.

Jo Painting, 1936
Oil on canvas, 45.7 x 40.6 cm
New York (NY), Collection of Whitney Museum
of American Art. Josephine N. Hopper Bequest
70.1171

1930. At the outset, Freud refers to "a little essay... that treats religion as illusion" which he sent to a friend. While the friend, Freud says, agreed in general with the argument, he felt the true source of religious feeling had not been given sufficient attention. This lay in something the friend would call an experience of "eternity," a feeling as of something "ocean-ic". Freud's reply to his friend's remark was, "It is not pleasant to deal scientifically with feelings."[22]

Hopper's picture truly does convey an oceanic feeling, a sensation to which a great deal of psychological study has since been devoted, despite Freud's misgivings. It is a diffuse feeling and hard to define, as Hopper himself once indicated when speaking about the difficulty of interpreting his paintings: "So much of every art is an expression of the subconscious, that it seems to me most all of the important qualities are put there uncon-sciously, and little of importance by the conscious intellect. But these are things for the psychologist to untangle."[23]

One of Hopper's final paintings was *Sun in an Empty Room* (1963; pp. 190–191). Reduced even more to essentials than *Rooms by the Sea*, the composition has a similar tripartite scheme, but lacks even a trace of requisites that would indicate human presence. The only remaining relic is the house itself. As O'Doherty relates, Hopper had planned a figure in a preliminary sketch, but decided to leave it out of the painting. Here again, the composition is dominated by verticals, to an even more ex-treme degree than *Rooms by the Sea*, and not a single horizontal occurs. The open door has been replaced by a window, and a tree outside stands for nature. The illumination disregards the actual, physical configuration of the room. It was with reference to this picture that Hopper made his famous admission of how difficult it was to paint inside and outside at the same time.[24]

The issue addressed with great radicality of means in *Sun in an Empty Room* was already present in the early Monhegan seascapes discussed above. Encompassing every conceivable facet of the contrast between civilization and nature, this issue is raised again and again throughout Hopper's œuvre. In fact it forms one of the essential focal points of the artist's work, which revolves formally and substantially around the fun-damental dichotomy between culture and nature from beginning to end.

Edward Hopper – Life and Work

Edward Hopper in Paris, 1907
Collection of Reverend Arthayer R. Sanborn

1882 Edward Hopper is born on 22 July in Nyack, New York.

1888–99 Attends a private school in Nyack and graduates from Nyack High School.

1899–1900 That winter Hopper attends the Correspondence School of Illustrating, New York.

1900–06 Enrolling in the New York School of Art, Hopper initially takes graphic design and illustration courses with Arthur Keller and Frank Vincent DuMond. Then he switches to the painting department, where his teachers are Robert Henri, William Merritt Chase, and Kenneth

Hayes Miller. Hopper's fellow-students include Gifford Beal, George Bellows, Homer Boss, Patrick Henry Bruce, Arthur Cederquist, Clarence K. Chatterton, Glenn O. Coleman, Guy Pène du Bois, Arnold Friedman, Julius Golz, Jr., Rockwell Kent, Vachel Lindsay, Walter Pach, Eugene Speicher, Carl Sprinchorn, Walter Tittle, and Clifton Webb. In Sunday courses held with Douglas John Connah and W.T. Benda at the school, he teaches drawing from the model, painting, design, and composition.

1906 Hopper is employed as an illustrator and commercial artist with C.C. Phillips & Company, New York. That October he travels to Paris, residing at 48 rue de Lille, in a building of the

Edward Hopper, c. 1915
Collection of Reverend Arthayer R. Sanborn

Eglise Evangélique Baptiste. He meets Henry Bruce, who introduces him to Impressionist art, especially that of Monet.

1907 27 June: Hopper leaves Paris for London, where he visits the National Gallery, the Wallace Collection, and Westminster Abbey. 19 July: Travels on to Holland, stopping in Amsterdam and Haarlem, where Robert Henri holds a summer academy for American students. 26 July: Hopper arrives in Berlin. 1 August: He travels on to Brussels, staying two days and then returning to Paris. 21 August: Hopper boards ship for New York, where he resumes his commercial art work.

1908 In March Hopper exhibits for the first time, in a New York show of work by Henri students titled Exhibition of Paintings and Drawings by Contemporary American Artists. He is represented by the oils *Le Louvre et la Seine*, *Le Pont des Arts*, and *Le Parc de Saint Cloud*, and by a drawing, *Une Demimondaine*. Other exhibiting artists are George Bellows, Guy Pène du Bois, Lawrence T. Dresser, Edward R. Keefe, Rockwell Kent, George McKay, Howard McLean, Carl Sprinchorn, and G. Leroy Williams.

1909 18 March: Hopper arrives in Paris for a second stay. In May he does a great deal of painting outdoors, on the Seine, and takes excursions to Fontainebleau and St. Germain-en-Laye. By 9 August Hopper is back in New York.

1910 In April Hopper shows an oil, *The Louvre*, in the Exhibition of Independent Artists in New York, organized by John Sloan, Robert Henri, and Arthur B. Davies. That May and June he travels to Paris and to Spain, visiting Madrid and Toledo, and seeing a bullfight. After returning to New York in July, he does commercial art to make a living and paints in his spare time.

Louise Dahl-Wolfe
Edward Hopper, c. 1933
Tucson (AZ), Collection of the Center for
Creative Photography, University of Arizona.
© 1989 Center for Creative Photography,
Arizona Board of Regents

1912 In February and March Hopper parti-
cipates in the Exhibition of Paintings, New York,
with five oils: *Riverboat*, *Valley of the Seine*, *Le
Bistro* or *The Wine Shop*, *Sailing*, and *British
Steamer*. He spends the summer in Gloucester,
Massachusetts, where he paints with Leon Kroll.

1913 Hopper is represented in the Exhibi-
tion of Paintings, held at the MacDowell Club of
New York, with two oils: *Le Barrière* and *Squam
Light*. He participates in the Armory Show (Inter-
national Exhibition of Modern Art) with *Sailing*,
which is sold for $250. Hopper moves to 3 Wash-
ington Square North, where he will reside until
the end of his life.

1914 Participates in the Exhibition of Paint-
ings, with the oils *Gloucester Harbor* and *The
Bridge*, and in the Exhibition of Water Colors,
Pastels and Drawings by Four Groups of Artists,
with *On the Quay*, *Land of Fog*, *Railroad Train*,
The Port, and *Street in Paris*. Both exhibitions
are held in the MacDowell Club. Hopper spends
this summer and the next in Ogunquit, Maine. In
October he shows an oil, *Road in Maine*, at the
Opening Exhibition, Season 1914–1915, at the
Montross Gallery, New York.

1915 Hopper makes his first etchings. He is
represented in the Exhibition of Paintings, held

that February at the MacDowell Club, with the
canvases *Soir Bleu* and *New York Corner (Cor-
ner Saloon)*. In November, at the same venue, he
shows *American Village*, *Rocks and Houses*, and
The Dories, Ogunquit.

1916 Eight of the watercolor caricatures
Hopper did in Paris are reproduced in the Feb-
ruary issue of *Arts and Decoration*. He spends
the summer, and those of the following three
years, at Monhegan Island, Maine.

1917 Participates in the Exhibition of Paint-
ings and Sculpture by Mary L. Alexander,
George Bellows, A. Stirling Calder, Clarence K.
Chatterton, Andrew Dasburg, Randall Davey, Ro-
bert Henri, Edward Hopper, Leon Kroll, Thalia
W. Millett, Frank Osborn, John Sloan, at the
MacDowell Club. Shown are Hopper's *Portrait of
Mrs. Sullivan*, *Rocks and Sea*, and *Yonkers*. He is
represented in April and May at the First Annual
Exhibition of the American Society of Indepen-
dent Artists, with *American Village* and *Sea at
Ogunquit*.

1918 Hopper exhibits etchings at the Chi-
cago Society of Etchers and in the MacDowell
Club. His poster *Smash the Hun* wins first prize
in a national citizens' competition held by the Na-
tional Service Section of the United States Ship-
ping Board Emergency Fleet Corporation.

1920 In January Hopper has his first one-
man show, which is held at the Whitney Studio
Club, New York. Sixteen oils done in Paris and

Hans Namuth
Edward Hopper, 1963; Hans Namuth © 1990

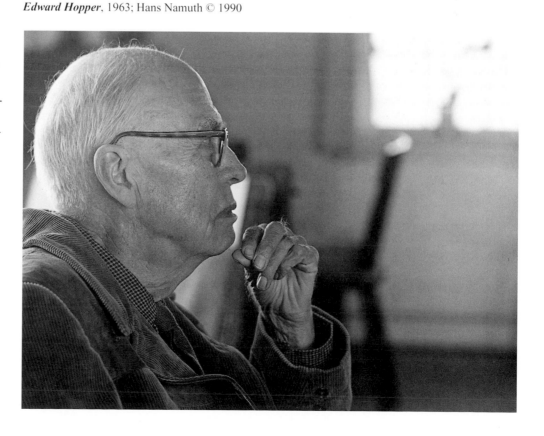

Monhegan are exhibited, including *Le Bistro* or
The Wine Shop, *Le Quai des Grands Augustins*,
Le Louvre et la Seine, *Blackhead, Monhegan*,
Rocks and Houses, *Ogunquit*, and *Road in
Maine*.

1921 Exhibits the oil *Park Entrance* at the
Annual Exhibition of Paintings and Sculpture by
Members of the Club, held in March and April at
the Whitney Studio Club.

1922 Participates again in the Whitney Stu-
dio Club Annual, this time with three etchings
and an oil. In October the Whitney Studio Club
presents ten of Hopper's watercolor caricatures
from the Paris period.

1923 Hopper attends evening classes at the
Whitney Studio Club and does a great deal of
life drawing. In February and March he shows
the etchings *East Side Interior* and *Evening Wind*
at the Exhibition of Etchers sponsored by the
Chicago Society of Etchers at the Art Institute of
Chicago. *East Side Interior* is awarded the Logan
Prize. In Philadelphia, Hopper's *New York Res-
taurant* is included in the 118th Exhibition of the
Pennsylvania Academy of Fine Arts. Spends the
summer in Gloucester, Massachusetts. Makes his
last etchings and begins to paint regularly in
watercolor. At the end of the year, Hopper ex-
hibits six watercolors in A Group Exhibition of
Watercolor Paintings, Pastels, Drawings and
Sculpture by American and European Artists, at
the Brooklyn Museum. The museum purchases
The Mansard Roof for $100.

1924 Hopper participates in the Annual Exhibition, Pennsylvania Academy of Fine Arts, Philadelphia; the Fourth International Watercolor Exhibition, Art Institute of Chicago; and the Annual Members Exhibition, Whitney Studio Club. 9 July: Marries fellow-artist Josephine Verstille Nivison. Exhibits watercolors at the Frank K.M. Rehn Gallery. All the works in the show, and more, are sold, permitting Hopper to give up his commercial art.

1925 Represented at the Tenth Annual Exhibition of the Whitney Studio Club, held at Anderson Galleries. Travels to Colorado and New Mexico from June to September.

1926 Participates in an exhibition of the Boston Art Club, and in Today in American Art, at the Frank K.M. Rehn Gallery. The St. Boltoph Club, Boston, mounts an Exhibition of Water Colors and Etchings by Edward Hopper, comprising nineteen watercolors and twenty-one etchings. Hopper travels to Eastport and Bangor, Maine, goes by boat to Rockland, then returns to Gloucester, Massachusetts.

1927 The Hoppers buy an automobile. They summer in Two Lights, Cape Elizabeth.

1928 20 January: Hopper makes his last print, a drypoint titled *Jo, a Portrait*. Summers in Gloucester, Massachusetts; travels through New Hampshire and Vermont to Ogunquit, Maine.

1929 One-man show at the Frank K.M. Rehn Gallery, comprising twelve oil paintings, ten watercolors, and a few drawings. Hopper vacations in Two Lights, Cape Elizabeth, Maine.

1930 Rents a house from A.B. Cobb, "Bird Cage Cottage", located in South Truro, Massachusetts, on a hill overlooking Cape Cod.

1931 Hopper is represented at the First Baltimore Pan-American Exhibition. Summers at "Bird Cage Cottage".

1932 Hopper refuses a nomination to membership in the National Academy of Design, on the grounds that his paintings were refused in earlier years. Rents additional studio space at 3 Washington Square North, New York. Hopper included in the first Whitney Museum of American Art Biennial; will be represented in almost every following Whitney Annual and Biennial.

Hans Namuth
Edward Hopper, 1963
Tucson (AZ), Collection of the Center for Creative Photography, University of Arizona. © 1993, The Hans Namuth Estate

Hans Namuth
Edward and Josephine Hopper, 1964
Hans Namuth © 1990

1933 Takes a short trip to Murray Bay, Quebec Province, Canada. Buys property in South Truro. Hopper retrospective takes place at the Museum of Modern Art, New York, with twenty-five oils, thirty-seven watercolors, and eleven etchings.

1934 In January, retrospective at the Arts Club of Chicago. Construction work on South Truro house completed in July. The Hoppers stay there until November of the year, and will spend almost every summer there from now on.

1935 Hopper receives the Temple Gold Medal from the Pennsylvania Academy of Fine Arts. He wins First Purchase Prize in Watercolor at the Worcester Art Museum.

1937 Awarded First W.A. Clark Prize, and Corcoran Gold Medal from the Corcoran Gallery of Art.

1938 Hopper buys a studio for his wife Jo in the back of 3 Washington Square North.

1939 Returns to New York early from summer vacation in South Truro, in order to travel to Philadelphia, where he has a seat in the Carnegie Institute selection committee.

1940 Cuts his vacation on the Cape short to go back to New York and vote for Wendell Willkie, Franklin Delano Roosevelt's challenger in the presidential race.

1941 From May to June, travels by car to the West Coast. The route takes the Hoppers through Colorado and Utah, then the Nevada desert to the Pacific coast, and north through California to the coast of Oregon. They return by way of Wyoming and Yellowstone Park.

1942 Hopper awarded the Ada S. Garrett Prize, Art Institute of Chicago.

1943 Travels by train to Mexico, where he visits Mexico City, Saltillo, and Monterey.

1945 Hopper receives Logan Art Institute Medal, and honorary membership in the Art Club of Chicago. Voted a member of the National Institute of Arts and Letters.

1946 Awarded Honorable Mention at the Art Institute of Chicago. Travels to Saltillo, Mexico.

1947 Serves in Indianapolis as member of jury selecting an exhibition of Indiana artists.

1950 Retrospective at the Whitney Museum of American Art, also shown in Boston and Detroit. The Art Institute of Chicago awards Hopper an honorary doctorate.

1951 Third journey to Mexico, including a visit to Santa Fe, New Mexico, on the return trip.

1952 Hopper is one of the four artists selected by the American Federation of Arts for the

Hans Namuth
Edward Hopper, 1964; Hans Namuth © 1990

Venice Biennale. In December he travels to Mexico.

1953 Co-edits the journal *Reality* with Raphael Soyer and other realist artists. Receives honorary doctorate from Rutgers University.

1954 First Prize for Watercolor, Butler Art Institute, Youngstown, Ohio.

1955 That spring, visits Mexico again. On behalf of the American Academy of Arts and Letters, Hopper is awarded the Gold Medal for Painting by the National Institute of Arts and Letters.

1956 Hopper becomes a member of the Huntington Hartford Foundation.

1957 Receives New York Board of Trade's Salute to the Arts Award, and First Prize, Fourth International Hallmark Art Award.

1959 One-man show at the Currier Gallery of Art, Manchester, New Hampshire. That December, the show travels to the Rhode Island School of Design.

1960 In January, Hopper has a one-man show at the Wadsworth Atheneum, Hartford, Connecticut. Receives Art in America Award. Meets with the group of artists who publish *Reality* at John Koch's house, to protest the increasing influence of abstract art at the Whitney Museum and the Museum of Modern Art.

1962 The Complete Graphic Work of Edward Hopper shown at the Philadelphia Museum of Art from October to November.

1963 Hopper retrospective at the Arizona Art Gallery, South Truro, from July to the end of November.

1964 Illness prevents Hopper from painting.

The Art Institute of Chicago awards him the M.V. Khonstamm Prize for Painting. The Whitney Museum of American Art organizes a large retrospective, which is later shown in Chicago, Detroit, and St. Louis.

1965 Honorary doctorate from the Philadelphia College of Art. Hopper paints his last picture, *Two Comedians*.

1967 15 May: Edward Hopper dies in his studio at 3 Washington Square North. His work is shown in the U.S. pavilion at the IX. Biennale in São Paulo.

Notes

Chapter 1

1 The following chapter is based primarily on the investigations of Brian O'Doherty, "Portrait: Edward Hopper," *Art in America*, 6, 1964, pp. 68–88; Lloyd Goodrich, *Edward Hopper*, New York (1970), 1989; Gail Levin, *Edward Hopper: The Art and the Artist*, New York, 1980; and Gail Levin, *Edward Hopper: The Complete Prints*, New York, 1979. Where other sources were used, this is indicated in the corresponding notes.

2 Quoted in O'Doherty, op. cit., p. 73.

3 Franz Roh, *Streit um die moderne Kunst: Auseinandersetzung mit Gegnern der neuen Malerei*, Munich, 1962, p. 148.

4 László Moholy-Nagy, *Malerei, Fotografie, Film*, (1927), repr. Mainz and Berlin, 1967, p. 91.

5 Quoted in O'Doherty, op. cit., p. 73.

6 Robert L. Herbert, *Impressionism: art, leisure and Parisian society*, New Haven 1988, p. 85.

Chapter 2

1 Hopper to Maynard Walker, unpublished letter of 9 January 1937. Quoted in Levin, *The Art and the Artist*, op. cit., p. 51.

2 Ernst H. Gombrich, *Aby Warburg: An Intellectual Biography*, London, 1970, p. 239.

3 J.P. Mayer and Max Lerner (eds.), *Alexis de Tocqueville, Democracy in America*, vol. 2, trans. by George Lawrence, (New York, 1966), London, 1968, p. 568

4 Quoted in O'Doherty, op. cit., p. 77.

5 Georg-W. Költzsch, "Prüfstein Realität," *Die Wahrheit des Sichtbaren: Edward Hopper und die Realität* (exhibition catalogue), Essen and Cologne, 1992, p. 9. The exhibition was held in the Museum Folkwang, Essen.

6 Joel Meyerowitz, "Stille und Zeit: Edward Hopper und die Fotografie," *Die Wahrheit des Sichtbaren*, ibid., p. 159.

7 Walter Benjamin, *Das Kunstwerk im Zeitalter seiner technischen Reproduzierbarkeit*, Frankfurt am Main (1936), repr. 1981, p. 15.

8 Mayer and Lerner, op. cit., pp. 767 f.

9 Cf. Adolf Halfeld, *Amerika und der Amerikanismus*, Jena, 1927; and Geoffrey Gorer, *The American People. A Study in National Character*, New York (1948), repr. 1964.

Chapter 3

1 A good general reference in this context is Lloyd Goodrich, "What is American in American Art?" *Art in America*, Fall 1958, vol. 46, no. 3, pp. 18–33.

2 Ibid., p. 21.

3 Goodrich, *Edward Hopper*, op. cit., p. 26.

4 Ibid.

5 Quoted in O'Doherty, op. cit., p. 73.

6 Barbara Rose, *American Art Since 1900. A Critical History*, New York (1967) repr. 1975, p. 27.

7 Mayer and Lerner, op. cit., p. 601.

8 Man Ray, *Self-Portrait*, New York, 1963.

9 Quoted in O'Doherty, op. cit., p. 72.

10 Samuel Eliot Morison, Henry Steele Commager and William E. Leuchtenberg, *The Growth of the American Republic*, two vols., New York and Oxford, 1980; vol. 2, p. 638.

11 Ibid., p. 302.

12 Ibid., p. 304.

13 Raphael Soyer, quoted in *Art Journal*, vol. 41, no. 2, Summer 1981, p. 131.

14 Robert Rosenblum, "Pop Art and Non-Pop Art," in John Russell and Suzi Gablik, *Pop Art Redefined*, London, 1969, pp. 53–56; this quote p. 55.

15 Susan Fillin-Yeh, "Charles Sheeler's Rolling Power," in Susan Danly and Leo Marx (eds.), *The Railroad in American Art: Representation of Technological Change*, Cambridge, MA, and London, 1988, p. 147.

16 Louis Aragon, *Le Paysan de Paris*, Paris, 1926, pp. 144–45.

Chapter 4

1 Arnold Gehlen, *Die Seele im technischen Zeitalter: Sozialpsychologische Probleme in der industriellen Gesellschaft*, Hamburg, 1957, p. 11.

2 Anne d'Harnoncourt and Kynaston McShine (eds.), *Marcel Duchamp*, New York: The Museum of Modern Art, (1973), 1989, p. 283.

3 Mayer and Lerner, op. cit., p. 603.

4 Siegfried Giedion, *Mechanization Takes Command. A Contribution to anonymous history*, New York (1948), repr. 1955, p. 219.

5 Walter Rathenau, quoted in Gehlen, op. cit., p. 17.

6 Dagobert Frey, *Kunstwissenschaftliche Grundfragen: Prolegomena zu einer Kunstphilosophie*, Vienna, (1946), repr. Darmstadt, 1992, p. 33.

7 Erwin Panofsky, "Die Perspektive als 'symbolische Form'" (1927), *Aufsätze zu Grundfragen der Kunstwissenschaft*, Berlin, 1992, p. 122.

8 Emerson's Essays, London, 1976, p. 149–167; this quote p. 149.

9 Gehlen, op. cit., p. 58.

10 Ernesto Grassi, *Die Theorie des Schönen in der Antike*, Cologne, 1980, p. 163.

11 Quoted in O'Doherty, op. cit., p. 78.

12 Quoted in Goodrich, *Edward Hopper*, op. cit., p. 129.

13 Hopper to the editors of *Scribner's*, vol. 82, March 1927, p. 706.

14 Gehlen, op. cit., p. 33.

15 Hopper to Marion Hopper, unpublished letter of 9 June 1910. Quoted in Levin, *The Complete Prints*, op. cit., p. 11.

Chapter 5

1 Eberhard Roters, "Die Straße," *Ich und die Stadt: Mensch und Großstadt in der deutschen Kunst des 20. Jahrhunderts* (exhibition catalogue), Berlin, 1987, p. 42.

2 Mayer and Lerner, op. cit., p. 600.

3 Walter Gropius, *Architektur: Wege zu einer optischen Kultur*, Frankfurt am Main and Hamburg, 1956, p. 11.

4 "The choice is yours – Schwarz-Weiß-Rhetorik in 'The City'," *Frankfurter Allgemeine Zeitung*, Frankfurt am Main, 25 Nov. 1992.

5 Gorer, op. cit.

6 Ibid.

7 Walter Benjamin, *Das Passagen-Werk* (ed. Rolf Tiedemann), two vols., Frankfurt am Main, 1983; vol. 1, p. 161.

8 Gert Mattenklott, *Blindgänger: Physiognomische Essais*, Frankfurt am Main, 1986, p. 31.

9 Richard Sennett, *The Fall of Public Man*, New York, 1977, p. 116.

10 Edward Hopper, "Charles Burchfield, American," *The Arts, XIV, July 1928*. Quoted in Goodrich, *Edward Hopper*, op. cit., p. 101.

Chapter 6

1 Sennett, op. cit., pp. 15/16.

2 Ibid., p. 259.

3 Ibid., p. 260.

4 Quoted in Goodrich, *Edward Hopper*, p. 104.

5 Sennett, op. cit., p. 13.

6 Ibid., p. 13.

7 Ibid., p. 15.

8 Ibid., p. 8.

9 Ibid., p. 15.

10 Ibid., p. 22.

Chapter 7

1 Quoted in Levin, *The Art and the Artist*, op. cit., p. 3.

2 Quoted in Grace Glueck, "Art is left by Hopper to the Whitney", *New York Times*, 19 March 1971

3 Quoted in "Art: Whitney Shows Items from Hopper Bequest", *New York Times*, 11. Sept, 1971

4 Clement Greenberg, "Review of the Whitney Annual," *The Nation*, 28 Dec. 1946. Repr. in Greenberg, *The Collected Essays and Criticism*, two vols., Chicago and London, 1986; vol. 2, p. 118.

5 Clement Greenberg, "Avant-Garde and Kitsch," *in Gillo Dorfles, Der Kitsch*, Tübingen, 1969, p. 118.

6 Although American criticism has since swollen to a torrent, the best discussions are still found in Gail Levin's books, mentioned above, and in Goodrich's *Edward Hopper*.

7 Cf. Thomas Wagner, "Eines langen Tages Reise," *Frankfurter Allgemeine Zeitung*, Frankfurt am Main, 23 Dec. 1993.

8 Christoph Vitali, in the preface to *Edward Hopper 1882–1967* (exhibition catalogue), Frankfurt am Main, 1992–93, and Stuttgart, 1992, p. 7.

9 Herbert Read, *Concise History of Modern Painting*, London, ³1974, pp. 7–8.

10 Cf. Goodrich, *Edward Hopper*, op. cit., p. 149.

11 Ibid., p. 27.

12 Quoted in Helmut Börsch-Supan, *Caspar David Friedrich*, Munich, (1973) 1980, p. 8.

13 Ibid., p. 7.

14 Quoted in Goodrich, op. cit., p. 161.

15 Jens Christian Jensen, *Caspar David Friedrich: Leben und Werk*, Cologne, 1974, p. 238.

16 Quoted in Harald Keller, *Französische Impressionisten*, Frankfurt am Main and Leipzig, 1993, p. 39.

17 Werner Hofmann, "Turner und die Landschaft seiner Zeit," *Anhaltspunkte: Studien zur Kunst und Kunsttheorie*, Frankfurt am Main, 1989, p. 207.

18 Rose, op. cit., p. 8.

19 Werner Hofmann, "Don Quijotes Seele im Körper des Sancho: Honoré Daumier," *Anhaltspunkte*, op. cit., p. 255.

20 Ibid., p. 260.

21 Quoted in Goodrich, op. cit., p. 161.

22 Sigmund Freud, "Das Unbehagen in der Kultur," *Abriß der Psychoanalyse*, Frankfurt am Main (1948), repr. 1953, pp. 90–91.

23 Hopper to Charles H. Sawyer, letter of 29 October 1939. Quoted in Goodrich, *Edward Hopper*, op. cit., p. 164.

24 Quoted in O'Doherty, op. cit., p. 80.

The publishers would like to thank the museums, public collections, galleries and private collectors, archives and photographers for their kind permission to reproduce the illustrations. In addition to the collections and institutions named in the captions, the following acknowledgements are also due:

© Addison Gallery of American Art, Andover, All Rights Reserved: 56

Photograph © 1993, The Art Institute of Chicago. All Rights Reserved: 43, 148–149

Artothek, Peissenberg: 40 bottom (Blauel), 142 left (Blauel/Gnamm), 186 (Blauel)

Bildarchiv Preußischer Kulturbesitz, Berlin: 42 bottom (Anders), 182 (Anders 1993)

© 1933 Geofrey Clements, New York: 162 top, 162 bottom

© 1989 Geoffrey Clements, New York: 22, 23, 42 top, 77, 89 top, 111 top

© 1992 Geoffrey Clements, New York: 66 top, 71 bottom, 121 bottom

© 1993 Geoffrey Clements, New York: 7

Geoffrey Clements: 13

Geoffrey Clements, New York: 9, 10 top, 13 bottom, 14, 20, 21, 27, 31, 35 top, 40 top, 41, 48, 53, 57, 61, 85 top, 90 top, 99 bottom, 104, 110, 118, 121 top, 138, 187, 188

Geoffrey Clements, New York, Courtesy Sandak/G. K. Hall Inc., MA: 179

Sheldon C. Collins, New York: 69

© 1992 D. James Dee: 45

© The Cleveland Museum of Art: 29

G.R. Farley-Photography, Utica NY: 99 top

Mike Fischer: 103

Jim Frank: 154

Photograph Courtesy Gagosian Gallery, New York: 174–175

Photo Courtesy Gagosian Gallery: 88, 144

Bill Jacobsen Studio, New York: 55

Bill Jacobsen, New York: 82–83

Photograph Courtesy of Kennedy Galleries, Inc., New York: 38, 90 bottom

Carl Kaufmann: 139

Photo: Ron Jennings: 95

Stephen Kovacik: 168 top

Robert E. Mates, Inc., New York: 6, 11, 15, 33, 39, 62, 100–101, 116, 185, 189, 192

Robert E. Mates, Inc., NJ: 8, 24–25, 30, 34, 35 bottom, 36, 142 right, 181

Robert E. Mates Studio: 32

© 1993 The Museum of Modern Art, New York: 78, 117, 128

© 1994 The Museum of Modern Art, New York: 72–73, 76

Scott McClaine – Sept. 1993: 28

© 1993 National Gallery of Art, Washington: 67, 96, 150 left

Henry Nelson: 129, 161

Ed Owen: 136

Rheinisches Bildarchiv, Cologne: 160 bottom

Lynn Rosenthal: 58, 59, 79, 85 bottom

© 1987 Steven Sloman, New York: 104

© 1989 Steven Sloman, New York: 80, 81, 91, 93, 112, 134 top

© 1990 Steven Sloman, New York: 60

Lee Stalsworth: 44, 50, 145, 169

Richard Stoner: 107

Whitney Museum of American Art, New York: 12, 68, 141 (Nathan Rabin)